behind the gloss

For Daisy

Thank you to my editors Isabel Wilkinson and Heather Boisseau, my agent Isabel Atherton at Creative Authors as well as Hazel Collins, Brigid Moss, Emma Dixon, Chris Royer, Willie Christie and my very patient husband, Mike.

Published in 2023 by Welbeck
An imprint of Welbeck Non-Fiction Limited
part of Welbeck Publishing Group
Offices in: London – 20 Mortimer Street, London W1T 3JW &
Sydney – Level 17, 207 Kent St, Sydney NSW 2000 Australia
www.welbeckpublishing.com

Design and layout © Welbeck Non-Fiction Limited 2023
Text © Tamara Sturtz-Filby

A CIP catalogue record for this book is available from the British Library.

ISBN 978-1-80279-403-8

Printed in China

10 9 8 7 6 5 4 3 2 1

Disco, divas and dressing up.
Welcome to the wild world of 1970s fashion

behind
the
gloss

TAMARA STURTZ-FILBY
Featuring interviews with Grace Coddington,
Zandra Rhodes, Barbara Hulanicki and more

WELBECK

contents

introduction

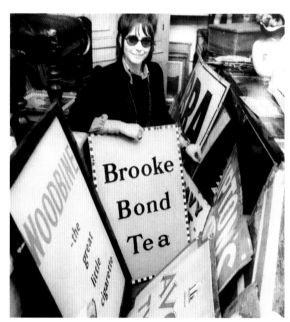

My mother, Jane Sturtz, the epitome of style, in the early 1970s.

Today, as I was browsing through my Instagram feed, I came across an image of Kylie Jenner. Nothing unusual there – until I scrolled down to the list of credits. Creative director, art director, photographer, fashion editors, hair stylist, make-up artist, nail technician, tattoo artist, set design, casting, executive producer, production. I have no doubt there were numerous assistants too. All of this for one fashion shoot.

In 1975, *Vogue* fashion editor Grace Coddington was in the Australian outback with one model (Marie Helvin), a photographer (David Bailey), a travel writer (flights and accommodation were free in return for a travel story) and a broom with which to smooth footprints from the sand. Marie did her own hair and make-up and there wasn't an assistant in sight. How times have changed.

*

I had always assumed that my love for fashion was a genetic fluke. My mother and I fought over what I was going to wear from as early as I can remember. I adored dresses and frills, but I was a child of the 1970s, and she dressed me in bright green dungarees and rainbow tops. I hated them. But while going through some old photos after she died, I began to realize that she had had the most incredible sense of style and clearly a huge love of clothes. From her signature pixie haircut and round sunglasses, purple flared jeans and floral chiffon blouses to beautiful hand-printed dresses with billowing balloon sleeves, she was the epitome of 1970s style.

I remember her telling me about how she and I would go to Big Biba on Kensington High Street, London, when I was two years old. Despite our taste differences in the early days, I'm eternally grateful that, by the 1980s, she would take me shopping on the King's Road for rara skirts, vintage army jackets and pink hair dye. It's no wonder I grew up obsessed with fashion.

It was this obsession that, years later, had me interviewing my old friend, the former model Hazel Collins, for a project I was working on. During the 1970s, Hazel had worked with fashion designers Thea Porter, Karl Lagerfeld and Yves Saint Laurent as well as photographers Terry O'Neill, Helmut Newton and Guy Bourdin, and her stories were fascinating. She explained everything in such vivid detail – from how she met Elizabeth Taylor at Thea Porter's exquisite treasure trove of a shop in London's Soho to having pears and Parmesan with Karl Lagerfeld on Sundays in Rome and partying with Catherine Deneuve and Charlotte Rampling in Paris.

Talking to Hazel made me realize that the 1970s was unlike any other decade. When people refer to it as the "decade that fashion forgot", they don't know the 1970s – or fashion. At the beginning of the film *Antonio Lopez 1970: Sex, Fashion & Disco*, Bob Colacello, former editor-in-chief of *Interview*, magazine sums it up perfectly:

> Everything was so new in the seventies: the gay thing was new, the drug thing was new, we were all baby boomers, it was like a social era that doesn't happen very often. One of the big social history trends was the emergence of the fashion designer as true social forces and as major figures in what was called "society" ... The sixties' social revolution really came true in the seventies. Everything underground was becoming overground. It was a much more open, fluid society – you

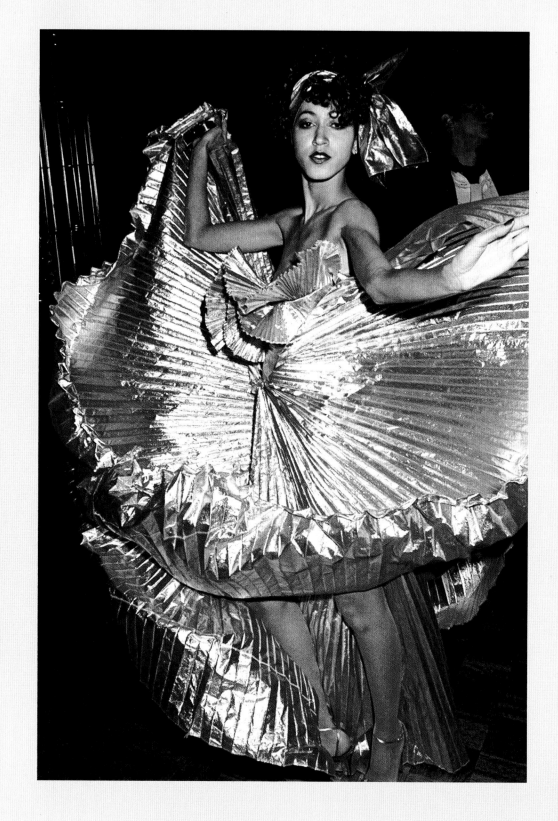

Model Pat Cleveland dancing the night away at Halston's disco bash at Studio 54, New York City, in December 1977.

had all these new groups that had not been accepted and were now running the show. It was all part of this scene that just took off in the seventies, took off and took over.

What I discovered was that it wasn't just fashion designers who exploded onto the fashion "scene" – it was also the models, editors, photographers, and even the shop girls behind the counter who completely changed the way we see fashion today. It was a transformative moment in time between the Pill, Stonewall and AIDS: the sexual revolution, women's liberation and Gay Pride. Those who had been supressed discovered they were creative and talented, that they were the ones who could make things happen and they no longer had to play by the rules.

The 1970s became the decade of experimentation in every sense of the word. Fashion became an "industry" but also, more importantly, a community. Anybody could wear it and anyone could be a part of it, regardless of gender, sexual orientation, colour or race. As a result, it became a melting pot of creativity and boundary pushing. Dressing up, partying all night, disco, drugs and sex – anything went.

There was a momentous change not only in the way clothes looked, but in the way they were designed, made, distributed and consumed. Ready-to-wear and "disposable" fashion had begun, and it changed everything. Until then, the fashion industry had been driven by couture, which was reserved for the rich but was beginning to be seen as elitist and old-fashioned.

It was the decade of taking risks, a decade of firsts. While stylist Caroline Baker was dressing women in men's tuxedos and high heels for *Nova* magazine and Barbara Hulanicki was selling £5 dresses, model Beverly Johnson was the first Black model on the cover of American *Vogue* and Cheryl Tiegs signed a cosmetics contract for a reported $1.5 million.

But it wasn't all gloss and glamour, and the decade didn't end without its victims. For many, the endless supply of cocaine on fashion shoots took its toll, as did the sexual revolution. Many of the bright young things who contributed to making fashion what it is today ended up either in rehab, going broke or dying. In the early 1980s, AIDS took its toll on the gay community and many talented designers, photographers, hairstylists, make-up artists and models lost their lives.

With the 1980s came new money and huge conglomerates that bought into what was now seen as a thriving fashion industry. But their big budgets came at a cost: the freedom, individuality and creativity that made the 1970s so special were stifled, taken over by sales targets and advertising.

Never have the voices from the frontline of this fashion and cultural revolution deserved to be heard more than now. They were the designers who dressed the Rolling Stones, Elizabeth Taylor, Charlotte Rampling, Brigitte Bardot and Catherine Deneuve, the photographers who photographed Diana Ross, Lauren Hutton and Jerry Hall, the fashion editors, hairstylists and make-up artists who worked with some of the most beautiful women in the world.

They spent nights at Studio 54 with Andy Warhol, danced on tables at Max's Kansas City, consumed cocaine like it was candy, had sex with whomever they wanted whenever they wanted, but stayed true to themselves. They were pioneers – not just in the world of fashion, but also as part of our social and cultural history.

One of the big things that stood out for me when I interviewed everyone for this book was the sense of friendship and community that developed during the decade. They didn't necessarily know what they were doing, but they knew they were in it together. They supported one another and their lives were intrinsically linked. There was room for everyone, and many of those friendships still exist today.

As make-up artist Sandy Linter says, "They were the disco days. We worked hard but mainly we had a lot of fun. We'd go to Studio 54 late, stay late and come home at daybreak. Then we would rock and roll our way to work. We were having the time of our lives. There is absolutely nothing we did back then that we'd be able to do today. The fashion world was much smaller then and it was a magical time."

Behind the Gloss documents the stories of those who broke the mould and changed the rules forever. They could be hedonistic and wild; they ruled the world of fashion from London and Paris to New York. Each story provides a glimpse into the world they inhabited and their moment in time. I hope you will be transported into this seductive, thrilling, brave, and yet often heart-breaking world of fashion, one that will never be seen again.

❝We'd go to Studio 54 late, stay late and come home at daybreak. Then we would rock and roll our way to work. We were having the time of our lives.**❞**

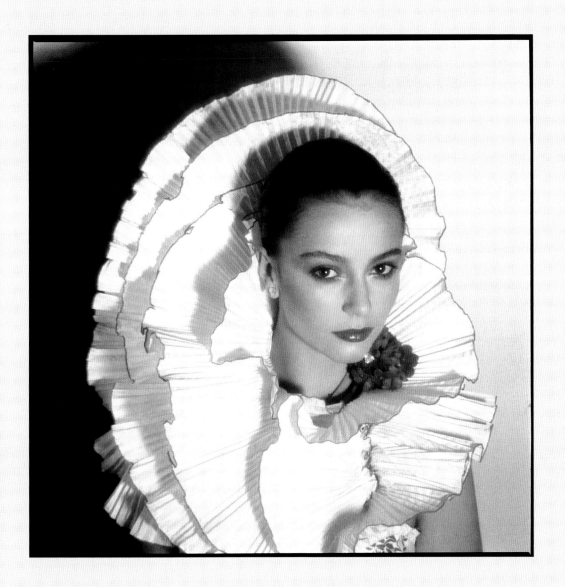

Model Rachel Ward in shaces of purple, British *Vogue*, 1977.

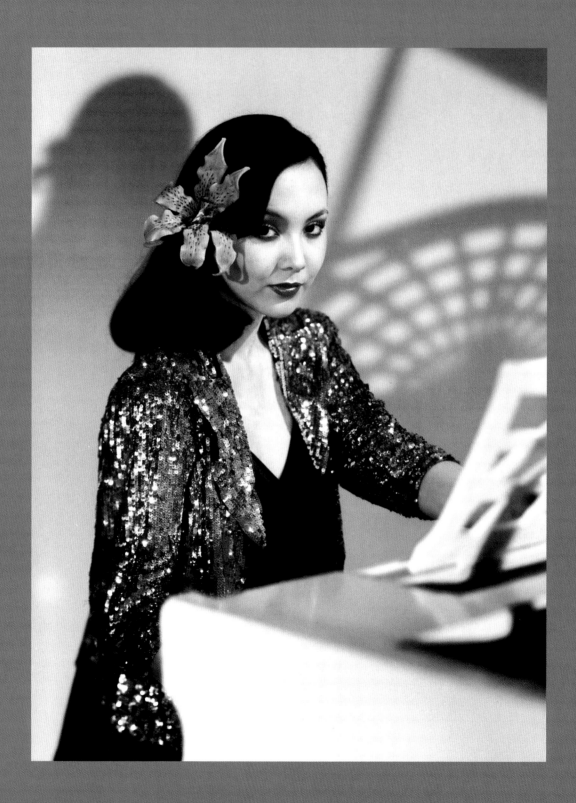

marie

Model

helvin

Marie Helvin began her modelling career at the tender age
of 17 and took the world by storm. British Vogue, 1975.

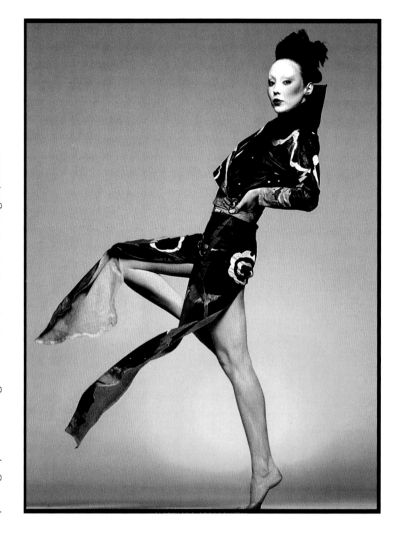

Marie Helvin was discovered by designer Kansai Yamamoto, and was often photographed wearing his incredible clothes. British *Vogue*, 1971.

Marie Helvin caused much confusion when she arrived in London in 1971. Nobody really knew what to make of her, this girl who had grown up in Hawaii, with an American father and a Japanese mother.

The press coined many a creative description for her, from "Asian supermodel" (which she hated) to "part Japanese, part Danish American tiger lily". But her friend, shoe designer Manolo Blahnik, put it succinctly: "An American-Japanese exotic, striking beauty. It was the look of the times, don't you think? She *was* the seventies."

Marie was 17 and inexperienced when she began her modelling career. "When I look back, it astounds me how young I was," **she says.** "A 17-year-old back then was really young, still a child, and I was completely thrown into this grown-up world by myself. There was so much responsibility, because as a model I had to do everything. There were no make-up artists or hairstylists, I did it myself and learnt as I went along."

As a result, Marie opted for simplicity. "My hair was slicked back most of the time because that was the easiest thing to do. There were no tongs, so if a photographer wanted big curly hair, it would mean setting it the night before and sleeping very uncomfortably in rollers. Hairspray was very basic and there were no such things as hair thickeners or styling products. I did discover through one hairdresser that the best thing to use for slicked back hair was KY Jelly, so I used to travel with tubes and tubes of the stuff. It washed out easily – unlike Vaseline, which stayed in your hair for weeks.

"When we arrived on location, I would be lucky if I was given one day to get completely fried and

brown. As soon as we arrived, I would get straight out into the sun. I created my own sun oil to help me tan especially fast, which was a concoction of Mecurochrome antiseptic solution and coconut oil, the worst thing you can put on your skin. We didn't know anything at that time about skin cancer and sun damage."

As the 1970s progressed, Marie became more confident: she was no longer the child pretending to be a grown-up. But there was still very little young fashion in London. "All the designers I worked for would give me clothes and I'd send them straight to my mother," **she recalls.** "There were very few stores for young people, but there was Biba and Bus Stop, which both had fantastic clothes. I also loved Kensington Market, which was packed with vintage and handmade clothes. That's where we all went to get our Afghan coats. Everyone was wearing these stinky coats that smelt like a farmyard, but they were so cheap and warm."

*

When she arrived in London, there was no such thing as a catwalk show, so Marie had to head to Paris, where the catwalk was still like the newsreels from the 1950s. "Designers would do them in their 'salons', or showrooms. It was a highly stylized way of walking and turning, and most often you would have to hold a card in your right hand, with the number of the outfit you were wearing. It was so old-fashioned."

But that was about to change. "In Paris, Kenzo was the first designer to use magazine models on the catwalk in his show Cover Girl. Most of them had no experience of the catwalk and that's what he wanted. There were no more hands on hips and no more cards in the hand. He wanted girls that you would recognize from *Vogue* and *Elle*, and for us to be completely free, with blaring rock music, the total antithesis of the salon show. It was what the French would call a 'spectacle', it was breathtaking." Soon, other designers followed.

But there was one fashion show that didn't go so well for Marie. "It was a disaster. Anjelica Huston was a close friend. Before the show a few of us got stoned, and I just didn't know where the hell I was. As I started to turn and twirl to the music, I lost my balance and ended up in the lap of Jennifer Hocking, fashion editor of *Harpers & Queen*. It was just awful. There was a terrible commotion and Anjelica thought it was hilarious, she couldn't stop laughing backstage. That was the first and last time I ever smoked grass before or during a show. Jennifer was actually very good about it and we worked together a lot, but I never told her about the grass, I said that I'd had too much Champagne."

*

And then Marie met David Bailey, and her life was about to change. "When I came to work in London, I think so much luck came into it. I met the young *Vogue* fashion editor Grace Coddington, and just became one of her girls. She booked me for everything. I worked with photographers such as Arthur Elgort, Barry Lategan, Eric Boman, Clive Arrowsmith and Willie Christie. One day, the editor of *Vogue*, Beatrix Miller – or Miss Miller, as I would call her in those days – asked me if I had ever worked with David Bailey.

"She told me that she had a shoot coming up with Bailey that she thought I would be perfect for. I had sat next to him on a plane once and I was fascinated by the way he was dressed, very casual yet he had on these beautiful Fred Astaire dress shoes, the kind you wear with a tuxedo. I remember thinking how glamorous that was. I felt very shy about meeting him again because I knew who he was by reputation, and he was considered to be the most famous photographer in London."

Marie went to see Bailey at *Vogue*. He was sitting on the floor, and as he flipped through her model book, he said, "Oh yeah, I know you," and that was it. The following day, she got the news that she was booked for two days with Bailey. "I started working with him every other day, and that's how it all began. It was the start of my working relationship with him, and then later on, our romantic relationship."

It also was the beginning of learning and being a part of the creative process between photographer and muse. "One of the most important things I carry from that period is having the intense good fortune to meet and work with Bailey, and to be able to understand the process from a photographer's point of view, which most models never get to do," explains Marie. "It was the only experience in my lifetime as a model of having that collaborative relationship."

At the same time, through Grace, Marie also had the perspective of working with a fashion editor.

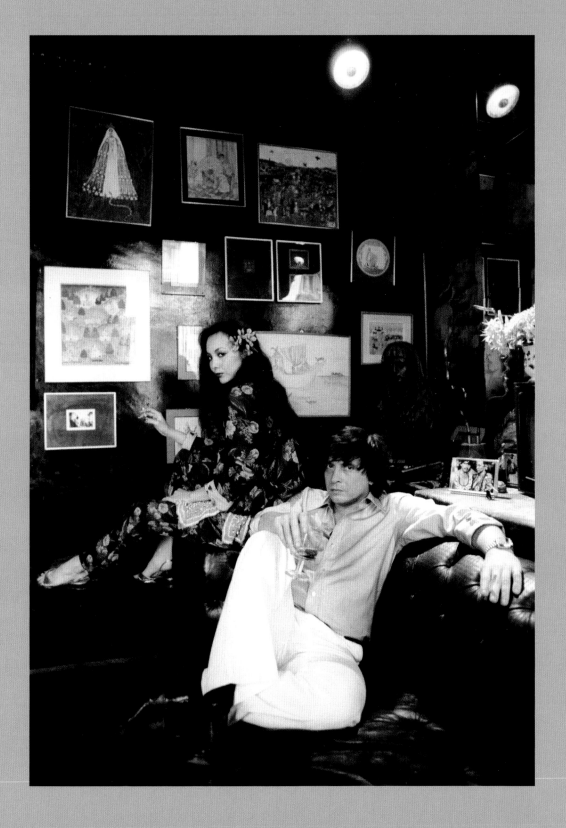

Marie Helvin and David Bailey relaxing at home in London, 1977.

"She really was unique and quite extraordinary. It is not a job that just anyone can do, the planning and foresight – you have to be an artist as well. I always remember the first trip abroad we did for *Vogue*. We went to Australia, and all flew separately. Grace had a two-hour stopover in Honolulu, where I happened to be with my family, and we flew on to Sydney together. My family were so excited, and as it was my first trip with *Vogue*, they all came to the airport to meet Grace. My entire family – poor Grace.

"My mom, sisters and I had made all these flower leis from the plumeria trees in our garden. We made six or seven so that she would be welcomed with fresh flower leis. She was covered up to her chin with them. We had a walk around the local shops, and I remember being shocked and quite taken aback when Grace decided to buy some plastic leis from a souvenir shop. I just didn't understand what was going through her head, when we had taken that time and made all these beautiful fresh ones. But she was still my boss, so I didn't question her.

"It wasn't until we got to our location in Australia that Grace whipped them out and we used them on the shoot. She had already been thinking ahead when she saw those leis, it was extraordinary. I saw this happen time and time again with her, including on a trip in Tunisia when she brought a broom so that she could rake the sand dunes. She would put me in position, lying on the sand, and rake the dunes into these beautiful waves, completely untouched by our footsteps and Bailey's boots."

Australia was a lesson for Marie in other ways too. *Vogue* may be a luxury magazine, but it was far from luxurious when it came to its staff. "I thought because it was *Vogue*, it was going to be luxury all

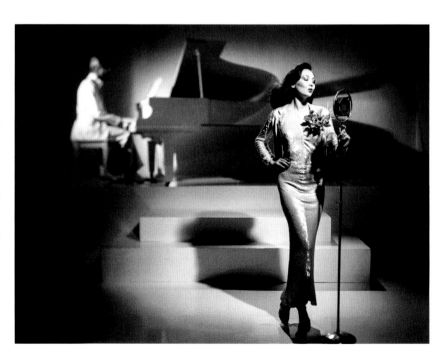

Marie Helvin singing on stage, British *Vogue*, 1975.

the way. What did I know? In those days, it was just me, Grace and Bailey, that's it. The photographer never had an assistant on location or anyone to help. It took us two days to drive from Sydney to Cairns where we were shooting and when we arrived, we weren't even staying in a proper hotel, it was some kind of motel. The *Vogue* travel editor met us there and we all shared one room, so Bailey and I ended up sleeping in the kitchen.

"It was so hot. There was no swimming pool, but there was an old, disused oil tank, which was the pool. Three people could fit in it standing up, or four in a tight squeeze. I was so shocked, but I never complained. It also never occurred to me how little I was being paid by *Vogue*. I think they paid £20 a day at the most, but in those days, we just accepted it. After my agent took 10 per cent, I wasn't left with very much. However, after that first trip, I knew never to expect four-star luxury."

<p style="text-align:center">*</p>

Marie's relationship with Bailey was a combination of chemistry, passion and exclusivity. "For British *Vogue*, Bailey made a rule that I couldn't work for any other photographer, and he only wanted to work with me. We were wildly attracted to one another, madly so, and there was obviously something about me that he wanted to photograph, something in me that inspired him."

On location, the duo was also exclusive: no other models, just Marie. Australia, Tunisia, Morocco and Hawaii for British *Vogue*. India, Goa and Sri Lanka for *Vogue Italia*, Haiti and Tahiti for *Vogue Paris*, they did them all together. "Between the three *Vogues*, we were working non-stop," remembers Marie. "I took it for granted at the time but looking back on it now, it really was quite an extraordinary time."

They were the perfect combination. Nothing was too difficult, whether it was working long hours or creating weird poses, Marie was prepared to do anything. "I think that because I gave so much of myself, Bailey was able to use me, from an artist's point of view, to create. I wasn't your average model because he was falling in love with me and there was the chemistry between us. When you're in the early days of falling in love and working together, it's quite magical."

Marie was only too aware of how special the collaboration was between herself and Bailey. Not only was she able to participate in seeing the photographs before they went to the magazines, but he allowed her to have a say, which, even today, is virtually unknown. "Once our relationship grew stronger, and we were working together constantly, as well as living together, it came to a point where he would actually let me choose the pictures. It was just the perfect working relationship. He was as lucky to have found me as I was to have found him.

"Everything about that decade was unique. Not only was it my first experience at life and of being a grown-up, but I had the most extraordinary teachers. My eyes were opened to many incredible things through Bailey, and also Grace. It was the whole experience of living, and it was such an incredible time."

David Bailey photographing Marie Helvin at their home in London, 1977.

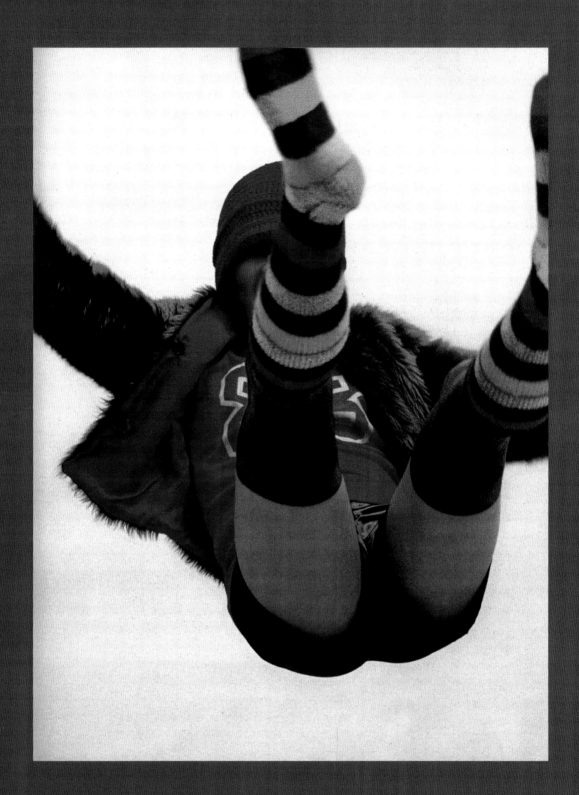

caroline

Fashion Editor, *Nova*

baker

Caroline loved using sportwear, from striped football
socks to American baseball tops, Nova, October 1971.

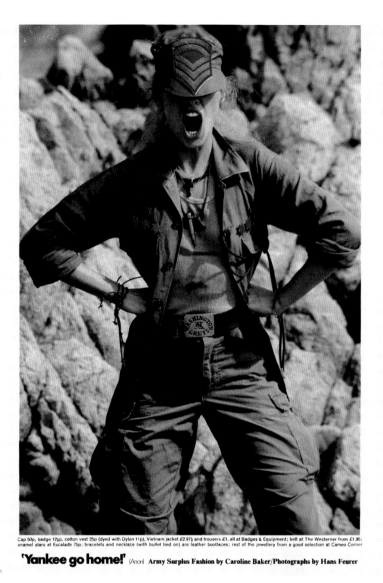

Army surplus stores provided cheap pickings for Caroline, and American combat gear took women's fashion by storm. Nova, September 1971.

Cap 50p, badge 12½p, cotton vest 25p (dyed with Dylon 11p), Vietnam jacket £2.97½ and trousers £1, all at Badges & Equipment; belt at The Westerner from £1.95; enamel stars at Escalade 75p; bracelets and necklace (with bullet tied on) are leather bootlaces; rest of the jewellery from a good selection at Cameo Corner

'Yankee go home!' (Anon) **Army Surplus Fashion by Caroline Baker/Photographs by Hans Feurer**

In the late 1960s, nobody had yet coined the term **"street fashion"**, but a controversial new magazine and a young secretary who was mad about clothes were about to change all that.

Nova, a magazine for independent, working women who couldn't identify with the likes of *Vogue* and *Harper's Bazaar*, launched in 1965. Two years later, Caroline Baker, a former secretary at the *Observer Magazine*, took over as fashion editor.

But *Nova* wasn't a fashion magazine. "It was set up like a Sunday supplement, and the whole idea of it was that it was not meant to be like *19*, *Woman's Own*, *Queen* or *Vogue*," **explains Caroline.** "Fashion was a small part, but I had no idea what a huge influence it would have." **There were no knitting patterns or recipes in *Nova*, and fashion images shot by photographers such as Helmut Newton, Hans Feurer, Jeanloup Sieff and Harri Peccinotti sat alongside controversial stories about politics, homosexuality, race and abortion. Because it was outside the normal confines of a woman's magazine, there was freedom to experiment.**

The 1960s had changed everything, and *Nova*'s pages were the perfect canvas for the new fashion revolution. "The sixties brought a change in attitude to what you could do and what was acceptable," **explains Caroline.** "My mother would always do what was correct. She wore gloves and a hat, and my father always wore a hat – it was just something they did. Whereas my generation suddenly decided we didn't want to do that, and we started rebelling against the status quo. And that's when Paris began to feel the shake, because until then, it had dominated the world of fashion. At the same time, Jackie Kennedy had completely influenced the way the world dressed, [as had] all those women in high society before her. But suddenly, along came pop stars and TV shows, and the youthquake, and everything changed.

"When I started at *Nova*, it was the beginning of another big change in fashion. We were moving away from the dolly bird, Mary Quant sixties girl and, with the influence of the hippies in America, clothes began to get softer, and we saw designers such as Ossie Clark, Zandra Rhodes and Bill Gibb, who were more ethnic. On the other hand, there was David Bailey shooting beautiful pictures of Jerry Hall and Marie Helvin for British *Vogue*, and Norman Parkinson creating images of women posing with glamorous make-up, big hair and high heels, and although it was beautiful, I was fighting it. Perhaps it was envy on my part, but I decided to do the complete opposite of what they were doing. *Nova* was about being different, and it ended up with the label 'street fashion'.

"At the beginning, as fashion editor, I was in absolute awe of the photographers I worked with – Jeanloup Sieff, Helmut Newton, Guy Bourdin, Hans Feurer, Harri Peccinotti – they were artists and we treated them as such. I was simply the clothes person and would arrive with a suitcase." **But Caroline quickly gained experience and confidence, and soon became fully immersed in the conceptual side of the magazine's shoots. She was incredibly influenced by those she worked with, and that showed in her stories.**

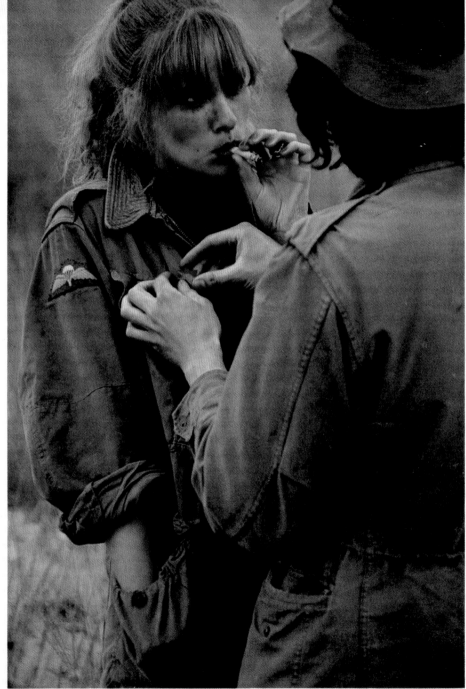

Khaki cotton zip-fronted flying suit £1.37 and long grey woollen scarf 33½p, both at Victor Laurence; star brooch at Escalade 75p. Stockists on page 95

'C'est magnifique, mais ce n'est pas la guerre' (Maréchal Bosquet)

53

"Hans Feurer and Harri Peccinotti were both into women's lib, and I very much got into that thing of not wanting to dress women in the overtly sexy way of the early 1970s, with heavy make-up and done hair, and they were both in the same spirit," **she remembers.** "They liked natural-looking girls, and that's when I started looking at men's clothing and army surplus, which I thought was infinitely more youthful and practical than women's stuff. But I made it feminine because it wasn't in any way about not enjoying men. I wanted to feel that women were pleasing men without being sex objects."

Everybody was ready for a change, especially the young. They were daring and brave, but it wasn't just women. "The whole glam rock thing happened in the seventies, which was amazing and brought out all the gay boys. They could suddenly come out of hiding, so that was a huge change to the whole clothing thing, such as the New Romantics, and what boys could wear. And the girls suddenly noticed competition."

Despite being obsessed with fashion, Caroline wasn't in the least bit interested in couture. "I used to go to the Paris collections and London Fashion Week, but I was more interested in what was happening on the street. It was so fascinating because at the beginning of the seventies, Yves Saint Laurent started doing the 1940s look, which was apparently inspired by the London gay clubs, with forties dresses and platform shoes. Suddenly, Patti Boyd and all the 'It Girls' and the girlfriends of the Rolling Stones and Beatles were wearing antique

clothes, and that was the beginning of second-hand clothes being okay, because until then, it had always meant you were poor.

"The King's Road in London had a lot of great second-hand shops, and I would pick up clothes from there. There was Laurence Corner in Camden Town for army surplus and a wonderful second-hand men's shop called Moss Brothers in Covent Garden." **Yves Saint Laurent had just launched the tuxedo for women, but who could afford YSL? Caroline bought men's suits (they didn't even have to fit), and simply put a gold belt around the waist and added a pair of high heels. She would wander through Soho, where she discovered a waiter's shop and fell in love with the cook's and painter's pants and jackets, piling on diamonds for a feminine twist.**

Decades ahead of her time, Caroline was the pioneer of sportswear as fashion. "I loved sports clothing, especially American baseball, with all the numbers and colours. That's where I got the idea to do all the shoulder pads, which I did for British *Vogue* when I left *Nova*. I always loved the look of athletes and ballerinas. There was a ballet shop in Covent Garden where I would stock up on leggings, as I was always cold. I was always prowling about finding things, and I had total freedom. That was the wonderful thing about the 1970s: complete freedom to express yourself."

At first, Caroline didn't realize the effect she was having with her styling. "I did an army surplus story with Hans Feurer, and about six months later at the collections in Paris, I just couldn't believe it when

I saw all this army surplus on the catwalks. It was the birth of the whole urban clothing look. Another time, I did a white story with diamonds and again in Paris, Kenzo did a whole show with white and diamonds. That's when I began to realize that the designers were following what I was doing.

"At *Nova*, I was always very price conscious, because I didn't have much money myself, just what I earned, and *Nova* was very much for the reader who was not a rich girl who bought *Vogue* or *Tatler*, but was more likely to be the emerging working woman on a salary. I used a lot of Bus Stop and Biba, or if I wanted to create the Bill Gibb or Thea Porter look, I would visit the antique shops and recreate it myself.

"It never mattered if the clothes were too big – it was my style to make them fit. I had everything I needed in my kit. I used to love using gold belts, which gave birth to the huge, bunched trousers with pleats, and I would put them together with huge shoulder pads. I loved layering and always made sure that I had black and white T-shirts and vests, as well as leggings and tights. I had leotards and legwarmers, which took off – and suddenly Jane Fonda and ABBA were wearing them. I used football socks on girls and would sew together rugby socks so that they would have all these stripes wrinkled around the ankles. I had Victorian white-lace collars. Lots of scarves, too, as the neck might suddenly need a bit of attention, or I would need to wrap the hair. Scissors and safety pins were

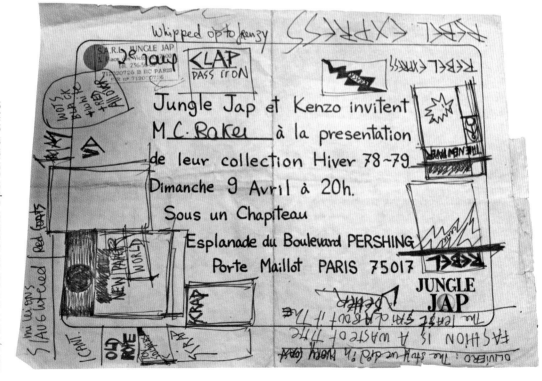

Invitation to a Kenzo runway show in Paris for A/W 1978/79. From Caroline Baker's personal archive.

Caroline Baker sketches ideas for fashion stories, 1977.

The perfect belt: curtain tie-backs were the new accessory at *Nova*, February 1970.

Caroline Baker was always looking for affordable and unusual ways to create new looks. DIY fringed leg warmers, *Nova*, February 1970.

Caroline Baker was keen to push boundaries with photographer Harri Peccinotti. Even simple stories on how to layer wool sweaters and shorts were photographed in different and subversive ways, *Nova*, 1971.

essential; I was always happy to put something together with safety pins."

*

Shoots were not always plain sailing. Being young and socially aware, Caroline did not enjoy fur shoots. "When I started at *Nova*, the only advertisers that were considered really important were the fur companies. Every year, in October or November, I was told to do a fur story. My first one was with Hans Feurer, and he suggested that we get some baby tigers from the zoo. I mean, why not? I found a small private zoo and we had this little tiger, which scratched us all. Real fur with real animals – but for me it was the beginning of the fur revolt."

One year, the fur story was with four models in an ice factory that was so cold she couldn't even fix the clothes. But the final nail in the coffin for fur and *Nova* was the story "Every Tramp Should Have One". "I had seen a woman living on the streets in Knightsbridge, and was intrigued by her. She had everything she owned in a pram, and she had a lot of dogs. I borrowed a pram and hired all these dogs. The model wore the furs with layers of clothes and several pairs of socks. I thought it was terribly funny, but the furriers were absolutely incandescent with fury, and never advertised again. It was the beginning of the end for both fur and *Nova*."

*

The importance of advertising began to take over, and the cost of printing and paper was on the rise. *Cosmopolitan* also launched, and this had a huge impact on *Nova*. "It was targeted at a specific woman, so suddenly, we had to know exactly what we stood for, who our reader was, what clothes she wanted to wear, and what she wanted to know. In the end, it became so important that it dictated my styling and fashion stories," **explains Caroline.** "The advertisers got stronger and stronger, to the point that if you weren't featuring their clothes, they wouldn't advertise. It changed everything entirely. The freedom had gone."

Experimentation was out and risk was too risky – and this change impacted everyone in the fashion industry. "British designers found it so difficult when they couldn't afford the advertising, and they struggled," **she remembers. A lot of talent fell by the wayside, and *Nova* was no exception. It folded in 1975.** "We had been free to do anything we wanted, but it didn't work in this new capitalist world. Suddenly, it was all about making money."

"We had a wonderful few years at *Nova* while it lasted. I loved my time there." **Caroline's talents weren't wasted – she went on to work for British *Vogue*, Vivienne Westwood, *The Face*, *i-D* and the *Sunday Times* – but nothing quite compares to the influences and themes, many of which are still around today, that she single-handedly created during her days at *Nova*.**

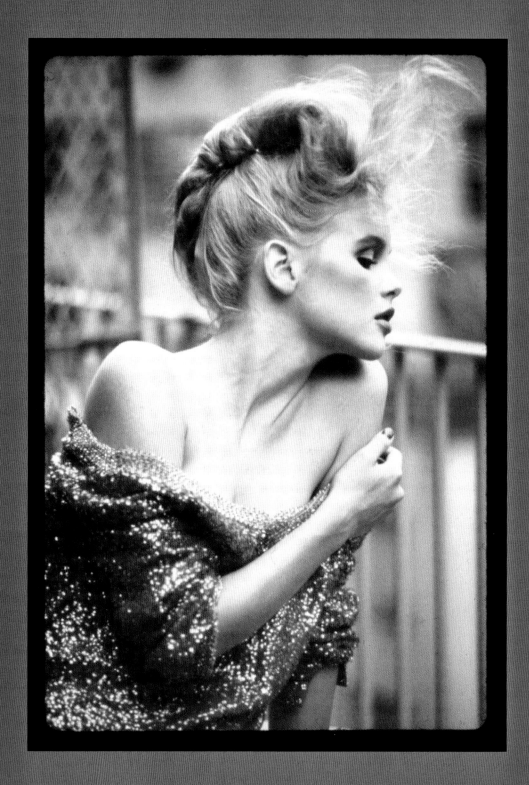

harry

Hairstylist

king

By 1975, British hairdresser Harry King was taking New
York by storm with his "never-seen-before" hair.

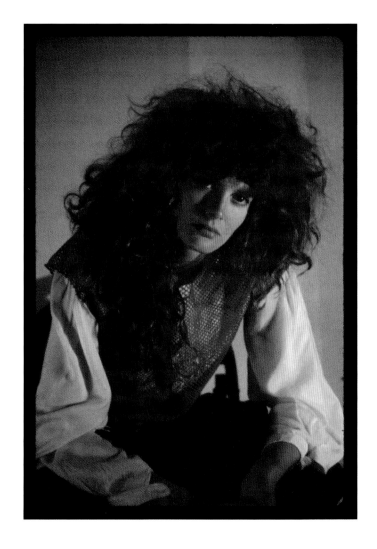

Harry King's apartment was a model hangout. If he didn't whip out his scissors it would be his Nikon camera – as seen here with model Rene Russo.

Harry King loved his childhood. Brought up by Russian immigrant grandparents in north London, he was surrounded by aunts, uncles and cousins – and most importantly, by clothes.

"My grandfather had a men's clothing store at Elephant and Castle, and I would go at weekends and hang out. I loved it," **Harry remembers. When he was 14, his grandfather died and his grandmother, who had never done a day's work in her life, took over the shop. She added women's clothing, and every Saturday, Harry would go with one of his aunts to East Street Market to sell their wares.**

So how did a young market trader who left school at 15 end up with a client list including Lauren Hutton, Sophia Loren, Debbie Harry, Diana Ross, Jerry Hall and Bianca Jagger, along with nearly 100 *Cosmopolitan* covers and 55 *Vogue* covers to his name?

When his aunt suggested he become a hairdresser's apprentice because the tips were good, Harry took her advice. Over the next few years, he worked his way from local hairdressers in Golders Green to the high-end salons of Bond Street. By the age of 24, he had become the first hairdresser to work alongside Michael and John at the renowned Michaeljohn salon. Little did he know how his life was about to change forever.

"I was working with two of the best hairdressers I've ever seen, but I lost all my confidence," **explains Harry.** "After about four months, Michael took me into a corner and told me that Lorna Cottel, the fashion editor of *Queen* magazine, was coming in and that I was to do her hair. Not only that, but if I

didn't do it well, I was out. But she came in and we hit it off and she booked me for a job for *Queen* with photographer Norman Eales and they loved what I did. My confidence soared." **Within weeks, Harry was booked with photographer Brian Duffy for the Paris collections, a far cry from East Street Market.**

Until the early seventies, hair was either very "done" or geometric, but Harry was about to change all that. In 1973, while still at Michaeljohn, he invented a new haircut and, with that, began his journey to fame. "I was doing a lot of free hair. No rollers, just cut and left to dry. I liberated women from the hairdresser and the hairdryer, the hairbrush, the geometric look. And they loved it."

*

Snapped up by *Cosmopolitan* magazine, whose editor-in-chief, Joyce Hopkirk, named this new look the "Lion's Mane", Harry started working with photographers such as David Bailey, Bill King and Norman Parkinson, and life was pretty good. But New York was calling. "I loved my life in London, I had a fabulous flat and my life was there, but London felt tired. We had the Three-Day Week [government-imposed measures to conserve energy], limited electricity and, for me, the fashion scene was over. I was very ambitious."

Harry arrived in New York in 1974 – just the right time. The big fashion designers such as Calvin Klein and Geoffrey Beene were just emerging and

he simply continued the look he started in London: natural hair. "Those hairdos would take me 10 minutes. I would simply ruffle the hair up with my hands. But within the free hair, I was also chopping hair – it was fucked-up hair, bed hair, rough hair, because that's how women look, and they loved to look sexy."

But Harry had a rocky start. "My first shoot was with *Seventeen* magazine, which I completely fudged. I'd never been told what to do in London and just wasn't used to it. Another job was for *Glamour* and with two new models, Rosie Vela and Patti Hansen (neither had made it to *Vogue* yet). It was a disaster. 'How to perm your own hair', and I had to put perm rods in their incredible hair to make it look like they'd done it themselves. A very lame sitting.

"I had a meeting with *Vogue* fashion editor Polly Mellen, which was very funny. I was sitting on the twelfth floor and her assistant, Vera Wang (who went on to become the fashion designer), came out and took me into Polly's office. A while later, Polly came in with books under her arms and she had her back to me. She was a woman in her fifties with steely-grey hair. She was wearing a tight navy cashmere sweater, grey flannel pants, black crocodile loafers and a thin brown belt over the sweater. She put down the books, and said to me, 'So Henry, where's your book?'

"I thought she was so rude, but I was naïve in those days, I didn't understand the power of *Vogue*. I didn't have a book, so I told her it was coming from London. I'd never had a portfolio in London – everybody knew me. Still with her back to me, she

asked me if I'd done any work in New York. I told her I'd done nothing to write home about, just a couple of jobs, but had she heard of Michaeljohn in London? I knew there was a big beauty picture from Michaeljohn in American *Vogue* that month, and I told her I was the creative director. With that, she finally turned around. She asked if I'd ever worked with David Bailey. Well, of course I had. And Norman Parkinson, Clive Arrowsmith and Patrick Lichfield.

"Polly walked me to the elevator, gave me a beaming smile as I stepped in, and two days later booked me for a trip to Fisher Island with photographer Deborah Turbeville, make-up artist Sandy Linter and a couple of models. It was meant to be a three-day trip, but they loved it so much they kept adding on days. I'd come back to New York, stay in a hotel overnight – there was no time to go back to my apartment – get up in the morning and set off again. It turned into a two-week trip."

Harry had won Polly Mellen over. She was quoted by him as saying, "He makes women look how they look. It's so modern. This is what I want for *Vogue*." **Harry found himself working for *Vogue* every day for the next three months, which turned into years.** "Everyone loved what I was doing, this free hair. Richard Avedon, Irving Penn, Francesco Scavullo, Deborah Turbeville, they all loved it. I set women free and I'm proud of that. All the girls wanted me to do their hair. To go to work was easy for me, because I had my own technique and it worked."

OVERLEAF: Models Rosie Vela and Patti Hansen relaxing with Harry King's windswept hair, American *Vogue*, November 1975.

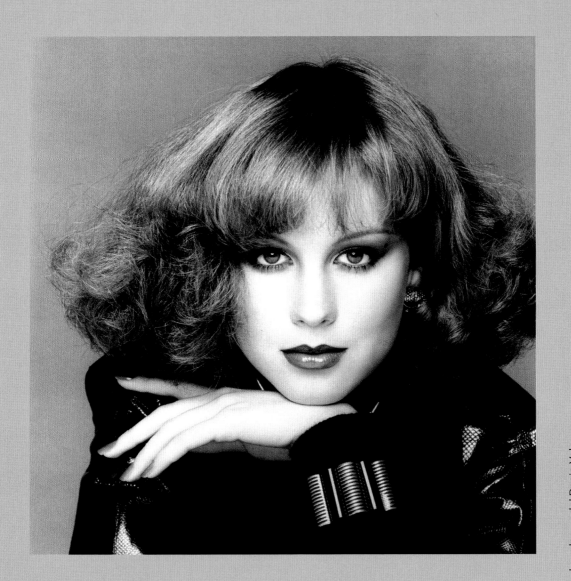

Beautiful bangs and curls: model Rosie Vela in American Vogue, September 1975.

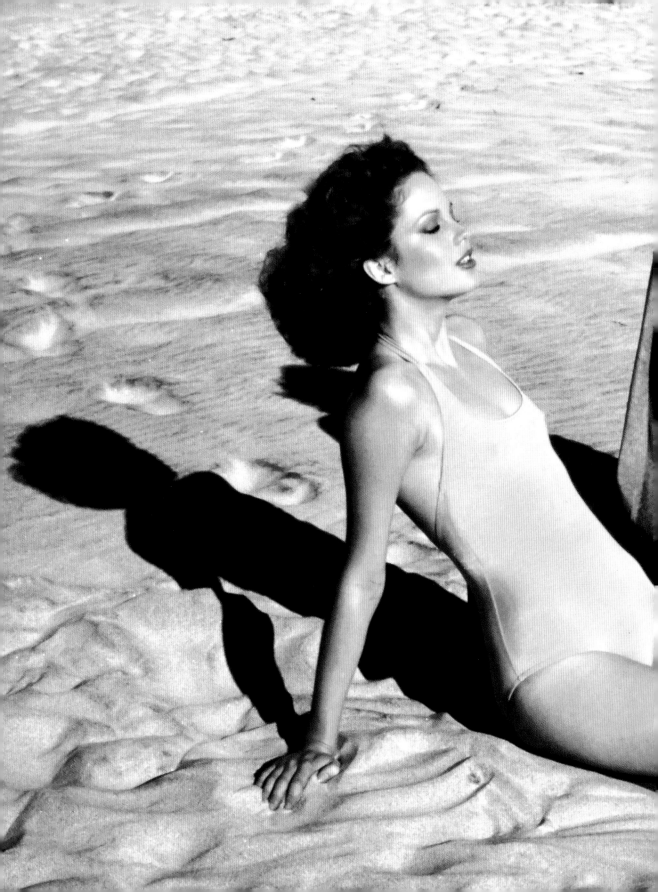

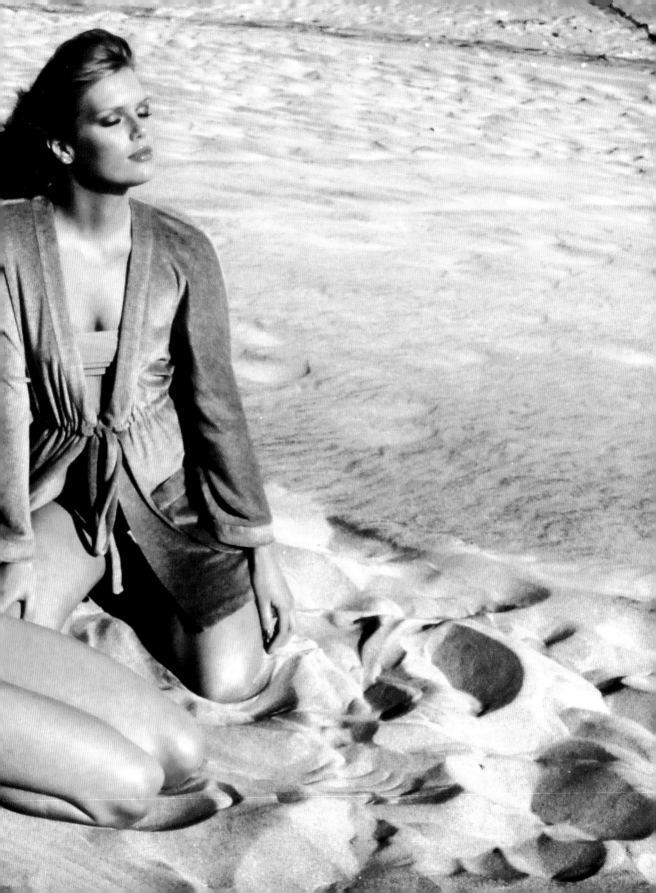

By 1975, Harry and his "girls" were taking New York by storm. Patti Hansen, Janice Dickinson, Rene Russo, Rosie Vela, Iman, Beverly Johnson, Gia Carangi. "They were all amazing. The girls would walk around the studio in nothing but slingback high heels with panties and nothing else. Just my loose, fabulous hair. Rene Russo told me that before I did her hair, she used to sit in the studio and cry. When we first met, I thought she was 28, but she was only 19. They used to set her hair with way too much make-up. But too much make-up with the hair I did worked, it was like a counterbalance".

And then Harry cut Rene Russo's hair, a near disaster which catapulted him further into stardom. "I had just done Patti Hansen's hair for her first *Vogue* cover, and I got a call from Rene. *Vogue* wanted her to cut her hair for a trip to Peru and she had requested that I do it. I told her not to cut her hair just because a magazine wanted it, and at the same time I was thinking, *Oh please, Rene, let me cut your hair*. We arrived in Peru with Polly Mellen and photographer Francesco Scavullo, and just before dinner, they asked me to cut her hair. I went to her room, and it was done in 10 minutes. I mean, Rene had the best hair in the world, but I cut it all off and gave her a savage cut, the quintessential Harry King haircut, and then I told her to meet me in the dining room, but not to touch it, just leave it alone.

"I went back to the dining room, smiling and walking on air. I told everyone that it was fabulous and they were going to love it. But Rene blowdried her hair out and she had this little flick with a fringe, it was awful. Scavullo screamed, 'He's ruined her, I can't work with her.' He was going on and on until Polly said, 'You haven't let Harry say a word,' so I simply said, 'Wait until tomorrow.' The next morning, I roughed it up a bit and of course, everybody loved it. So much so that the *Vogue* beauty editor did a big story on it. It was really fabulous."

Harry and New York were made for each other. "I was young, I was working for *Vogue*, the drugs were fabulous. And that's what was great about living in New York. The nightlife, the restaurants, the new friends. I was being flown to Paris and London two or three times a year for the collections. I was living the life."

❝I was young, I was working for *Vogue*, the drugs were fabulous. And that's what was great about living in New York. The nightlife, the restaurants, the new friends.❞

With success came the disco, drugs and sex. "I was sleeping eight and a half hours a week. We would start the evening in my apartment, with friends, smoke dope, maybe have a vodka or beer, do a line of coke, and then we'd go to Studio 54, where there were lines of coke in the toilets and poppers on the dance floor. That was the lifestyle, it was clubs, people hanging out doing drugs together in fashionable restaurants. We would sit at the table and chop lines of coke on the tablecloth – it was normal, it was just fun and we were all so uninhibited."

But for some, the drugs and the lifestyle took their toll. "There was cocaine on shoots, it had become so fashionable. Everyone had eyes that looked like piss-holes in the snow, they were so high, but it was how we worked. Nine out of ten people on bookings were high. There was a trip to St Barts with Gia Carangi, and when I showed up in the morning to do her hair, Gia was packing her bags to leave because she'd lost her stash of drugs. I had to convince her to stay, that we'd get the drugs on the island, speak to the right people."

"This was followed by Janice Dickinson coming over to my apartment one day and I chopped all her hair off. It looked fabulous. But the next day she seemed gone, so gone to me. I couldn't hang out with Janice anymore, and I couldn't hang out with Gia, because she was doing drugs that I didn't do. In the end, Gia was just unlucky, she chose a dirty needle."

The other great loss was AIDS. "I was going to gay sex clubs, along with everybody else, and one night, I was standing there thinking that something terrible is going to come of this. And suddenly, at the end of the seventies, two friends of mine, the writer Henry Post and male model Joe MacDonald, got sick and everybody became very nervous. People started dropping like flies. I lost over 40 friends in both London and New York to AIDS, including make-up artists Way Bandy and Vincent Nasso, and friends Tina Chow and Gia Carangi. There was no medicine. It was a new plague – if you got it, you died quickly and in a lot of pain. I would visit friends in hospital and they would be screaming from the pain. It was a horror story."

Harry considers himself one of the lucky ones. "When AIDS exploded, everything changed, everyone cleaned themselves up. I can remember sitting with Patti Hansen and her boyfriend, Keith Richards, at a restaurant called One Fifth Avenue, toasting my first negative AIDS test. I knew how lucky I was."

But Harry has no regrets. The hair he created back in the seventies never went away. It still looks modern to this day; he was a true innovator and influencer of our times. "The seventies was like a rush. It was a roller coaster of a ride, but it was a wonderful ride, because I learnt so much. It was magical."

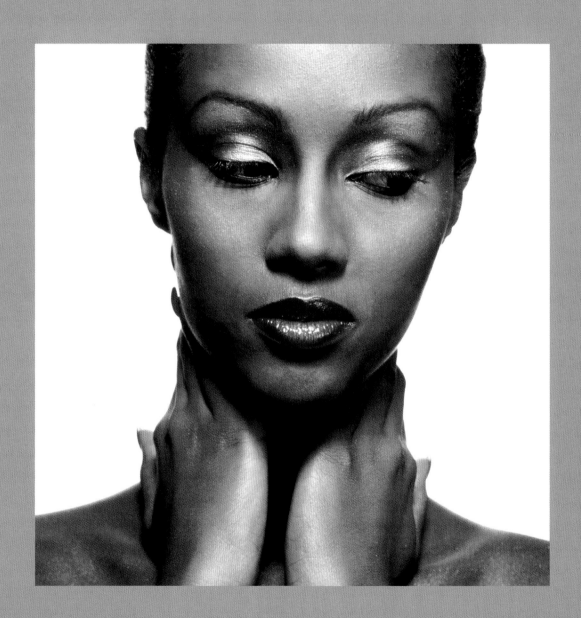

sandy

Make-up Artist

linter

Sandy Linter worked with some of the most beautiful women in the world for American *Vogue* during the 1970s, including the legendary Iman, as in this December 1977 issue.

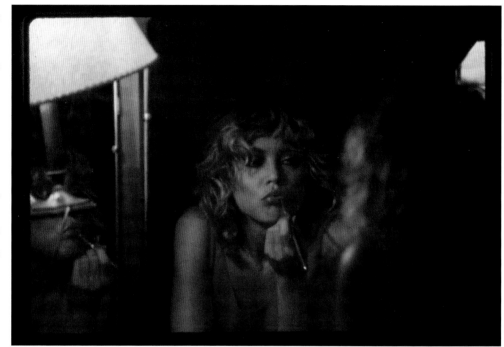

Most weekday nights, Sandy would get dressed up and go to Studio 54, often going straight to work the following morning.

When New York make-up artist Sandy Linter looks back at old issues of American *Vogue*, she can't quite believe her luck. Yes, she was in the right place at the right time, but the fashion world was a much smaller place in the early 1970s, and the opportunities were endless if you had the gumption to grab them with both hands.

Little did she know, but Sandy Linter, the counter girl at Bloomingdale's, was about to change the course of make-up and magazines forever, while also having the time of her life.

It all began at the Kenneth Cosmetics counter on the ground floor of Bloomingdale's. "I went to Wilfred Beauty Academy on Broadway in New York City for six months and got my beauty licence," explains Sandy. "I loved make-up, so Bloomingdale's was where I went. Our little counter did so well because both the other salesgirl and I loved make-up so much and were always wearing it. We would stop people – its seems old-fashioned now, but it was so new at the time – and they would literally buy it off our faces."

One Thursday evening, Kenneth himself came into Bloomingdale's to see how the counter was doing. "Mr Kenneth also owned the most exclusive hair salon in Manhattan at the time, and I asked him to consider me if he needed a make-up artist. I had never thought of myself as a counter girl, although I was. As far as I was concerned, I was a make-up artist. Not only did he hire me, but one of my first clients was Jackie Kennedy Onassis. After that, I did all his society clientele, from Barbara Walters to Diana Vreeland."

However, the real turning point was when Shirley Lord, the beauty editor of American *Vogue*, came into the salon. "I did her make-up, perhaps once or twice, and she did a two-page article about me in *Vogue* – and that was it, I was off. I was in every magazine every month from the end of 1973 into the early eighties."

*

Before the first wave of make-up artists came along, models did their own make-up. It meant that the first make-up artists could be as adventurous as they liked; nobody had written the rules yet. "We did what we wanted, we were free because no one knew what to tell us to do," recalls Sandy. "I was just trusted to do Sandy Linter make-up, and that's what I did."

Her canvases also happened to be the most beautiful faces in the world, including Rosie Vela, Patti Hansen, Christie Brinkley, Lisa Taylor, Cheryl Tiegs, Gia Carangi, Janice Dickinson, Jerry Hall and Iman. Not only that, but they were photographed by geniuses such as Albert Watson, Helmut Newton, Arthur Elgort, Deborah Turbeville, Chris von Wangenheim and Irving Penn. For the first 10 years of Sandy's career, she worked with the best of the best, but at no point did anybody tell her what to do with the faces. She had carte blanche and was trusted wholeheartedly for a decade.

From the very beginning, she worked with the biggest models in the industry. Her first tear sheet in *Vogue* was in November 1973, with model Karen Graham. According to Sandy, Karen's delicate features were the most photogenic of the early

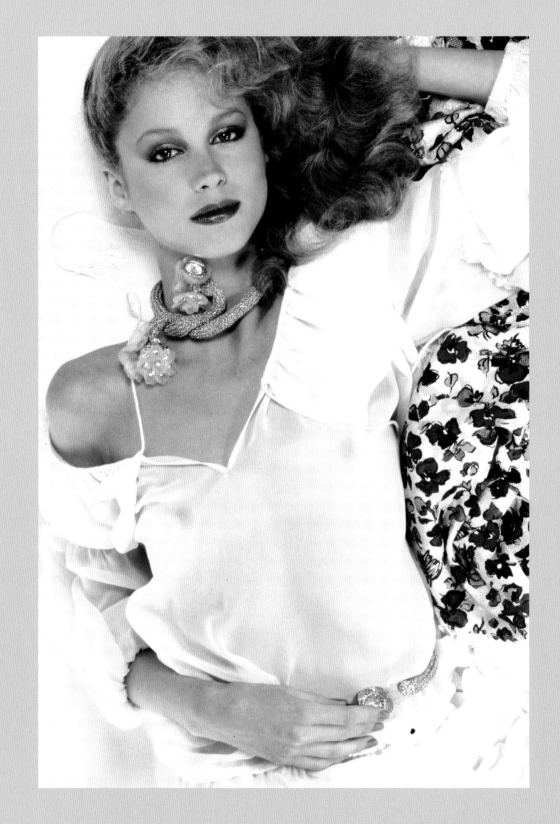

Model Rosie Vela was Sandy Linter's biggest inspiration for the 1970s – and the face that *Vogue* wanted on every page. American *Vogue*, December 1977.

1970s. She was everywhere – a true beauty who could wear any make-up. But it was model Rosie Vela who was Sandy's biggest inspiration of that decade. "When I first started to work, she was the face that *Vogue* wanted on every page," recalls Sandy. "Luckily for me, I loved working on her face, and I liked the way she looked in the make-up I was doing. All the girls were beautiful, but some just lent themselves to make-up more than others."

Sandy met Jerry Hall on a shoot for *Harper's Bazaar* in 1975. Jerry was a teen with a dream, and had just returned from Paris, where she had been working with photographer and illustrator Antonio Lopez. Sandy remembers the model bringing her *Katy Keene* comic books on the shoot, which she studied to learn poses. According to Sandy, Jerry was an original and natural-born model. And then there was Iman. Sandy was the first to do her make-up when she arrived in New York from Somalia and took the world by storm.

She first worked with model Patti Hansen in 1976. Just two kids from Staten Island, they hit it off immediately. Patti could work with anyone and understood the nuances of modelling innately. She was one of the strongest models of her time – her freckles, style and easy manner made her a star – although sadly for the world of fashion, it was a brief modelling career, put on hold after her marriage to Keith Richards of the Rolling Stones.

*

Sandy was inspired by the pages of the British, French and Italian versions of *Vogue*, and their use of colour. British make-up artist Barbara Daly was one of her icons, and in the early days, Sandy fantasized about going to England to be her assistant. She was also greatly influenced by Viennese make-up artist Heidi Morawetz (the creator of Chanel's global phenomenon Rouge Noir, aka Vamp, nail polish in the mid 1990s), who often worked with photographer Guy Bourdin. "Heidi loved a very fuchsia cheek and lip, and because of Guy's lighting, something I really didn't understand back then, it could absorb the pinks that she was using in a way that just looked so beautiful on the girl," remembers Sandy.

"I wasn't interested in the way that American models were looking. I didn't like the simple look. I liked it more extreme and more colourful. I was a young make-up artist, so of course that's what I wanted. I didn't want to just go in and do something plain and simple. I had the energy, and enough people behind me that loved what I was doing, so I really pushed it in those early years."

As with fashion, it was also the decade of firsts for make-up: "The smoky eye; pink and purple eyeshadows with a classic red-orange lip; plum and wine shades with lots of highlight; contoured cheeks; matching blush and lips. Nudes and naturals had not yet arrived, and these were the disco days. At the time, it was all so new. They were also the days of no retouching or airbrushing: what you saw was what you got."

One of Sandy's favourite photographers was Chris von Wangenheim. He was a protégé of Helmut Newton, and his work was glamorous and sexy, the

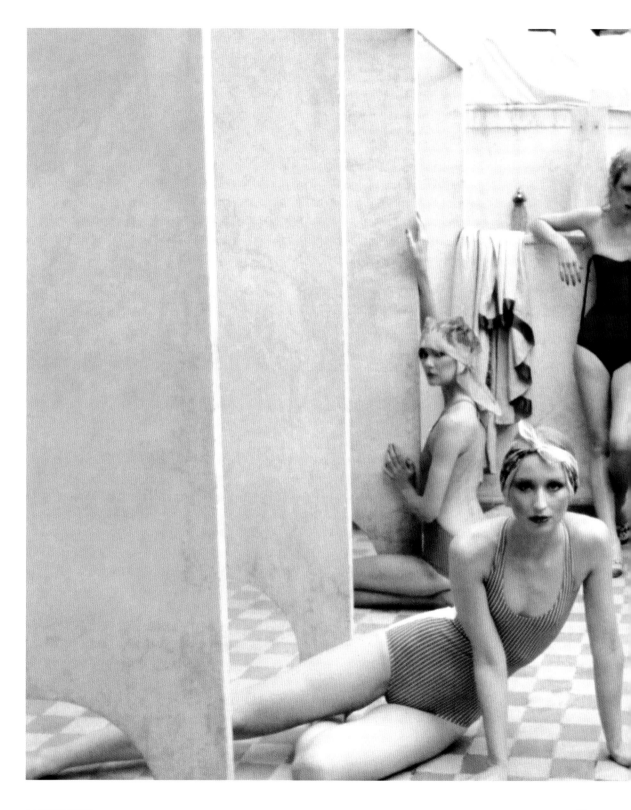

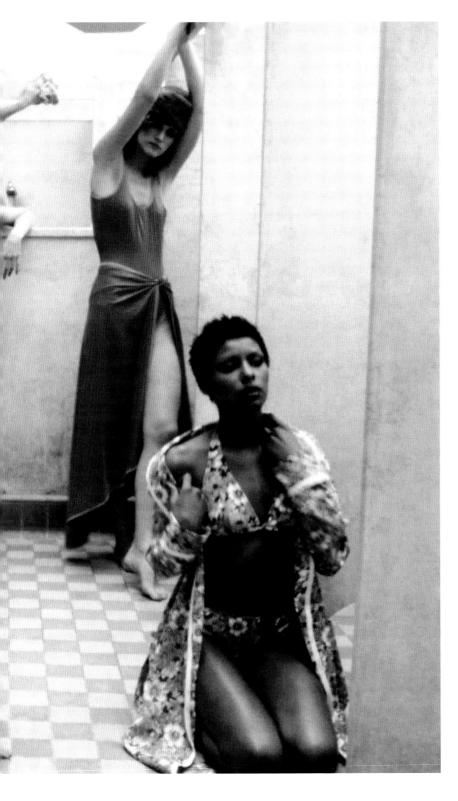

Photographer Deborah Turberville's iconic bathhouse shoot for American *Vogue* in 1975, which influenced Sandy Linter's make-up for the rest of her career.

epitome of the time. "He made girls look as good as they could ever possibly look," **explains Sandy.** "I worked with him a lot, there was just something between us and he knew I loved working with him. Helmut Newton could get a little ugly sometimes with his images, and the girls would suffer. Although there was something I loved about his images, they were a little hard-looking for me. Chris didn't do that; I don't know how he managed it, but he was able to create something pornographic and sexy, but it never looked hard or uninviting. There was just something about it." **Chris von Wangenheim sadly died in a car crash in 1981, at the age of 39.**

However, it was the iconic bathhouse shoot for *Vogue* with photographer Deborah Turbeville in 1975 that inspired Sandy's make-up for the rest of her career. "Deborah saw things very differently from anyone I had ever met," **she explains.** "It wasn't sexy, it was all about colour and shape and form, often based on images she had seen in movies. During all her shoots, she would reference some film. She was a genius, and the idea of shooting these models for *Vogue* in a bathhouse downtown, on the Lower East Side of Manhattan, a very poor area at that time, was very daring.

"It was a three-day shoot and there were five girls every day. It was both exhausting and stimulating; it was an unforgettable shoot. The girls were all inspired and were moving around like puppets, in just the way she wanted them to, yet she didn't have to direct anybody. She would hold her big camera up and clutch it tightly to her chest when she knew it was right. The girls would take their cue and it just worked."

Sandy recalls it was a "haunting journey" to collaborate with Deborah, because she had such vision. "We also worked on freezing cold beaches and [in] the most desolate places." **Looking back, she knows how lucky she was to have been a part of these incredible shoots, with the drama, dedication, art and skill.** "She was so dedicated to her work; she would really take us along on her trip."

*

Sandy worked every day from 1973 to 1981, but it was by no means all work and no play. She went to Studio 54 every weeknight for the 33 months it was open. On the opening night in April 1977, wearing a vintage turquoise poodle skirt by Fiorucci and

66We had the times of our lives and partied hard. I lived for those days. There was absolutely nothing we did back then that we'd be able to do today.**99**

with no invitation – but armed with charm and youthful hustle, along with her friend, hairstylist Howard Fugler – Sandy had no doubt she would get beyond the velvet rope of the hottest club in town. Along with Debbie Harry, Diana Ross, Keith Richards, Jerry Hall, David Bowie, Bianca Jagger, Andy Warhol, Donna Summer and Grace Jones, Sandy entered into the realm of "Studio", and there was no going back. "It was the only time in my life that was truly carefree. It was hot and sexy, without a care in the world."

Sandy's friends, more often than not Fugler and hairdresser Harry King, would congregate at Sandy's apartment after work. "I have to give my friends credit for taking me out at night," she says. "Howard was a great stylist. He would take one look at me – I already thought I looked great – and redo my hair. I would get changed, and this went on for hours and hours. I was out every night with them, and I have no regrets."

What to wear at Studio mattered. "I used to wear a lot of Fiorucci. His clothes were for very young people who didn't actually want to wear many clothes, and you needed to wear clothes you could dance and move freely in. It was all about dancing. You could hang out if you didn't want to dance, and drink if you wanted to drink, but the dance floor was packed every night.

"Andy Warhol summed up perfectly what was so special about Studio: 'It was like a democracy on the dance floor and a dictatorship at the door.'

And it was. It meant that once you got inside, and everybody inside was cool, you were just a cool person meeting another cool person, and it went on like that all night long. It was very free, and everybody felt fabulous about themselves. It was incredible."

"We would often go out and then go straight to work, such as the night I wore fuchsia tights with clear plastic heels, which came from Frederick's of Hollywood that used to sell mostly to transvestites and hookers." Sandy went to the studio the following morning with photographer Albert Watson. "I was very lucky because at the time when I was going out to Studio and then straight on to work the next day, the fashion people loved it. They ate it all up because I had that Studio 54 disco energy, and that's what everybody was into at the time."

For Sandy, the 1970s was *the* decade to remember. "From 1973, when I started my career, to 1981, it was a very small industry. I knew the names of all the make-up artists, hairdressers, photographers and models. But by around 1981 to 1985, the industry was exploding, and there were all these new people. I went from being a very well-known make-up artist to being someone from the past who was not really known."

"We had the times of our lives and partied hard. I lived for those days. There was absolutely nothing we did back then that we'd be able to do today. Every day was special."

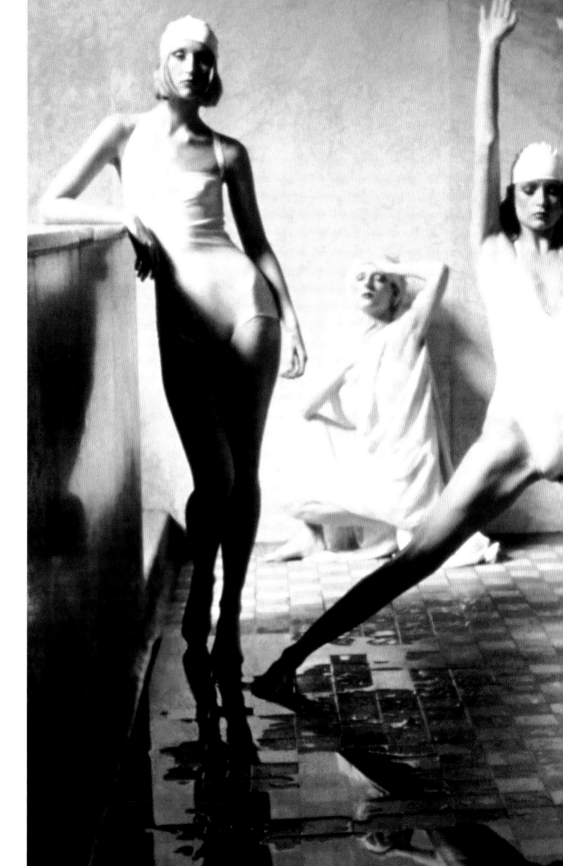

The idea of shooting *Vogue* models in a bathhouse downtown, on the Lower East Side of Manhattan in New York City – seen by some to promote lesbianism – was incredibly daring and controversial at the time.

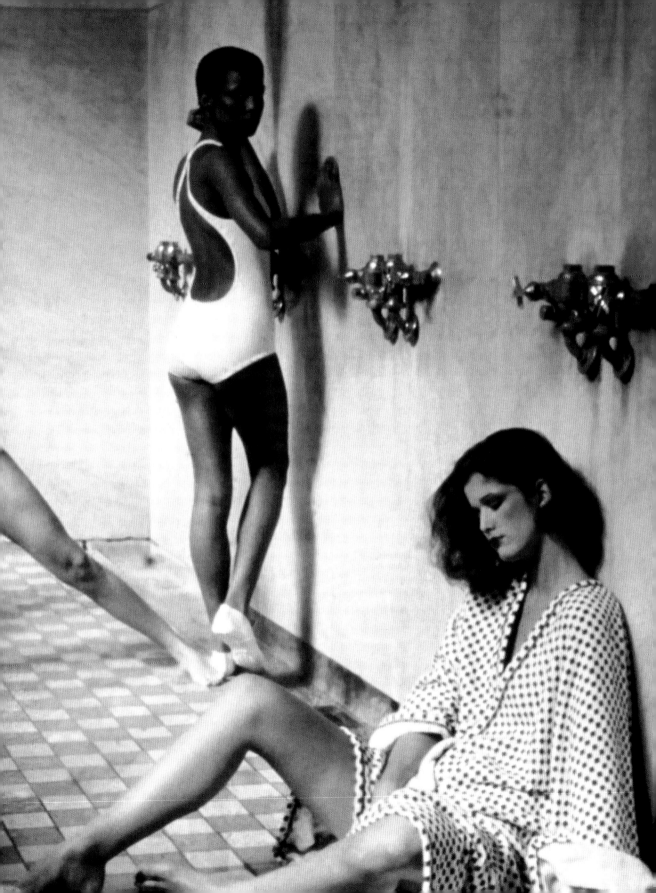

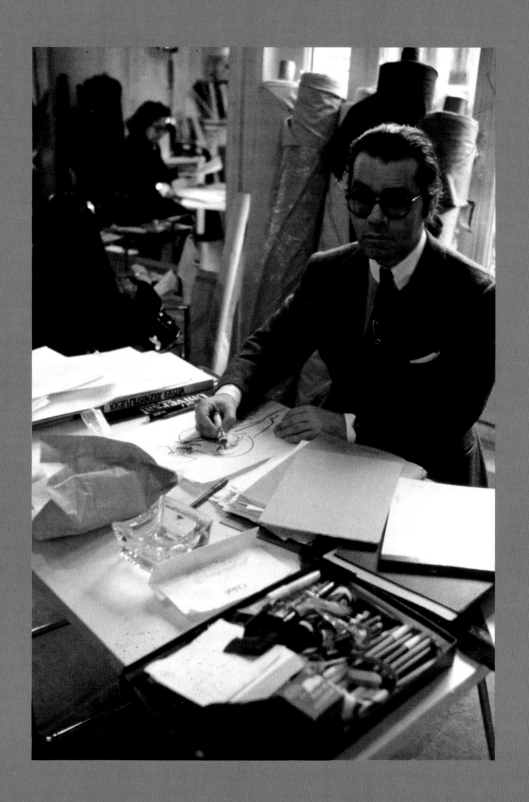

"sundays

Hazel Collins
Model

in rome"

Karl Lagerfeld at work in his studio, 1979.

Former model Hazel Collins was still a teenager when she met Karl Lagerfeld, first at a chance meeting at Rome airport. She became his muse and good friend, and worked closely with him at Fendi.

"I first met Karl and his boyfriend at Rome airport. It gives me goosebumps just thinking about it," **remembers Hazel.** "Although I had been modelling for a good four or five years, I was still only 19, and quite shy in those days. Karl approached me and introduced himself in his thick German accent. I didn't know who he was and told him that I wasn't interested. To be honest, I thought he was probably a dirty old man but in fact, he was this incredibly famous fashion designer, and I had no idea. His boyfriend handed me a card and asked me to call them. I had no intention of doing so.

"The following day, I had a meeting at Fendi, and who should be sitting there at the desk in front of me, drawing, but Karl. I couldn't believe my eyes – in fact, none of us could believe it – and we became firm friends after that. I became Fendi and Karl's 'bambi' and prima model, which meant that I was fitted for all the toiles [a draft garment in muslin] for the collections."

During the twice-yearly collections, when the world's fashion press and buyers would descend upon New York, Paris, London and Milan, there was no such thing as Sundays. "I had to fly from wherever I was at the time on a Saturday, to be there for Sunday morning, and I would fly back on Monday morning," **explains Hazel.** "I would either go to Paris and work with Karl, or we would go to Rome for meetings and fittings at the Fendi studio. It was a very famous label, and they didn't trust anybody. I was the only person they trusted;

I was part of the family. They would only bring in the other models once the clothes were ready, the night before the showing of the collection, so that nothing could be leaked and copied. I would work for Karl for months leading up to the collections and then again during the shows.

"Karl was a brilliant artist and illustrator, he had very definite strokes with his pencil and was incredibly disciplined. His favourite food was pears with Parmesan, which we would have for lunch. We would work from the crack of dawn through to two or three in the morning. I would try on the toiles, and he would tweak them, draping me in fabric; they were practically made on me. He would take hundreds and hundreds of Polaroids and stick them up on large boards. The following Sunday, he would throw most of them away and start again.

"During the actual collections in Paris, we would have the bridal suite at the Ritz or the presidential suite at the George V (for the same price of 10 rooms), and the whole team, including models and make-up artists, would sleep on the beds, sofas and floor. When shoots were happening at the same time, we would often work through the night, shooting, and then sleep underneath the make-up table. When I was needed, the make-up artist put ice cubes on my face to wake up my skin. I would often have to wear shoes that were one or two sizes too small, but we never complained, we just got on with it. They were such fun times – the world was different then and there was real loyalty."

Karl was also famous for his parties, especially in Paris, at the era's most popular restaurants and nightclubs. "La Coupole was so decadent, like a snapshot from the 1930s, and people would dance on the tables, it was crazy. And Le Palace, a converted theatre, where guests would literally swing from the chandeliers. It's no coincidence that the Cirque du Soleil was born from Karl's parties."

But for Karl, it was all about work. "The parties were for networking with editors such as *Vogue*'s Diana Vreeland, models he wanted for his next collection, choreographers, photographers, model agents and celebrities such as Jane Fonda, Catherine Deneuve, Françoise Hardy, Charlotte Rampling and Anouk Aimée. He was a genius at it, but he'd only stay for an hour and then leave. He would speak to the key people and then say to me, "Darling, don't forget you are my A girl. Time to go home.""

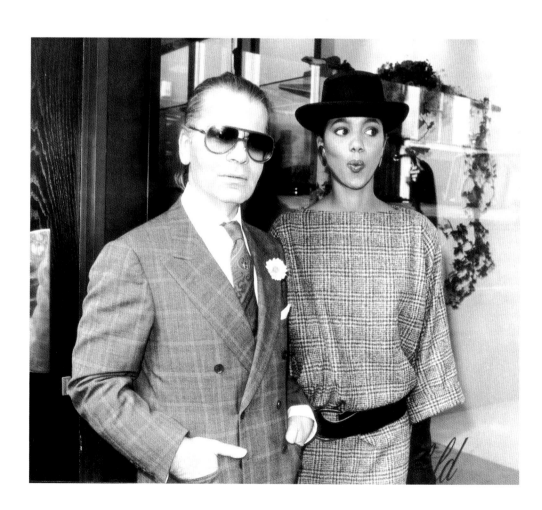

Every Sunday during the collections, Hazel Collins and Karl Lagerfeld would work together into the early hours of the morning.

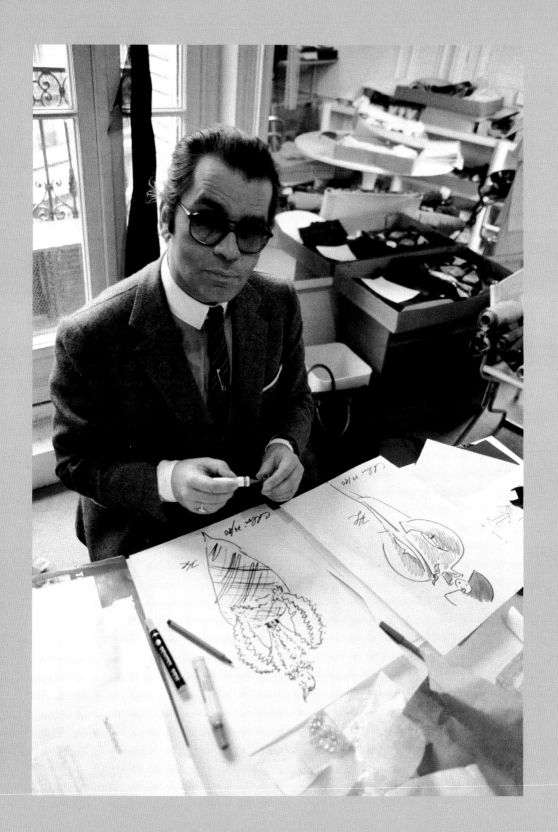

Karl Lagerfeld was an incredible artist and could interpret his ideas with a flick of his pencil.

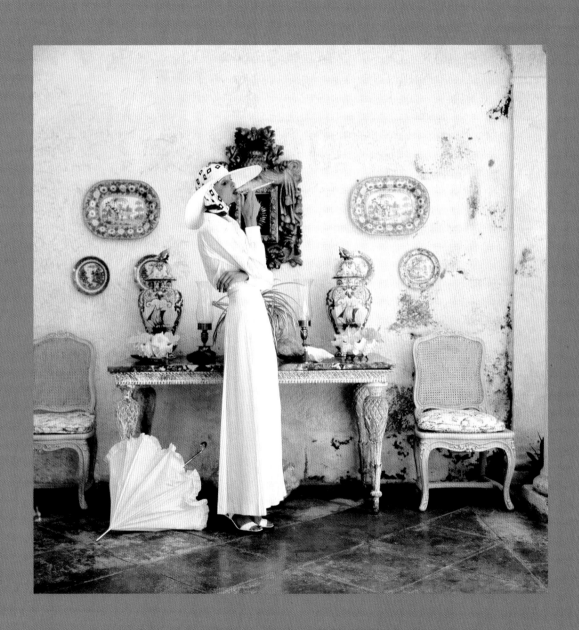

grace

Fashion Director,
British *Vogue*

coddington

Model Apollonia van Ravenstein photographed at artist Oliver Messel's house in
Barbados, wearing Yves Saint Laurent Rive Gauche, British *Vogue*, July 1973.

When former model Grace Coddington entered the *Vogue* offices for the first time on a cold London morning in January 1968, she was disappointed. It was a far cry from the glitz and glamour the magazine featured on its pages – with cluttered, shabby wooden desks, worn-down carpet, and numerous rails crammed with clothes. But despite that, and the fact that she was earning a fraction of what she could as a model, Grace loved every minute of her time at British *Vogue*.

"Everything was new and different," **she remembers.** "We got a kick-start from the 1960s with the youth revolution, which we were then able to take through to the seventies without making all the mistakes that happened in the sixties. It was a very creative time." **There was little money, but it didn't matter.** "We got things for free. We'd borrow props from shops, photograph in a friend's house – I even went on a trip to Africa for two weeks and it cost me about £20, which was basically for cigarettes. Flights were always free because they were given by the airline in exchange for a credit."

Grace's celebrated fashion pages always told a story, and during her first years at *Vogue*, she got much of her inspiration from Chelsea Antique Market on the King's Road in London. It was a rather scruffy tourist destination, with stalls selling everything from First World War army coats to 1930s cocktail shakers and 1920s flapper dresses, and Grace would trawl through rail upon rail of vintage clothing.

But it wasn't just about vintage finds for Grace. She loved daring designers too, especially a young and talented French designer called Yves Saint Laurent. "He was very young and making news with every collection. He was daring and brilliant, probably *the* most brilliant designer. His clothes were relatable to real life and everyone wanted to wear them, myself included, so it was fantastic when he launched his ready-to-wear line, Rive Gauche.

"The young British designers were very cool too, but in a completely different way. They didn't have what the French had – they were all about youth and were responsible for the whole youth revolution in fashion in the 1960s. Paris then took it and made it more sophisticated."

*

But it wasn't just clothes that inspired Grace. Being one of the younger members of the *Vogue* team, she did most of the trips abroad. "Some of the more senior staff were a bit too old to travel easily, so I was lucky. Often they would put the clothes together and I would be the one that carried them across mountains, but we always went somewhere exotic, you didn't just go to Miami Beach."

These trips could last for anything for up to three weeks. Grace and her very small team, often consisting of just a photographer and model, would research locations and soak up the atmosphere, wait for as long as necessary for the best light and take time off for the models to get perfectly tanned. Unlike today, where the average location shoot involves a huge team – photographer, models, hairdresser, make-up artist, production people, scouts, prop styles and numerous assistants for everyone – and can be wrapped up in two to three hectic days.

"It was a very exciting time because there were so many places we went to that were very young in terms of tourism. We were on one of the first flights into the Seychelles. Before that, you had to get a fishing boat and that was about it. We were also one of the first to go to China (American *Vogue* went just before us) as well as the Soviet Union, so I was able to take my inspiration from all around me. One

of my favourite photographers to work with was Norman Parkinson and he said something to me I'll never forget: "Always keep your eyes open." He taught me so much, really educated me in so many things from fashion to photography.

"Visiting all these countries, certainly for the first time for me, was awe-inspiring. We'd go shopping at local bazaars and include it all in the pictures. It was fantastic working with Parkinson because he had a similar kind of narrative spirit in his pictures and we would create these wonderful stories together.

"My first trip to China with photographer Alex Chatelain was eye-opening and extraordinary. It was such a different world and everybody was still in uniform at that time. I remember getting off the plane and just seeing a sea of blue uniforms, everyone looking identical. I didn't really understand what it all meant – I was very naïve. It was a whole way of life that was so different from ours. It made me feel so fortunate because we took for granted so many things that they didn't have. Even getting books was impossible for them.

"These trips were an example of what has been so incredible about my whole life and career. It wasn't just about going to fashion shows, picking clothes and putting them on a pretty girl, it was really broadening my mind in so many directions."

Not all trips went to plan. Grace recalls one trip to Australia in 1975 with photographer David Bailey and model Marie Helvin: "We were set up in some really shabby little motel in Cairns, on the north-east coast. It had the bare minimum and it was tiny and rough. But a lot was rough in Australia at that time, and this trip was really problematical because there had just been a hurricane before we arrived. We set off to this island off the coast that the Australian tourist board wanted us to visit and, despite the hurricane, they still insisted that we went. We arrived and the whole island had been flattened. The trees were black, there were dead birds everywhere – it was a disaster area."

Borrowing friend's houses also came with its risks. "I knew Karl Lagerfeld very well and hung out with him a lot in those days," **explains Grace.** "We shot in his house many times because all his houses were so incredible and we could never afford a location. I used to shoot there with Helmut Newton, Guy Bourdin and David Bailey. He had this one apartment in Paris which was extraordinary, with very high ceilings and lacquered walls. It was that kind of lacquer that has about 15 layers which are each sanded down and lacquered again. It was beautiful and must have cost a fortune.

❝There was always imperfection in a picture that was so perfect, so beautiful, that made it breathe.❞

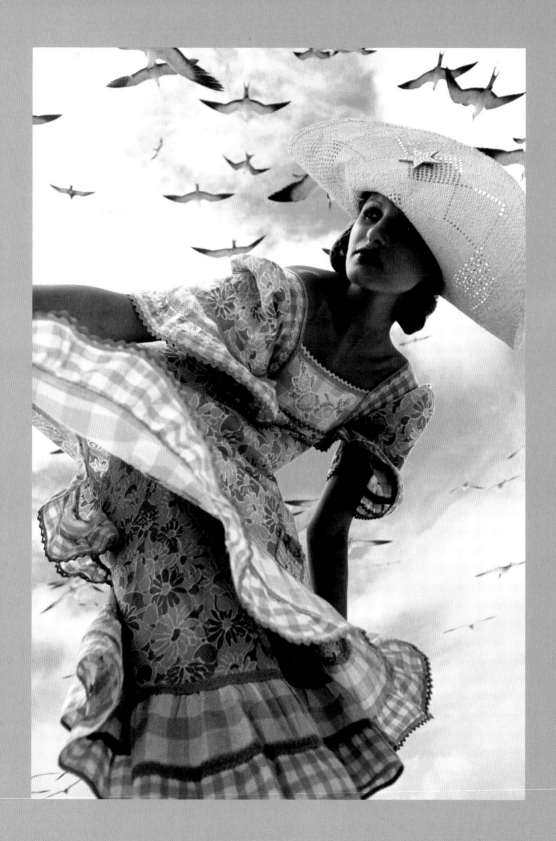

Model Apollonia van Ravenstein photographed on Bird Island in the Seychelles, wearing a dress from Kensington Antique Market and a straw hat, British *Vogue*, December 1971.

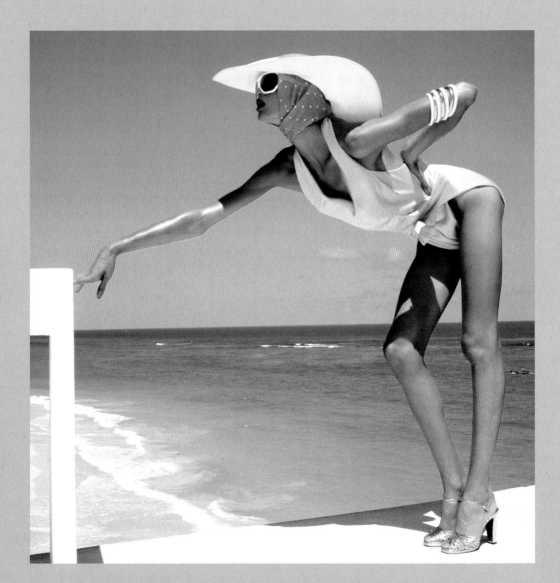

Model Apollonia van Ravenstein at the Crane Beach Hotel, Barbados, wearing a Jane Cattlin swimsuit and Yves Saint Laurent Rive Gauche heels, British *Vogue*, July 1973.

"I was doing a shoot with Guy Bourdin and he had these huge lights. I think we were working with model Pat Cleveland and he was photographing her leaning against the doorway. Suddenly, I saw all the lacquer on the walls bubbling in the heat of the lights. We quickly turned them off and, thank God, it sank back into place. Nothing was ever said, but it was a nasty moment."

Guy Bourdin and Helmut Newton were never the easiest photographers to work with at the best of times. "Every shoot was memorable with those two," **she recalls.** "They were amazing – any picture in French *Vogue* that wasn't done by them wasn't worth looking at – but they weren't easy. They both had completely free rein, so what they produced was absolutely extraordinary.

"I adored Guy, but it was funny working with him because I don't speak French and he didn't speak English, but somehow we understood each other. He was a complicated man but a brilliant photographer, and influenced so many people, even today. And likewise with Helmut. Everybody is still doing a Helmut Newton picture. Guy's were very erotic and Helmut's were just out and out sexy."

*

While British and French fashion designers were still at the helm of the fashion hierarchy, Grace was one of the first British fashion editors to start covering the collections in New York. "The Americans had such a different attitude to fashion and, having lived through the whimsy of London and the artistry of Paris, I loved the fact that they really thought about women and what they needed. Clothes were simplified, and I particularly loved what Calvin Klein was doing."

In the early 1980s, Grace felt it was time for a change. Anna Wintour had taken over as editor at British *Vogue* and Grace wasn't used to being asked to prepare budgets and rigidly plan shoots in advance. "Calvin kept offering me a very enticing job at his studio in New York, so I took the plunge and off I went. I have never regretted it."

But after a year and a half, she missed her life at *Vogue*. So when it was announced that Anna Wintour was going to edit American *Vogue*, Grace rang her up and asked for her old job back – but at American *Vogue*. "Anna said, 'Absolutely. I'm starting on Monday, start with me,' and so I did."

For Grace, the beauty of the 1970s aesthetic lay in the lack of perfection. "These days, it's very much about a team of people banding together to create perfection, it's all about production, production, production," **she explains.** "Personally, I think imperfection is a whole lot more beautiful. I remember working with Irving Penn and I noticed some hair pins had fallen out of the girl's hair onto the floor. When I rushed onto the set to pick them up, he said, 'No, no leave it.' There was always imperfection in a picture that was so perfect, so beautiful, that made it breathe."

OVERLEAF: Married bliss – Grace Coddington photographed by Willie Christie on their honeymoon.

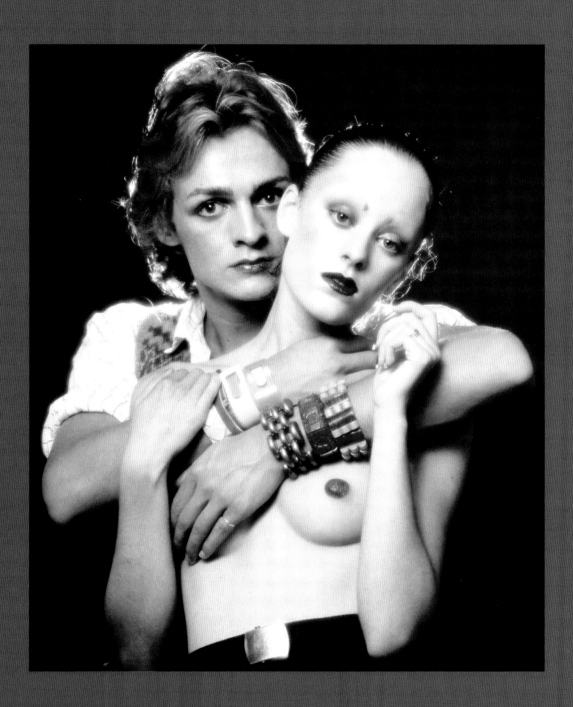

corey grant

Make-up Artist

tippin

Corey Grant Tippin created a storm by shaving off model Jane Forth's
eyebrows and experimenting with make-up. New York, 1970.

You could say that Corey Grant Tippin was an unintentional muse, model and make-up artist – and that it all happened by accident. After graduating from high school in Connecticut, he went to New York to study at Parsons School of Design until a chance meeting with fashion illustrator Antonio Lopez changed everything.

"I had only been there a month, and Antonio showed up as a guest professor one day. The whole student body had congregated around this room where he was teaching a class," **remembers Corey.** "He had brought Cathee Dahmen with him, who was his muse and [a] top model of the day who I adored and idolized, as well as his business partner Juan Ramos. For me, it was like seeing Jesus or something, like a miracle to see my idols in person."

"I was standing in the doorway watching Antonio and he pointed me out. 'You, come here,' he said, and made me get up on this big platform with Cathee and pose for the class. Afterwards, he introduced himself and gave me his phone number. 'Call me,' he said. And, of course, I did."

A month or so before, Corey had also crashed Andy Warhol's studio, known as the Factory – on the advice of his mother, he had just turned up one day – and was hanging out with Warhol and his crowd. "Both Andy and Antonio were leaders of the culture I wanted to be a part of, and I thought, 'Why am I going to school when I can hang out with them?' So that's what I did," **he recalls.** "Fashion wasn't a huge business then, and you could just hang out with the people you wanted to meet. It didn't last long but luckily, at the time, I was there."

*

Corey met models Jane Forth and Donna Jordan while they were still in high school and they became the ultimate teenage gang. "Donna was a little bit mouthy, but had personality and drive, and Jane was already part of the Warhol entourage," **explains Corey. They hung out, played dress up, spent hours and hours getting ready and partied every night at the restaurant and nightclub Max's Kansas City, where they lived on French fries and Coke.**

A lot of their time was spent playing with make-up. "Their looks were very different, they were kind of like Snow White and Rose Red," **says Corey.** "Jane was more pre-goth and very pale, she had an almost spooky look. We dyed her hair blue-black and got rid of her eyebrows and she looked vampire-ish, yet she was so sweet and gentle.

"Donna was very New York and brazen and kind of rude. We were bleaching her hair more and more until it was so white it was almost albino. She had a Monroe look about her, a fabulous American blonde with red lips. I started bleaching her eyebrows to go with the hair and, eventually, they became so white that I would just put this white grease paint over them and leave it at that, so that when she was photographed, she seemed to have no brows at all."

They were obsessed with the Hollywood starlets of the 1930s, such as Jean Harlow, Dolores del Río, Marlene Dietrich and Joan Crawford. "We would pick over them and create our own personas, it was fascinating. I loved having the power to change the girls' appearance. They were complete opposites and the more extreme one got, the other would

(From left to right) Donna Jordan, Pat Cleveland and Corey Grant Tippin brought a whole new, modern and youthful glamour to the French capital. Paris, 1972.

get in the opposite direction. Jane's skin would get whiter and her eyes darker, while Donna would become more blonde, voluptuous and glowing. We were just so young. Jane was 15 or 16 and Donna and I were 17. We didn't go to college, none of us were educated, we didn't care about politics or reality, we just wanted to live as though we were in a movie.

"We were so lucky to have met, and we loved being with people like Antonio and Andy, who really liked to have an entourage around them. They had found the perfect disciples in us, because we were totally willing. We wanted to be in the limelight, we wanted to be photographed, we wanted to be in the movies and we dressed with hats and props as though we were. We played the part."

*

In 1969, Antonio and Juan headed to Paris, and Corey and Donna followed. Initially, Corey was disappointed and despondent. "Paris was stuffy and depressing. I was so shocked," **he remembers.** "There was no youth culture. All the kids were students living at home with their families and we thought, 'What a bore.' The idea of being a student was the absolute antithesis of what we aspired to. We wanted to be famous and glamorous and here we were, stuck, outsiders in this really staid and traditional French city."

But change was rumbling away under the surface, and during the early 1970s, things started happening in Paris. "Rather than the focus being on couture and the society women who could afford it, ready-to-wear emerged and fashion became more about youth," **says Corey.** "Suddenly, Karl Lagerfeld and Yves Saint Laurent were doing ready-to-wear and there were all these new young designers, such as Kenzo and Sonia Rykiel. They all exploded at the same time and drove a necessity for a younger image, and suddenly there was a demand for our generation. And we found ourselves in the centre of it.

"There was also a big revolution in music. I can't begin to tell you how bad the French music was. There was no collaboration, there was none of the fabulous music from the States, such as Motown or any of the Black dance music – it really hadn't come to France. But a new club called Le Sept opened and they started bringing in this kind of music, which was embraced immediately by the French. Suddenly, we had a background soundtrack for our lives and culture started to open up."

Corey was spending most of his time with Donna, and she was trying to kick-start her career as a model, which hadn't really taken off in New York. "Antonio was drawing her and I was hanging around. I didn't really know what to do with myself," **he says.** "Antonio said, 'Why don't you be a make-up man?' I'd been doing it anyway with Donna and Jane in New York, creating their looks for them. I loved make-up and wore a lot of it myself in those days, so I thought it made sense. Antonio said, 'Just say you're a make-up artist and see where it takes you.' So that's what I did.

"Back then, there was only a handful of professional make-up artists, it wasn't the real career that it is today. Everyone was sort of underground and it

wasn't a profession that had much visibility but, all of a sudden, make-up stars started to emerge. When I started, I was lucky – there was very little or no competition. We didn't realize it at the time and it wasn't our intention to influence what was going on. It was probably actually more to do with being different and expressing ourselves. The make-up we wore looked like make-up; it was theatrical and fashion-orientated."

*

There were two people who had a great impact on Corey and Donna while they were in Paris. The first was Karl Lagerfeld, whom they met through Antonio and Juan, and they all became part of one big entourage. Karl loved to surround himself with fashionable young things, and he was mesmerized by them. Their talent, modernity and youthful glamour was addictive. They brought a whole new way of being fashionable to Paris, and Karl saw that. Their association worked both ways. While Karl looked after them and gave them a lifestyle they could never afford, they gave him an insight into a brand new youth culture that was fresh and exciting.

"When I think about it today, I don't know how we did it," **says Corey.** "I don't really remember paying for anything. We were always part of an entourage with Antonio and Juan, who didn't really have the means to support us, but when they got involved with Karl, he was always very generous and paid the bills. Restaurants and bars, clothing, make-up, all that glamorous stuff. We didn't pay for a thing."

The real turning point was Andy Warhol. "Andy decided he wanted to make a movie in Paris. He saw France as a real opportunity, as he was always very welcome in Paris and the French were fascinated by him and his art." **The film, *L'Amour*, starred Karl, Donna and Jane, who came over with Andy from New York, and was shot in Karl Lagerfeld's apartment, with Corey as the make-up artist. It was a camp and risqué comedy about girls finding love in Paris – you could say it was a slice of their own lives. Despite being canned by the press, the film elevated them to stardom.**

"You can find clips of it, but you'll never be able find the whole film, which I like. It makes it more mysterious," **says Corey.** "Everyone in Paris thought we were real movie stars and we took advantage of it. Suddenly, we had all these opportunities

❝We stood out – and Donna was always outrageous. We dressed up in full outfits, hats and make-up, putting together a different look for the beach each day.❞

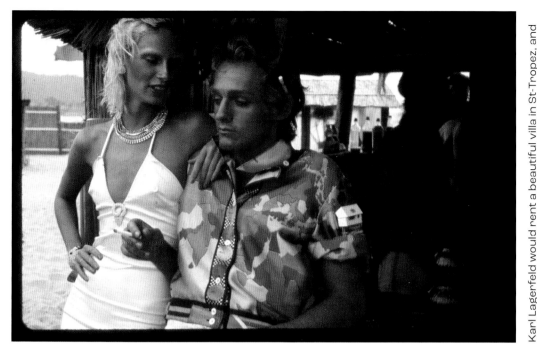

opening up to us. We were 'trending', as you would say today." **Corey began to work with photographer Guy Bourdin and Donna had her first *Vogue* cover. Life was good.**

Summers were spent in Saint-Tropez with Karl, where he would rent a beautiful villa for them all to stay in. They ate in the best restaurants, danced on tables, indulged in sexual encounters and spent their days on the beach. The girls would swim in sunglasses, high heels and diamonds, and life was lived as though it was a fantasy. People followed them everywhere, and they loved the attention.

"We stood out – and Donna was always outrageous. We dressed up in full outfits, hats and make-up, putting together a different look for the beach each day. We laughed and were hysterical. We were funny and really enjoying ourselves. It just felt like the cameras were rolling and we were part of a technicolour movie."

*

But even fantasies lose their gloss after a while. "I wasn't prepared for the pressure and I didn't want the responsibility of being a make-up artist," **says Corey.** "I didn't want to put make-up on people that weren't Donna or Jane. I wasn't really ambitious enough, so I threw the opportunity away, although for a while it was fun. Our look was embraced and imitated – but even that can become tired. In the world of fashion, you need to keep reinventing yourself and I just wasn't very ambitious about that."

The cool kids of New York City: (from left to right) Antonio Lopez, Cathee Dahmen, Jane Forth and Corey Grant Tippin outside Antonio's studio in Carnegie Hall, New York.

It was time to leave Paris. Karl had hooked up with the dandy Jacques de Bascher, whom none of the gang liked, and it felt like it was time to move on. "I was happy to leave it behind, go back to New York and see what was awaiting me there. Donna's career really took off, and I think she was a little frustrated with hanging around gay men. She needed to move on. Antonio and Juan also felt they had done their time in Paris and that it was time to get back to New York and to business.

"Making money and business started to become a little more important. You can only be a hanger-on and part of an entourage for so long, until people get tired of you and others replace you. It's so temporary and your time runs out. We all began to realize there was more to this than just going to parties, having your picture taken and running about being fabulous."

In autumn of 1973, Corey returned to New York and was modelling for Pierre Cardin. "For a while, I felt quite disillusioned. It was very hard to start a life that no longer involved that kind of attention. I was starting over at 24, without any education or solid work habits. It was difficult. It took me a long time to get my life back."

"I have regrets. I wish I had been more aware of my opportunities and engaged with people more, but I do think that's part of youth. I didn't have the consciousness that I have today. But it was who we were at the time – who I was. A lot of people didn't survive it and I feel so blessed to have been a part of it."

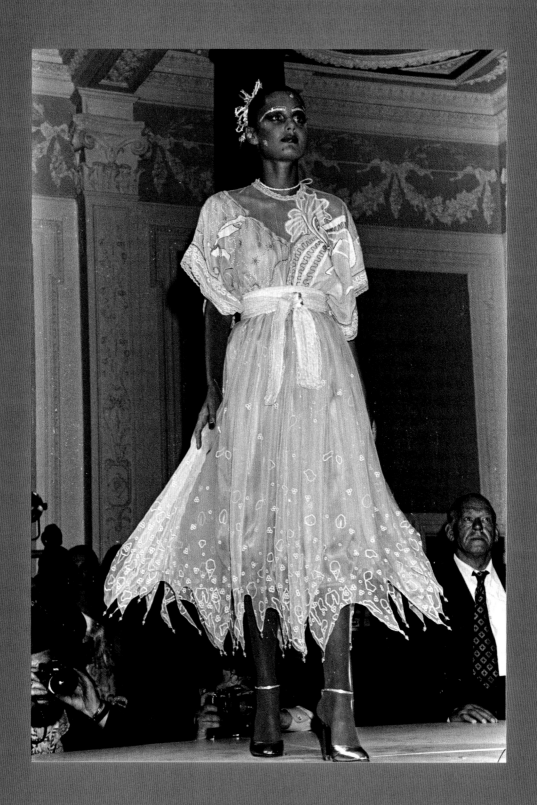

zandra

Designer

rhodes

Exquisite embroidered chiffon dress from the
Zandra Rhodes 1978 Mexican collection.

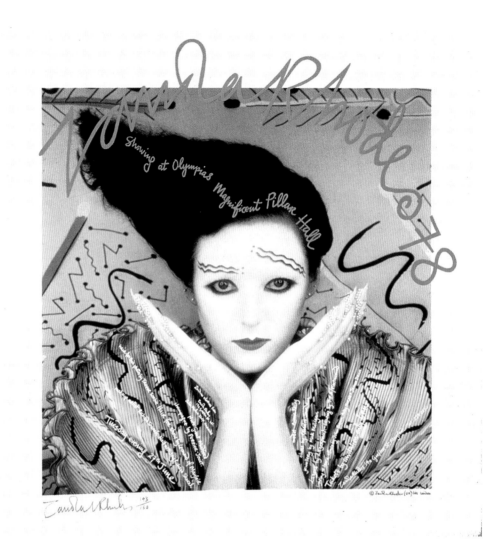

With her signature fuchsia hair, cobalt eyeshadow and instantly recognizable prints, Zandra Rhodes is as relevant now as she was when she hit the headlines in the early 1970s.

After studying printed textiles at London's Royal College of Art, she was at a loss as to what to do. Curtains and furnishing fabrics, a common route for textile designers, were not inspiring her, and she wanted to do something different. She then discovered Emilio Pucci, the Italian fashion designer famous for his prints, and her mind was made up. She would transfer her art to clothing.

Despite the fact that her mother taught dressmaking at Medway College of Design (now Kent Institute of Art & Design), Zandra couldn't sew. "I designed the print first," she explains. "I would have a vague idea of the finished piece, but you can't know how it's going to look until you actually cut it out and put it together." She would hold the paper design up against herself in the mirror and work out where it needed to go on the body. For her, the print was the essential component; everything else came second. "Everything was printed, cut out and finished by me, but I wasn't doing the sewing. I had someone in who could machine and, from there, I gradually learnt everything."

Being self-taught gave Zandra a great sense of freedom. Her inventive prints were inspired by her travels, popular culture and what was going on around her, from Native American tribal patterns and Japanese calligraphy to Aboriginal markings and Andy Warhol pop art.

"I looked at peasant costumes and really let the textiles do all the work with the historical references. People were wearing old vintage shawls at the time, so I started printing on shawls. For me, it was very much about being in touch with art, the hippy scene and what people were wearing. I was young enough to be a part of it and I was creating new ideas that had never been seen before."

London's punk scene led to Zandra's infamous Conceptual Chic collection in 1977. "Punk was this whole street movement going on, with young people wearing these heavyweight looks. I wondered how it would look putting dresses together in a different way. That went together with safety pins and chains and holes in the fabric, that became the pattern."

*

Zandra revolutionized the world of fashion with her extraordinary shows, the first of which was in London in 1972. "I had done small fashion shows in my boutique on London's Fulham Road, but Midnight at the Roundhouse was different." Helped by her friend and mentor, the restaurateur Michael Chow, the show was fantastical and unlike anything anyone had seen before.

Choreographed to music from the Rio Carnival, the show opened at midnight, with the models wearing pearl-encrusted masks created by the legendary make-up artist Barbara Daly. "I had clothes coming out of objects and the most incredible girls. Donna Jordan, Pat Cleveland, Cathee Dahmen, Anjelica Huston and Renate Zatsch all flew out and were amazing. There were no shows like it back then, but I didn't think about it like that. We were just doing our thing."

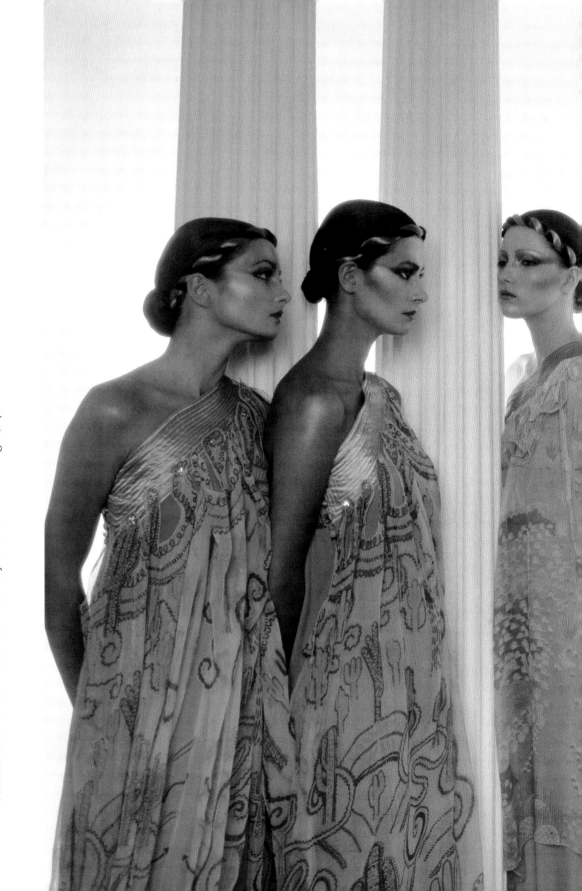

Models wearing evening gowns from the Zandra Rhodes 1974 Ayers Rock collection and the 1976 Cactus and Cowboy collection. British *Vogue*, April 1976.

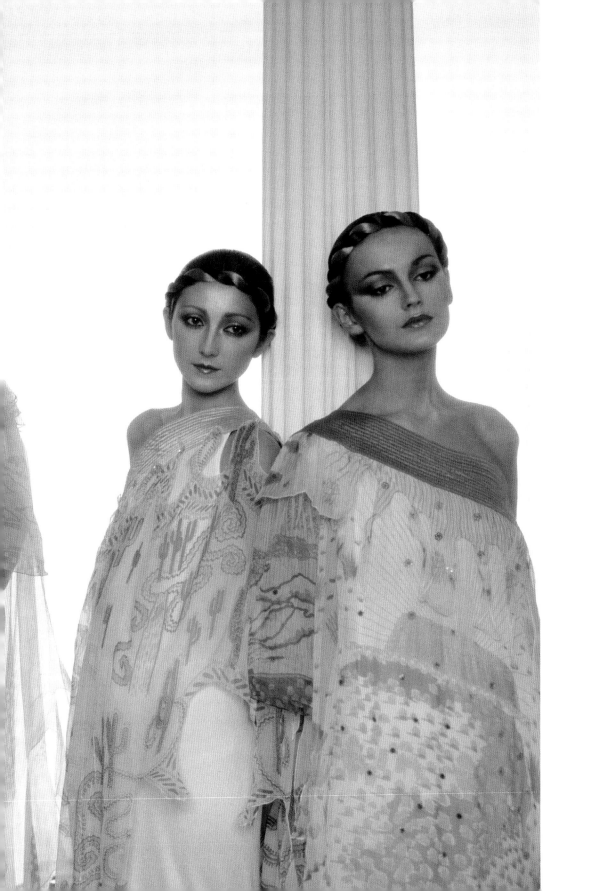

It was such a success that Zandra was asked to take the show to New York, where the whole of fashion society – from Halston, Elsa Peretti and Joe Eula to Diane von Furstenberg, Bill Blass and Nan Kempner – were witness to the performance of the year. *Vogue* editors from both sides of the Atlantic were there; after the show, Zandra's prints were regularly featured on the pages of their publications.

<div align="center">*</div>

Despite being a huge success on the other side of the Atlantic, with patrons such as Jackie Onassis, Elizabeth Taylor, Lauren Bacall, Debbie Harry, Diana Ross and Barbra Streisand wearing her clothes, Zandra was still a quintessentially British designer. She created the dress that Princess Anne wore in the official portrait of her engagement to Captain Mark Phillips and later went on to design clothes for Princess Diana during the 1980s. She created Freddie Mercury's famous pleated white top for Queen's Queen II concert tour in 1974. "He came round one evening and I picked things off my rail for him to try. I can just remember him dancing round the room in my tiny studio in Paddington."

Decades before the digital era revolutionized print, what was it that made Zandra Rhodes such a success? "When I look back now, it was an adventure and we had complete freedom," **she explains.** "None of it was associated with big fashion houses, like today. We were independent designers and weren't supported by industry whatsoever, but it wasn't about making money in those days.

"Things gradually changed without us realizing, and fashion became a serious business. New York began to show its collections just before London, which would often cut off the beginning of the London shows, and a lot of money was put into Paris, so everyone had to go there too. By the early 1980s, everything was owned by big conglomerates – and if you weren't part of it, you didn't stand much of a chance. London simply got left behind.

"You could say that the 1970s represented me and the true flowering of my art. I like to think that I didn't disintegrate after the seventies, but have continued making creative statements. We were forging a new path and it just happened."

❝I like to think that I didn't disintegrate after the seventies, but have continued making creative statements. We were forging a new path and it just happened.❞

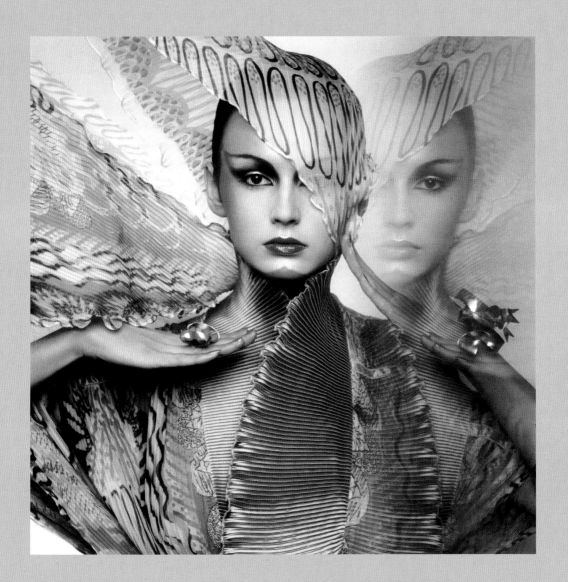

Zandra Rhodes regularly collaborated with photographer Barry Lategan to produce the most incredible images of her designs.

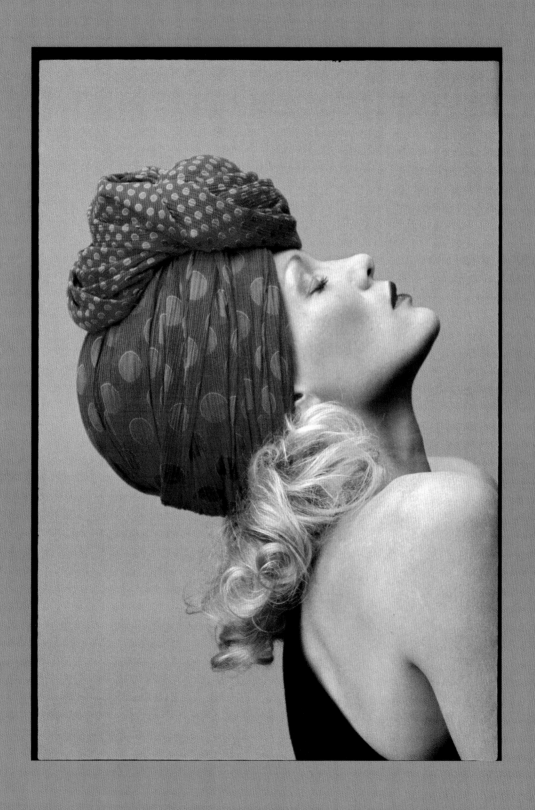

willy van

Model

rooy

Willy van Rooy worked closely with Yves Saint Laurent for many years, from modelling to designing accessories. French *Elle*, March 1971.

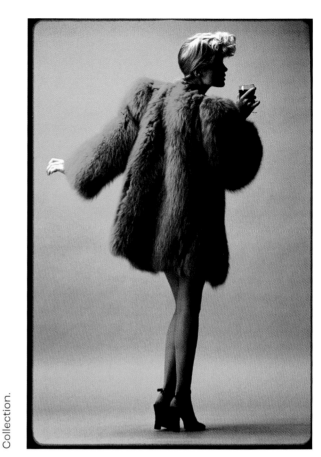

Originally from The Hague, where she had spent much of her childhood in an orphanage, Willy van Rooy first set foot in England in 1967. She had already crossed half the globe with nothing but a backpack, from the Netherlands to Japan overland – crossing Europe to reach Turkey, Afghanistan, Iran, Pakistan, India, Nepal, Burma, Malaysia and Singapore – a round trip that took two years. But it was London that stole her heart and launched her into the world of modelling.

"London was *the* place to be, it was where the fashion scene was, and fashion was my passion," **explains Willy.** "You could feel the excitement in the air; things were happening. The King's Road, Chelsea Market, Granny Takes a Trip – it was all so exciting." **Willy knew that she wanted to be a model, and arrived at the model agency prepared with a book made up of pictures she had directed and printed herself, as well as wearing her own designs.** "I walked in dressed all in red: a red velvet coat, red hat and red Yves Saint Laurent platform sandals. Luckily, I was a hit, the doors flew open and I landed a job with *Vogue* straightaway, working with David Bailey, Norman Parkinson and Helmut Newton."

Willy worked with many of the great photographers of the time, including Hans Feurer, Barry Lategan, Guy Bourdin, David Bailey, Jeanloup Sieff, François Lamy and Eric Boman, but Helmut Newton was always a favourite. Despite working for *Vogue*, he was still relatively new. "He would never shoot rolls and rolls of film like some photographers. He would not click if it did not look good; he knew exactly what he wanted. It was intense, but exciting. Something would happen between the camera and me – he sort of disappeared and gave me the space in front of the camera. It worked most of the time, but not always; at times, it was not right – the clothes, the light, the idea, something could frustrate him, and then it was very difficult. But he was a great photographer. Making pictures was his love and passion, it was his life, and he left a big legacy."

That same year, Willy went on a trip with Helmut to Marrakech, Morocco to do a shoot for the *Sunday Times*, and it was there that she met her husband, artist Salvador Maron. After the three-week shoot, Willy stayed on in Marrakech with Salvador while the rest of the crew returned to London. "The model agency was calling desperately because I was booked for jobs and every photographer was eager to work with me. They couldn't understand how I could simply leave and give up my fame in London. But I was in love, and for me it was more important to live life to the full and Morocco was so magical at that time."

Willy returned to London for a few days to shoot for *Vogue* with Helmut Newton. A display mannequin had been made of her, and the shoot of Willy with her "display dolls" was to be published when they were unveiled two months later. "Helmut told me that if I didn't come back to London for the shoot, he would break the heads off the mannequins and photograph them like that," **she recalls.**

She was meant to receive £1 for every mannequin sold, but the bank book that Willy had to keep track of her mannequin sales had been lost over the years. It was only when, 40 years later, she took her own mannequin to be restored in the Netherlands that she learnt the truth. "The man that opened the door nearly fainted. He recognized me immediately. 'You are Willy van Rooy. Oh my, I have painted your face more than 250,000 times!' – and that was just in the Netherlands, Belgium and Luxembourg. I knew that in Germany they had been all over the place, in the big department stores, as well as Spain, Italy and the USA. There could have been half a million, if not more. It turned out that

it was the most popular mannequin ever made." **Unfortunately, due to the lost bank book, Willy has yet to see a penny.**

*

After several years of dividing her time between Marrakech and London, as well as having a baby, Willy headed to New York – but was disappointed. "My agent, Eileen Ford, told me that I should dress differently. To be more commercial-looking, I should look like the healthy all-American 'girl next door', but that was the last thing I looked like. I knew she was right, but I wasn't interested in trying to be somebody I wasn't, and as for the way I dressed, it was very important to me. Very seldom were the clothes exciting and I couldn't wait to change out of them and back into my own."

After a rather short stint in New York, Willy, Salvador and their young son settled in Ibiza for the next year. Since the 1950s, it had been known as the place where artists went to find peace and tranquillity, and it was still relatively quiet and unspoilt. "Ibiza was a very special island where you could find a wonderful farmhouse to rent for next to nothing, unlike today," **says Willy.** "We made many lifelong friends, designed clothes, baked in the sun, had full moon parties, vegetarian dinners and daily morning coffee at the Gran Hotel Montesol. We designed wooden sandals and had them made up by a local carpenter, and hand-painted them in all sorts of colours and patterns. I still went everywhere in my Yves Saint Laurent platform shoes, despite it being virtually impossible to walk in them on Ibiza's roads, but when it had rained, I would wear these wooden sandals to keep my feet out of the mud."

Magazines and photographers would come to Ibiza to shoot their summer editorials, but it wasn't long before Paris beckoned. "I found myself in Paris and following a new direction. Being a model was great, but it had become much less exciting for me. I had many other interests, such as drawing and designing. In 1971, Helmut had a heart attack and I never worked with him after that, as he stopped shooting fashion and started his nude series and photographing celebrities. I wasn't doing jobs that I was really interested in and there were also many new, fresh, beautiful faces around to fill the pages of the fashion magazines and they were all flocking to Paris."

But something new was happening in the Paris fashion world. "Up until then, the haute couture shows were always presented by 'house models', beautiful girls with long, slim bodies and a lot of patience who were there every day to do fittings and have outfits made on them. Yves Saint Laurent was the first designer to use 'photo models' or 'cover girls' to show his couture collections, and I was one of the first invited to do so. I loved it.

"Then came prêt-à-porter, or ready-to-wear, and some great models started to walk the catwalk.

OVERLEAF: For Willy van Rooy, working with photographer Helmut Newton was intense but exciting. "Something would happen between the camera and me – he sort of disappeared and gave me the space in front of the camera." *Nova*, April 1971.

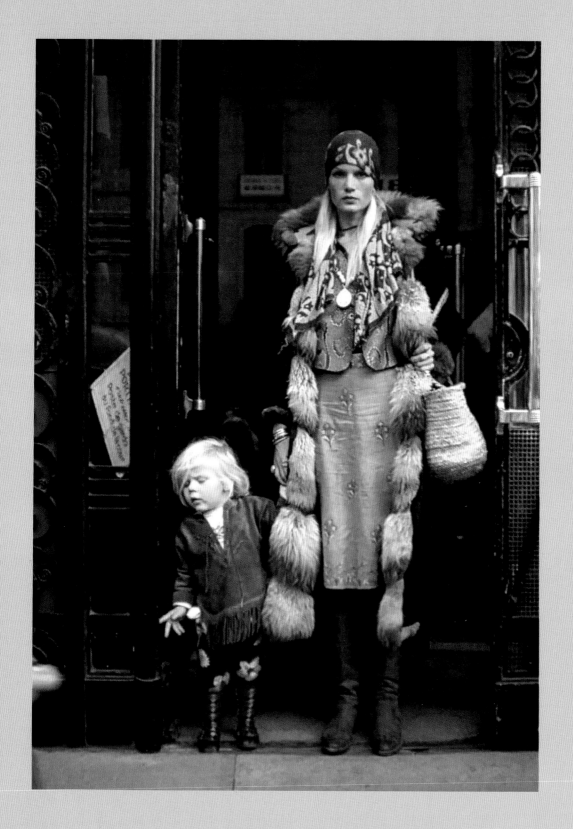

Willy van Rooy and her son Alejandro, 1971.

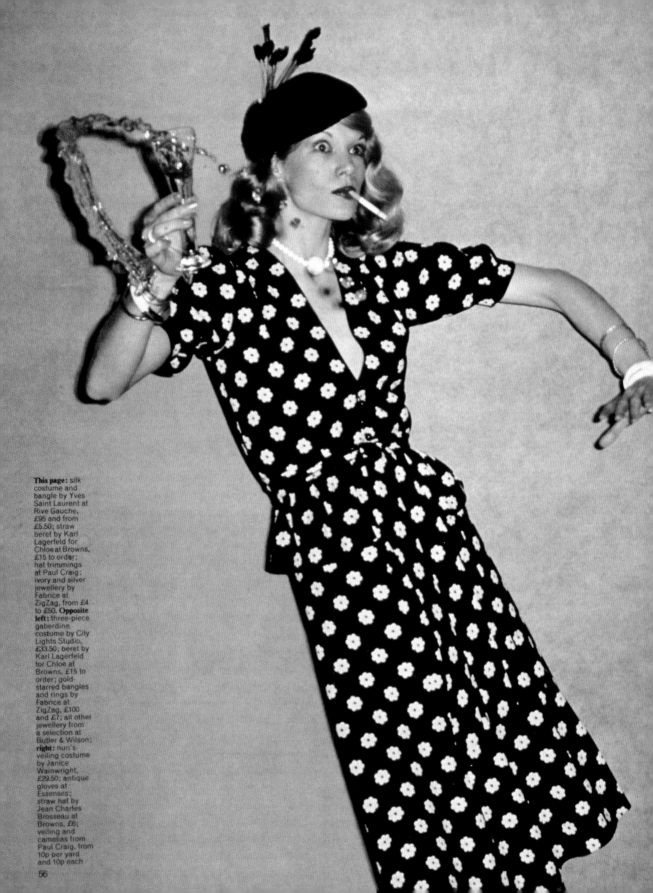

This page: silk costume and bangle by Yves Saint Laurent at Rive Gauche, £95 and from £5.50; straw beret by Karl Lagerfeld for Chloe at Browns, £15 to order; hat trimmings at Paul Craig; ivory and silver jewellery by Fabrice at ZigZag, from £4 to £50. **Opposite left**: three-piece gaberdine costume by City Lights Studio, £33.50; beret by Karl Lagerfeld for Chloe at Browns, £15 to order; gold-starred bangles and rings by Fabrice at ZigZag, £100 and £7; all other jewellery from a selection at Butler & Wilson; **right**: nun's-veiling costume by Janice Wainwright, £29.50; antique gloves at Essenses; straw hat by Jean Charles Brosseau at Browns, £6; veiling and camelias from Paul Craig, from 10p per yard and 10p each

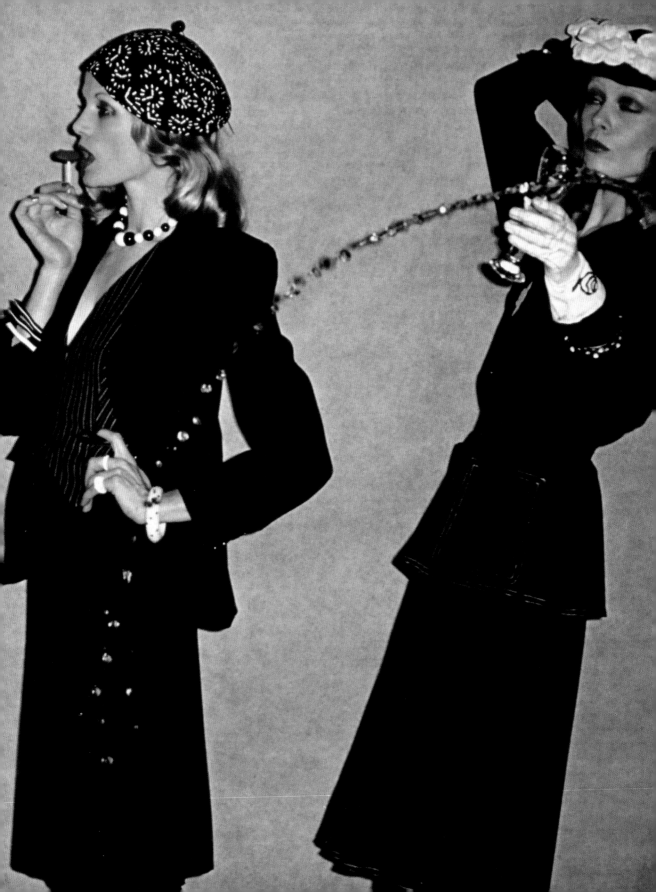

Opposite: silk print frock by Cacharel, £28; antique kid gloves at Universal Witness, from £4; suede bag by Chelsea Cobbler, £14.95; straw beret by Karl Lagerfeld for Chloe at Browns, £15 to order; swizzle-stick by Cartier, 580 francs; veiling at Paul Craig, from 10p per yard; pearl choker by Ciro Pearls, £2.75; Gold Glitter Eye Shadow by Innoxa, 40p; Softly Beige Foundation by Elizabeth Arden, £1.65. **This page:** striped waist-coat at City Lights Studio, £9.50; satin straight skirt by Froks at Che Guevara, £6.95; stockings by Christian Dior, 55p; black pearls by Ciro Pearls, £6; Red Hot Chili lips by Helena Rubinstein, 95p; Brightest Red nails by Max Factor, 35p. Hair by Frederic of Mod's Hair; perfume, Norell, £8.15 for 1oz

There was Jerry Hall fresh from Texas at Yves Saint Laurent, such a beauty and still very young, with that long blonde hair that she was whipping about while she walked. Another was Pat Cleveland, who was full of energy and had beautiful movements. There was also Grace Jones and many other beauties."

"The shows were getting more exciting and became so popular that people would be pushing by the hundreds to get in. We would run from one show to another, always in a hurry and arriving late because we couldn't find a taxi. And then there was all the excitement, the make-up, hair, screams, nerves and then ready to go, as cool as if nothing had happened. They were fun times.

"The clothes, the music, the audience, it all made you feel beautiful. Sometimes I was the first to come out and I particularly remember a white trouser suit I was wearing for Yves Saint Laurent in 1978. I was opening the show to Stevie Wonder's 'Isn't She Lovely' and through the flashlights, I could see Mick Jagger, Yul Brynner and Catherine Deneuve. She came up to me after the show and said, '*Vous – très, très belle.*' It was great: the compliments, the applause, the after parties."

In Paris, Willy had a particularly close relationship with Monsieur Saint Laurent, as everybody at the "House" politely called him. But there was also Anne-Marie Muñoz, the directrice at YSL, whom Willy adored. "She was a very special woman, so kind and beautiful, with such great taste and wonderful manners. She was impeccable with her dark red lips, high heels and of course, always dressed in YSL," **remembers Willy.** "She helped me a lot and we became good friends, sharing many great dinners at her home."

It was at one of these dinners that Willy had to make a big decision on the spot – and still wonders whether she made the right one. "As we were leaving, Anne-Marie asked me, out of the blue, if I would be the model for Yves Saint Laurent's next collection, in other words, his muse and inspiration. It would need dedication, maybe long and irregular hours every day, and was a job that most models at the time would have dreamt of doing," **says Willy.** "But by this time, I had a young family and had started working on my own collection; all these things went through my mind in a flash, and I turned it down." **After that evening, Willy was never**

66 We would run from one show to another, always in a hurry and arriving late because we couldn't find a taxi. And then there was all the excitement, the make-up, hair, screams, nerves and then ready to go, as cool as if nothing had happened. 99

asked to walk the catwalk in shows for Yves Saint Laurent again.

*

Towards the end of the 1970s, Willy got into shoes. They had always been an obsession of hers, with good reason. "I remember so well the first pair of shoes I actually bought in a shoe store. I had eyed them for weeks on my way to school, they were moccasins, they looked so soft and comfortable. When I was growing up in the orphanage, we got to choose, group by group, from a mountain of used shoes in the middle of the room. We were allowed two pairs, one for summer and one for winter, and you were lucky if you found something that you could live with and was your size. So shoes were an issue for me.

"Later, when I had earned some money from modelling, I had my dream pair of shoes made up by a shoemaker in Italy. I wore them to pieces, literally. They were gold leather with a purple platform, like a short boot with cut-out heels and toes, tight with a string so that they were snug. A pair of golden boots followed.

"Soon after I arrived in London, I found this ordinary-looking shoe store, but saw in the very back of the window a glimpse of gold that called [to] me, so I went in, and can you believe it? The owner had seven beautiful – and I mean outrageously beautiful – pairs of original Ferragamo shoes that had been there for over 20 years. Ferragamo was the greatest shoe designer of his time. They were happy to get rid of them and I got them for next

to nothing, and they fitted. I wore them and wore them, silk satin with silver leather, red suede with gold leather, all of the best quality."

After Willy turned down the modelling job at Yves Saint Laurent, she was drawing a lot, which she loved. Salvador suggested that she show her drawings to Anne-Marie Muñoz. "She liked them and asked me to design some shoes and then call her, so that's what I did.

"It was the end of 1979, and in early 1980, I started drawing a collection of shoes for Yves Saint Laurent. When I had 24 of them, I called Anne-Marie and went to see her at YSL. I had been there often for fittings and private shows, but this felt different. I was nervous but excited to show my drawings, as I really liked them. Fortunately, she did too, and I got my first cheque as a freelance designer. She then asked me to illustrate the box for the "Opium" and "Rive Gauche" fragrances. I did dozens of them as well as jewellery, umbrellas, handbags, evening bags, fabrics, T-shirts, scarves and so on, all the accessories."

One day in 1981, Willy found herself confronting a case of déjà vu. Anne-Marie offered her a full-time job at YSL. This time it wasn't modelling, but in the design studio, another dream job. Although she didn't answer straightaway this time, in her heart she knew what her answer would be. "Paris had been great, we had done a lot of things, met a lot of wonderful people, we had made friends, enjoyed the best parties. But I couldn't do it. The next adventure was in the making, and I had to follow my heart."

"lunch with

Marie Helvin

Model

Yves"

Marie Helvin on the catwalk for Yves Saint Laurent, Paris, 1977.

Marie Helvin modelling Yves Saint Laurent haute couture in Paris, 1977.

Marie Helvin wasn't just a model and muse to Yves Saint Laurent – she was also his friend and part of the YSL family. Having arrived in London in 1971, where there was no such thing as the fashion show, Marie would head off to Rue Spontini in Paris, where Yves had his showroom.

"They were very intimate salon shows," **remembers Marie.** "It was a tiny place and the audience could touch you. I can remember Lauren Bacall constantly touching, bringing her arm out for me to stop, wanting to touch the garment. We would do maybe three shows a day, but they were very small. It was years before the catwalk evolved."

Marie loved working with Yves. "He was highly sensitive, very gentle and softly spoken, and always very kind. I adored working with him, particularly when I would be booked for two months in advance of the shows to do haute couture with him. Once, in Paris, I was given a white doctor's coat, which I wore with no bra – Yves hated bras – underwear, black tights and high heels, which I lived in all day long.

"I would then put on the toile [a draft garment in muslin] and he would design on my body. A whole group of people would be sitting in the salon, including Yves, his business partner Pierre Bergé, his assistants and Loulou de la Falaise, his muse and right-hand woman. It was my first experience of working so closely with a designer – to actually see him create on my body, cutting into the cloth without a pattern with his giant cutting shears. It was extraordinary. Only a technical genius could do that."

*

Despite her love for Yves and his work, Marie was not a fan of his clothes, being barely 18 at the time.

"All the designers who were famous at that time created clothes that were heavily structured," **she explains.** "If Yves gave me anything, I would pass it on to my mom. They were all tailored and the last thing I wanted to wear. I generally wore Kenzo with clogs, which were sporty and useful. Kenzo created the first designer label in Paris for young people. This was pre-sneakers (they were something you stopped wearing when you finished school), so for me it was clogs, jeans and a Kenzo jacket."

But when Loulou joined Yves in 1972, she brought with her a sea of change. "She was his mouthpiece and, because she was young, she was his entry into the youth market," **says Marie.** "He followed her lead and gradually, his designs became less structured and more wearable. I stopped sending my clothes to my mom and became one of his youngest customers."

Marie became part of the Yves Saint Laurent family, and she and Loulou were good friends. "She was just so kind to me and all the models. Every day she would say, 'Marie, would you like a whisky soda?' They thought of me as part of the gang and grown-up enough to drink whisky soda. As a teenager, it was the most revolting drink I'd ever had in my life."

After the couture shows, Yves would give a big lunch for all his workers in one of the large ballrooms at the Hôtel de Crillon. "Models were not generally invited, but because I'd been working with him constantly for the two months leading

Marie Helvin at the Yves Saint Laurent Opéras-Ballets Russes catwalk show in Paris, A/W 1976.

up to the shows, I was considered one of the staff. His mother would always be there, sitting next to him, and I used to think she could be Catherine Deneuve's twin. They had the same hair, the same way of dressing in that very French, bourgeois style that Catherine epitomized. It was so lovely that his mother was there."

During the early 1970s, Marie and her YSL family would go out and party, usually with Karl Lagerfeld and Kenzo. "Loulou organized the clubbing, and Kenzo would know where to go, who was around and who to invite. If Loulou and Kenzo were involved, you always knew it was going to be fun," **remembers Marie.** "We would begin with dinner and drinks at La Coupole – there was a lot of alcohol in those days – and from there, we'd make our way to the club Le Sept. As the years went on, Yves preferred to entertain at home, and who could blame him? He had the most incredible apartments. They were just unbelievable – so beautiful."

Marie worked with Yves right through until the 1980s, when she stopped working in Paris altogether. "I decided to stop doing the shows. When you're a model, you just know when it's time. Being a model didn't last as long as it does today. If you managed to make it through to your thirties and were still working, it was considered an incredible feat. I wanted to be in London and develop other areas of my career. I have fantastic memories of working with Yves. It was an extraordinary time and opportunity. It was a gift to be there."

❝It was my first experience of working so closely with a designer – to actually see him create on my body, cutting into the cloth without a pattern with his giant cutting shears. It was extraordinary. Only a technical genius could do that.❞

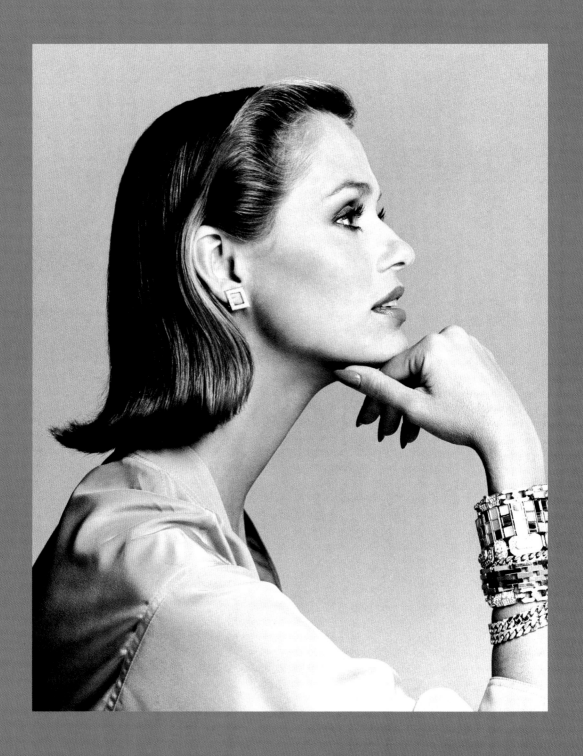

rick

Hair and Make-up Artist

gillette

Rick Gillette worked with Lauren Hutton often throughout his hair
and make-up career. American *Vogue*, November 1975.

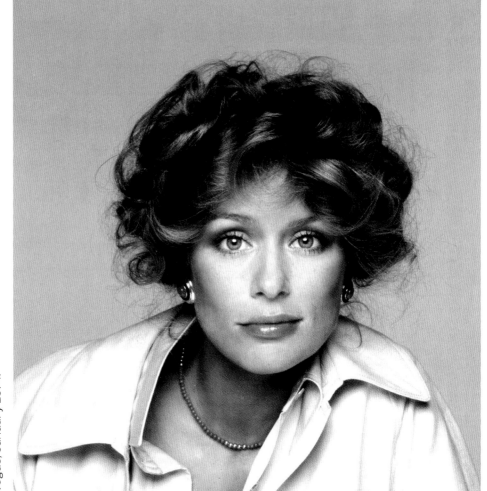

Big hair: out-take of Lauren Hutton from a *Vogue* cover shoot. American *Vogue*, January 1974.

Even as a child, Rick Gillette knew he wanted to work for *Vogue*. At the age of 16, with absolutely no training – simply a copy of *Vogue* open at a page featuring a 1960s Vidal Sassoon haircut – he cut a girl friend's hair into an edgy Sassoon cut. It looked exactly like the haircut in the picture.

"After that, whenever I had the opportunity to copy a hairstyle from *Vogue* I would practise on the girls at high school," **remembers Rick.** "One afternoon I was hanging out with my brother and a girl friend of his, I must have been 16 or 17. The girl had long straight blonde hair, and we were all looking at the new Vidal Sassoon haircuts in *Vogue*. She was saying how fabulous they were and I offered to cut her hair. I spent well over an hour, but when I was finished, it looked exactly like the haircut in the picture. That's when I said, wow, how did I do that? I went to see *Breakfast at Tiffany's* with one and when we came out of the theatre, we went to the drugstore to buy bleach and I put these big streaks in her hair like Audrey Hepburn. She had really long dark hair and the streaks were ash blonde. They were beautiful."

Rick became a hairdresser because he knew it could be his way into *Vogue*. He got his first job at 18 and two years later, in 1966, he moved from his hometown of Rome, a small city in upstate New York, to New York City . "One night, I told the guy I was living with that I was going to New York to work for *Vogue*, and he thought I was crazy."

It wasn't until 1973 that Rick was to achieve his *Vogue* dream. In the meantime, he was building up quite a reputation – and a star-studded client list. One of his most memorable shoots was with Faye Dunaway. "It was my first shoot with photographer Richard Avedon and it coincided with Faye's film, *The Arrangement*, in 1969," **he explains.** "I had to show up at her penthouse apartment at the San Remo on Central Park West at 7 a.m. I don't think I slept the night before.

"She answered the door herself in a white towelling bathrobe, obviously just out of the shower because her hair was soaking wet. She looked the most beautiful I have ever seen her look, so much younger than her screen image. She was friendly and just lovely. She gave me coffee and we went into her dressing room and I started setting her hair.

"By the time she was putting on her lashes, she had gone from a gorgeous, sweet young woman into Faye Dunaway the movie star. She became demanding and condescending and I felt she was being a bitch. In the limousine on the way to the studio, she sat there with her sunglasses on, smoking a cigarette, no longer speaking to me."

*

Hairdressing wasn't enough for Rick; he wanted to do the make-up too. "Why both hair and make-up? I wanted to influence the whole look of the woman and the look of the photograph," **he says. But at first it wasn't easy to convince the powers that be, especially at *Vogue*.**

"At my first meeting with *Vogue* fashion editor Polly Mellen, she said to me, 'Well nobody does both,' but I said, 'Well, that's what I do.' She looked through my whole portfolio but couldn't understand that I'd done both hair and make-up in every photograph. She kept asking me, 'Who did the hair here?' or 'Who did the make-up there?' and each time, I'd say, 'I did.' She closed my portfolio and asked, 'Well, what would you like to do for *Vogue*?' I replied, 'Hair and make-up,' and she said, 'We'll be in touch.'"

Rick heard from her office two weeks later. Thus began his career as the only person who worked for *Vogue* **consistently doing both hair and make-up. But it was a shoot with Richard Avedon and model Lauren Hutton for the June 1973 issue that was to put his name on the map.** "Even today, those pictures are used for inspiration, that's how incredibly modern they were," **he says.** "Lauren had been chosen as *the* American woman of 1973 and the story was all about her. We had already been working together and she chose me for the shoot – in fact, it was she that recommended me to Polly Mellen in the first place."

"Because the story was about Lauren, she was supposed to be doing her own make-up – even though I helped – so I was only credited for the hair, but that was fine because it was that hair that helped me become a household name. Everything just took off after that and I was in almost every issue of *Vogue* between 1973 and 1975."

"I achieved something with Lauren that other people did not, and we were close for many years. From the first haircut I ever gave her to consulting on her look for the 1980 film *American Gigolo*, we were together so much and had a lot of fun."

*

Rick loved fashion photography and knew that he would ultimately become a photographer. His aim was to work with all the *Vogue* **photographers at the time and, fortunately for him, within his first year of doing hair and make-up work, he did. He particularly loved Helmut Newton.**

"I worked with Helmut whenever possible. Everything was special about working with him, and I was incredibly lucky because he let me do whatever I wanted to do, and that was unusual. He rarely worked in a studio and his photographs always had a real narrative about them. They had a cinematic quality, and he would create these scenarios with the models – always with an underlying sexual vibe about them."

One of the most memorable shoots was Helmut's infamous "Story of Ohhh", shot in Saint-Tropez. "It was all about the heat and had this very sensual thing going on," **remembers Rick.** "The story was about a man with two women, and you never quite knew which woman was supposed to be his girlfriend and which one he was fooling around with. Model Lisa Taylor was the star and I did the most undone hair I had ever done for *Vogue*. I cut Lisa's hair so that it had a really great bob shape to it, and before she went to bed, I did tiny little braids so that in the morning her hair would be big and frizzy. It looked great.

"I would be lying if I said I hadn't wanted to be the best. I certainly wanted to be the best at what I did within the business. Before any shoot, Polly would show me the clothes to give me a sense of what the story was about, and I would create this woman in my head. What was she going to be? What would she look like in those clothes? Other hair and make-up artists didn't do that."

Vogue **called Rick "The Visionary", particularly when it came to make-up. Cosmetic companies such as Revlon and Avon hired him for his**

14 THURSDAY • APRIL 1977
104TH DAY • 261 DAYS TO COME

NOVEMBER 1977 • MONDAY **21**
325TH DAY • 40 DAYS TO COME

Ultima - Blake
Hutton

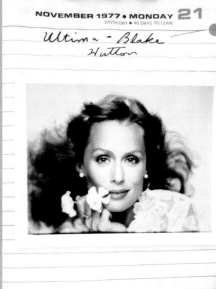

MAY 1977 • FRIDAY **27**
147TH DAY • 218 DAYS TO COME

Vogue Patterns Cover
Rosie Vella
Von Waigenhiem

Polaroids of models Juli Foster and Lisa Cooper, Lauren Hutton, and Rosie Vela in Rick Gillette's date book.

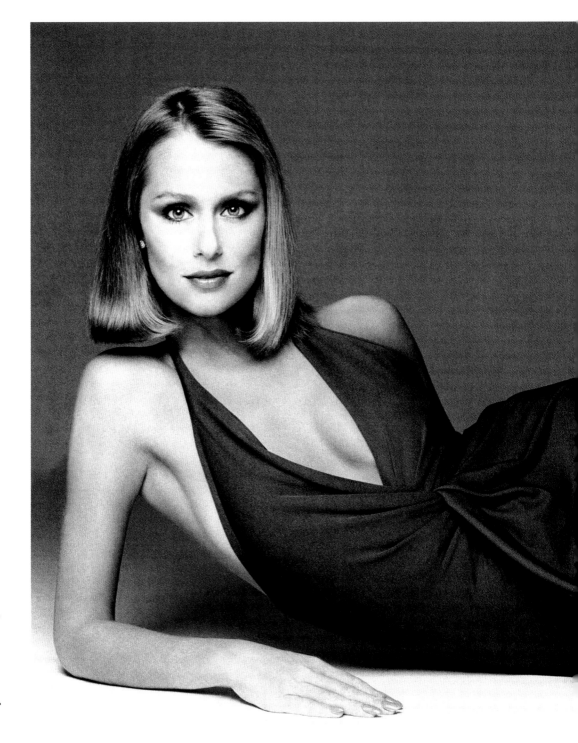

Polaroid of Lauren Hutton posing for a cosmetics campaign for beauty brand Ultima II, November 1977.

expertise. "Every three months or so, they would come out with a new group of colours – for example, a new colour range of lipsticks or eyeshadows – and they would rely on me to come up with looks using these colours."

At *Mademoiselle* magazine, he was known as the "King of Blending". "The beauty editor said, 'The thing I love about Rick is that he can put so much make-up on someone. I can watch him put on a considerable amount of foundation, blusher and eye make-up and, in the end, it looks like there's nothing on the girl's face, it's so well blended.'"

<p style="text-align:center">*</p>

In the early 1980s, Rick did a beauty story for *Vogue* with Irving Penn to go alongside the Fall 1985 ready-to-wear collections in New York. It was the first time he had done more of an abstract make-up look. "That really changed *Vogue*'s and the whole industry's perception of me as a make-up artist, and people started calling me an artist. I ended up being even more successful in the 1980s than I was in the 1970s – and nobody thought that could be possible. But that's what happened."

As the 1980s were drawing to a close, Rick reached a point where he felt his job was done in hair and make-up and it was time to move on. "By this time, I had created a loft studio for myself and had started building up a photography portfolio. The moment I went out showing it, I got work." **And what did he have his sights set on?** *Vogue*, **of course.**

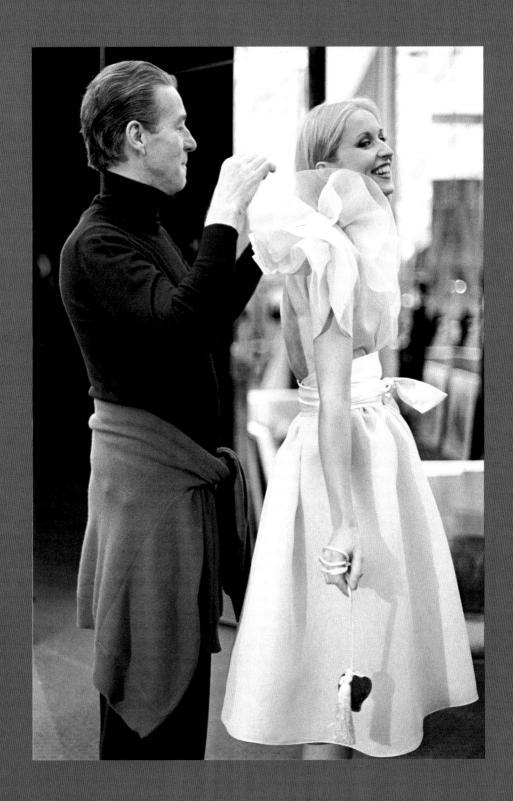

chris

Model and "Halstonette"

royer

Halston adding the final touches to Chris Royer's
Halston Originals evening dress, 1981.

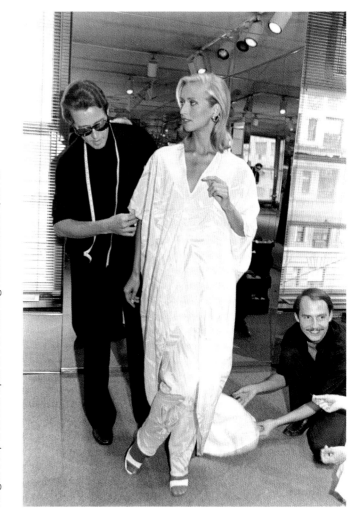

Chris Royer would go through numerous fittings with Halston until he got the perfect shape. Chris wearing Halston Resort, 1978.

Halston adored women. Often regarded as America's first superstar fashion designer, he was one of the first to produce both couture and ready-to-wear, believing that every woman in America should be able to wear Halston.

It therefore comes as no surprise that he surrounded himself with an entourage of beautiful women – or "Halstonettes", as they famously became known. What made them unique was not only their beauty, but their diversity, from cool blondes such as the Nordic Karen Bjornson to African American beauties including Alva Chinn and Pat Cleveland.

One of the original "Halstonettes", Chris Royer was discovered by Halston after appearing in *Mademoiselle* magazine in 1971. Although she loved modelling, she was a former design student of Pratt Institute, and knew that eventually she wanted to be involved in the creative process of fashion. "My agent, Wilhelmina, knew my passion for fashion and told me she had the perfect match for me, and that I should go and meet Halston," **says Chris.** "'You two would be perfect together,' she said."

Stepping out of the elevator at his salon on 68th Street and Madison Avenue, Chris entered the seductive world of Halston for the first time. "The walls were a cream-ivory colour, with just a touch of pink in it so that it glowed. There were orchids and cypress trees, and the bleached polyurethane floors looked like marble. There were sofas in cream Ultrasuede® and expensive Rigaud candles in Cyprès. They had a really clean, fresh smell, yet were very sexy and sensual. It was fabulous. There was Brazilian music playing and lots of sunlight. It felt like California."

Chris was expecting to meet the design team at Halston – you never met the designer initially, it was usually an assistant – so when she saw an extraordinarily handsome man in a black turtleneck and pants sitting on the sofa, she introduced herself. "He said to me, 'We know who you are,' and asked me to sit down. We talked about fashion and how I loved to design, it was all very standard. I tried on the clothes, which all fitted perfectly, and we talked and talked. I told him I had some questions. 'How old is Halston?' He replied, 'Old enough.' I asked if Halston had a sense of humour. 'Yes, he does.' I explained that, as I figured I'd got the job, and because I was interested in design, could I model and evolve and work with him on the design team? Once again, the answer was yes. I had one more question. 'Since we get along so well, could you tell him that you and I can work together?'"

"All of a sudden, one of the assistants came in and said, 'Halston, Jackie Onassis is here for her fitting.' I looked around for Halston, thinking he was behind a door, but when I turned back to the sofa, I realized my mistake. 'You're Halston!' He was laughing hysterically, and it turned out that he did have the best sense of humour. That was so like him."

*

Halston was famous for his simple-looking styles and draping fabrics. "Because of my background in pattern-making and design, we worked really well

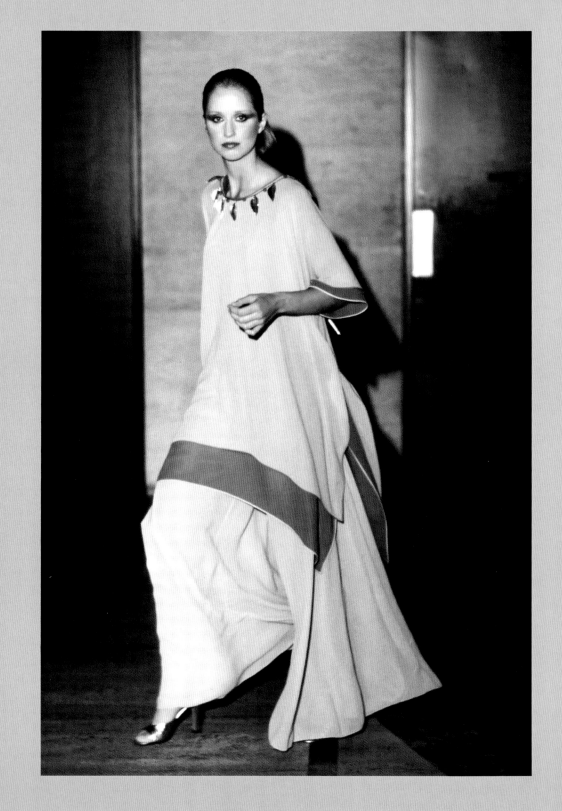

Pretty in purple: Chris Royer photographed for *American Vogue*, November 1975. Hair by Harry King and make-up by Way Bandy.

together," **explains Chris.** "I could also stand for a long time and Halston loved to drape. This was unique, and it was mesmerizing watching him cut and drape. Within 15 minutes, you could see the start of a dress, but to perfect it, he would cut and pin, cut and pin, cut and pin. He was like a sculptor and the fabric was his clay: he sculpted it with his fingers and knew exactly where to cut and where to pin the layers of fabric. Then the whole thing would be taken off me with all these pins in it, and the patterns would be made. It was a very intricate way of doing things.

"One of the most important things for Halston was that his clothes had to be comfortable, and we would go through numerous fittings. It varied a lot depending on the fabric. For example, he would simply pin and drape an evening dress in silk jersey, but a coat would be cut in muslin and then revised again and again until he got the perfect shape – and only then would it be cut into the right cloth. I would tell him how I felt in it, how my arms moved, and we would work in complete synergy."

Halston's famous sarong dress was created on Chris – but completely by accident. "We were staying at Halston's house on Fire Island, and he would sit on the deck facing the pool and sketch. I'd been swimming and, when I got out of the pool,

I was wrapping one of those large Fieldcrest bath towels around me when Halston said, 'No, no, no, come to the mirror.' He started to pull it and, in a very specific way, he pulled, turned and twisted the bath towel to make it tight around the chest and bust area, and then he tied two bunny ears at the front. We both looked at it, saw the silhouette and said, 'Silk charmeuse!'"

When Halston and Chris returned to New York City, they realized there were two problems if they wanted the sarong in silk charmeuse, a silk satin that drapes beautifully. It may have looked simple, but it was, in fact, a work of art. "We had to create an invisible inner bra and the pieces of fabric inside the bunny-ear ties were cut on the bias, so everything had to be configured to make sure that it would hold in place and not slide off the body. Halston constantly evolved the sarong silhouette using different fabrics and prints, a classic sarong that had become this beautiful iconic dress with ties."

A couple of months later, Halston and Chris had another idea. "At that time, raising the hemline by even an inch was a big deal," **says Chris.** "We thought it would be fun to do something short, but we knew that we had to do it in a different way." **As a result, the skimp was born and, like the sarong, it happened by accident.**

66Within 15 minutes, you could see the start of a dress, but to perfect it, he would cut and pin, cut and pin, cut and pin. He was like a sculptor and the fabric was his clay.99

CHRIS ROYER

"Halston was out having a lunch meeting and I was waiting to start fittings. He liked to have the air conditioning on all the time, even in the winter, and it was freezing. So to keep changes to a minimum – some days I would wear up to 80 different outfits for fittings – I would wear a half-slip in taffeta, flat ballet pumps and a light raincoat to keep warm. When he got back, he looked at me and asked me to walk up and down. I had the half-slip pulled up over my chest and he said, 'Okay, that's it. Give me one of those cashmere dresses, let's put it on Chrissy and cut it to the length of the actual slip.' I put on the raincoat and pumps, and he added what he called a 'poor-boy cap', and we called it 'the skimp.'"

*

Halston was the first American designer to diversify and understand the benefits of putting his name to more than fashion. By the 1980s, he had many licensing contracts including perfume, bed linen, luggage and even wigs, as well as creating an affordable range of clothing for the mass retailer JCPenney, the first of its kind and worth a reported $1 billion. But it was Halston's perfume that became one of the bestselling fragrances of all time.

House model, muse and accessories designer Elsa Peretti and illustrator and creative director Joe Eula were also part of Halston's tight inner circle, and were key players in the creation of the perfume. "Elsa was to design the fragrance bottle and Joe would oversee all the designs and advertising," **explains Chris.**

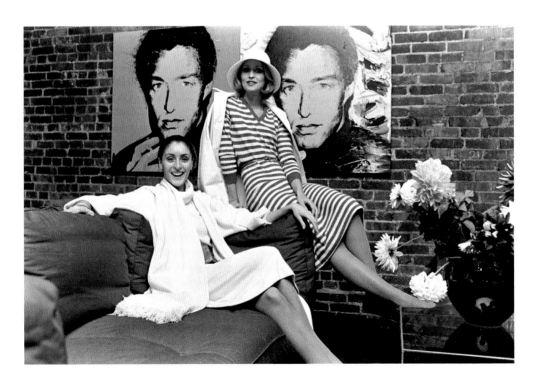

Chris Royer and fellow model Shirley Ferro wearing Halston at the designer's New York townhouse, 1975.

Standing among Halston's favourite white orchids, Chris Royer models a stunning chiffon evening dress, 1979.

Chris Royer wearing a chiffon Halston evening dress from his Spring 1976 collection. American *Vogue*, February 1976.

"It was all so spontaneous and collaborative. I was there when they were brainstorming for the perfume bottle. I would be waiting for fittings and just watch them. Elsa would come in with things she had collected, such as little gourds and squash, and Joe would just start painting shapes with his watercolours. It was an interpretation of this that became Halston's iconic perfume bottle."

Chris and Elsa weren't the only women close to Halston. When he met Liza Minnelli, they developed a close friendship that would last his whole life. "He knew exactly what Liza needed," **says Chris.** "Halston met her when she was very young. She came from a very distinctive style of Hollywood and didn't know how to develop her own style. He created her signature look, which brought out her personality in such an ingenious way. When you saw her in other designers' clothes, she looked good – but not like Liza Minnelli. He did it in a very subtle way, but knew exactly what he was doing."

Working for Halston wasn't always easy. "He was very kind and considerate, but kept you focused. He was incredibly disciplined, especially in the mid-1970s. It was nothing for us to work for 18 hours a day on a collection with him. Once the process started, he'd say, 'Cancel your dinners, because we're going to be in for it.' He produced 150 outfits per collection, which was a lot of work, a lot of clothes and a lot of tailors. That's just the way it was."

Towards the end of the 1970s, Chris could see that he was getting tired and disorientated. "His workload had increased and became huge and very demanding, especially with the new JCPenney deal. That's when it was believed to be too much for him to take on at that time." **Halston died from complications related to AIDS on 26 March 1990.**

"Halston was a great mentor, and it was a very special and unique experience. He was a genius, and when he was at his peak, it was wonderful and he was so happy. He knew the best of the best, from the fabric suppliers to the sewers and weavers in the Garment District. His workroom was not only diverse, but the workmanship was superb. He created many incredible dresses and concepts, but sadly so much of this is not really recognized."

Chris continues to promote Halston's legacy and has an extensive collection of over 200 pieces, including daywear, evening dresses, coats, shoes and accessories. "Clothes were always disappearing, especially when they were sent to the magazines. All designers had this problem of clothing getting lost. Halston was fed up and asked me to start my own private collection. We chose certain things together that were a perfect representation of his work, and the idea was to donate them to a museum." **As a result, Chris has contributed both her collection and historical knowledge to numerous exhibitions, books and films, as well as coaching actor Ewan McGregor on perfecting Halston's voice and mannerisms for the Netflix show *Halston* (2021).**

Chris Royer, president at Consulting by CRC has contributed to the following exhibitions: *In America: An Anthology of Fashion* (The Met Museum Costume Institute, 2022), *Ravishing: The Rose in Fashion* (The Museum at FIT, 2021) and *Studio 54 Night Magic* (Brooklyn Museum, 2020).

virginia

Founder,
Virginia Antiques

bates

Virginia Bates in her sparkling treasure trove of a
shop, tucked away in London's Holland Park.

Virginia Bates standing outside her Holland Park shop, Virginia Antiques, during the 1970s.

Former *Hammer House of Horror* and *Clockwork Orange* actress Virginia Bates opened Virginia Antiques in the heart of Holland Park, London, in 1971, selling antiques and clothes, found in the dark depths of dusty attics, that nobody wanted. She established a huge name for herself with the treasure trove of exquisite clothes that she sourced and over the years would sell to supermodels and designers such as Donna Karan and John Galliano.

"Everything changed for my generation in the 1960s. When I was 15 and 16 and going to dances at the local church hall, we all used to wear these terrible dresses that our mothers bought for us. They were boring and just awful, and we used to have to wear girdles – these terrible rubbery things that made you itch when you got hot – with suspenders and stockings. Tights didn't exist then. But then we decided that we weren't going to dress like our mothers anymore."

The late 1960s and early 1970s heralded the start of our love of vintage and the wearing and customizing of pre-worn clothes. "The most important thing about the sixties and seventies is that at the time there wasn't 'stuff' – the stores were very dull and boring – so we made our own things. We ditched the girdles and suspenders and found things in markets and jumble sales, inventing our own look. We dyed grandpa vests purple and shocking pink and wore groovy socks to the knee with Anello & Davide boots.

"I had done sewing at boarding school. I'd be invited to a party and wanted to look like Brigitte Bardot, so I'd go down to the market and find a roll of gingham fabric and trim it with broderie anglaise. I would never finish anything. I'd cut the hem, and if it was too long, I'd cut it a bit more, and it would be half sewn. Half of it would be beautifully made and half would probably be pinned together with safety pins, but that was our way."

However, the idea of fashion from another era didn't go down well with the older generation. "I would wear 1940s dresses with padded shoulders, which horrified my mother because of the

association with the war, but it kind of rocked and I did it my way. I wore them with petticoats underneath, with the lace showing, and didn't care if they were old and battered. I'd tie a miner's scarf to my belt or my head and a funny hat. There were Victorian jackets and blouses and I wanted to be Brigitte Bardot in *Viva Maria*! There weren't charity shops as such, but the markets were full of stuff that people were literally throwing out. Many things were antique, 1920s and pre-war, and nobody wanted it."

Because of the way she dressed, Virginia was also having problems at acting auditions. "I'd go to an audition wearing something fabulous, and my agent would call and say that I couldn't wear 'that funny dress'. The old-school casting directors were not ready for the fashion revolution. They'd rather you went showing your tits and a bit of leg, that's what got you work, so wearing a long chiffon floaty dress wasn't really a great career move."

*

The opening of Biba in the mid 1960s changed the whole landscape of fashion for young women. Suddenly, here was a store aimed at them, not their mothers, and it was affordable. "The high street began to change when Biba opened in Abingdon Road. I can remember seeing an ad in the *Evening Standard* before it opened, and when I went, there was this tiny shop with these fabulous little skinny dresses with fluted sleeves, and everything was so cheap. When they opened, there was a queue, and then suddenly all your mates were there, and they sold out in minutes. Every Saturday, I would go and buy skinny tops and boots. It was sensational."

Keepsakes, such as invitations to Christian Dior fashion shows and personal notes, were all part of the décor that made Virginia Antiques so special.

When Virginia first opened Virginia Antiques, it was full of stuff that people were getting rid of. "Old ladies would come in and offer a bag of old beaded dresses and ask if I wanted them, and so I'd wear one in the shop in the day and throw on a velvet coat in the evening to go out. For years, people would come in with little brown suitcases they had found in the attic, which probably belonged to their granny or an aunt, and ask if I wanted it. They'd want a tenner for the suitcase, but were never interested in what was inside. A lot of it was junk, but more often than not I would open it and see the arm of a sequin jacket or lovely little rolls of Victorian lace, which I could use for repairs."

There was something else distinctive about the 1970s. The young lived in the moment and worried about little. "We never owned anything and had no responsibilities. We didn't think about it. Even our parents didn't have expectations of us, they were all too busy making up for lost time during the war. My mother wasn't interested in what I was going to do, and that suited me fine. We didn't think we needed to be qualified in anything to get on, you just got on with it and we survived somehow. We didn't go to university, and I didn't go to drama school. If you were talented, you could blag your way in anywhere, and that was the point. You just had to have the confidence to do it.

"It was the beginning of a whole new way of life, and we were happy. Life wasn't fast; you rented a flat or a bedsit, and then if you couldn't pay the rent, you would find another one. We never stayed in the same place for very long. Nobody had a car, so we walked everywhere or rode bikes. At one point, my boyfriend and I did have a motor caravan and we'd go off for weekends in it. It was a converted ice cream van and bits kept falling off it."

What Virginia remembers most is that they were gentle, kind times. "People would drop by the shop and hang around, and if somebody was ill or had a drama, we'd all chip in and find them somewhere to stay or lend them things. Nobody ever had much money, but it really didn't matter."

*

The shop that became Virginia's Antiques was originally an old dairy near Holland Park, which she initially took on for two weeks at £20 a week. "I had an old hipbath, a dresser, some Lloyd Loom chairs and other bits and pieces from my mother's basement, and made £20 in the first day. I would open the shop at 2 p.m. and close at 10 p.m. to catch the restaurant trade from Julie's Restaurant and Bar opposite. I would go round skips on my bike and pull out something old, paint it and sell it." **Virginia kept the shop for another three months, followed by six more, and ended up staying for 43 years.**

"The shop changed as time went on. I got more and more clothes, I had no trouble finding the stuff in those days, the petticoats and 1930s bias-cut and sequin dresses, there was so much of it around."

Some years later, model Helena Christensen bought a bias-cut petticoat and left wearing it. She took it to Paris and Naomi Campbell saw it, and then John Galliano. "Suddenly, I was flavour of the month. Ralph Lauren, Donna Karan, Donatella Versace – they all came in and bought from me and I knew what they loved.

"Looking back, the shop was unique; it was like a fantasy showgirls' dressing room. People would come in and want to stay, I was often asking them to leave at midnight. On Saturdays, I had open house; if you were invited you could bring your friends, and despite being incredibly precious about all the clothes, we always ended up dressing up, with men in sequin dresses and capes and us wearing Victorian camiknickers. It was terrific."

Virginia closed the shop in 2012. "It felt like it was the right time. Times were changing and people were becoming a bit arrogant and rude. The designers were sending in their assistants to take pictures or wanting to borrow clothes – I got fed up with seeing copies of my dresses on the catwalk a few weeks later. The area changed too, and all the people I loved dearly, who were part of the scene, had moved because they couldn't afford to live around there anymore.

"I think about the shop sometimes. I miss those old times, but I don't miss paying the VAT every three months, or the rows with the local council because they wouldn't let me put a table and chair outside. I miss sitting in the shop and mending something, when there would be a ring on the doorbell and Barbra Streisand would be standing there."

clive

Photographer

arrowsmith

Having to include lemons, eggs and flowers in a natural beauty story, Clive Arrowsmith was inspired when model Ann Schaufuss came in with a bunch of lilies. He knew they would be perfect for this shot.

With a résumé that reads like *Who's Who*, Clive Arrowsmith has photographed everyone from David Bowie, Kate Bush, Cher, Jane Birkin, Elton John and George Harrison to King Charles III and the Dalai Lama. And then there are the numerous issues of British *Vogue* and *Harper's & Queen* to add to the star-studded list.

Long before taking his first photograph, Clive was at art college in north Wales. "I used to go to Liverpool at the weekends because that's where it was all happening, the start of rock 'n' roll, and the girls were much more fun," he remembers. "I met this guy called Stu [Stuart Sutcliffe] at the pub one evening and we got drunk together. 'Come and stay at our place, I've got a squat with my mates John [Lennon], Paul [McCartney] and George [Harrison],' he said, so I slept on their floor every weekend. They hadn't even formed the Beatles yet."

Clive didn't train to be a photographer and he was never an assistant. "I was very into the old French, Italian and English painters and loved that kind of light. Not many people were doing that in the 1970s, and it was the only light I knew. I taught myself everything." His first job was to take some shots at the popular music TV programme *Ready Steady Go!*, on which the Beatles and the Rolling Stones first appeared.

He got his first break into fashion at *Town* magazine, where he had been doing drawings. "They asked me to go and shoot the Royal College of Art fashion show. I printed it in the garden shed at my home in Cobham, Surrey, and somebody from *Harper's & Queen* saw the pictures and asked me to come in and do some work for them. The next thing I knew, I was in India shooting a lead picture for the magazine. They liked my work because my pictures looked more like paintings."

*

Then Clive met *Vogue*'s Grace Coddington. "She and Barney Wan, the art director, came to my house in Kensington to look at my drawings and photographs," he remembers. "They arrived just after lunch, and I'd been to the pub with my band (I played guitar). The room was full of incense and I think I was stoned. I think I'd forgotten they were coming. The next day, Barney rang up and asked if I'd like to come in and discuss my career with *Vogue*."

"My first job with Grace was with white clothes and white doves. I had no protocols and I didn't know what you're not supposed to do, so I just did it my way. A lot of people thought my work was very avant-garde, but *Vogue* loved it. I remember one particular beauty shot with the model Ingrid Boulting, with an egg floating on her head and some bubbling milk with half a slice of lemon. What they had wanted was the lemon and milk as a face pack, but it turned out to be this kind of abstract floating face in the dark. I never looked at things in the normal way but always from a painting and creative point of view."

In addition to photography, the other love of Clive's life during the 1970s was the model Ann Schaufuss. "Ann was my muse. She was a Danish ballerina with crooked teeth and nobody wanted to work with her, but I photographed her and showed the pictures to *Vogue*. Grace loved her. She was so sweet and beautiful, I could look at her and weep."

"Green Goddess": Clive Arrowsmith's muse, Danish model and ballerina Ann Schaufuss, in *British Vogue*, 1972.

Clive Arrowsmith's impeccable beauty shots were famous throughout the 1970s.

CLIVE ARROWSMITH

Clive almost cut his ties with *Vogue* over Ann. "We were in Paris photographing the collections when Ann had a row with Loulou de la Falaise," **he explains.** "It was over in five minutes and to us it was just a spat, but because Loulou worked with Yves Saint Laurent, it was a big deal to Ann. It was the first time she'd done the collections and she was terribly upset, so I walked off and left. I couldn't let her down, I loved her more than the world and I thought it would break her heart if I didn't do something."

After New York, Clive didn't work for *Vogue* for six months. But it wasn't to last. "I went back and did some beauty shots of model Maudie James. *Vogue* editor Beatrix Miller called me in and, standing there with her Benson & Hedges cigarette and Dunhill lighter, she told me it was one of the most beautiful pictures she'd ever seen and wanted to send me to see Alexander Liberman in New York, editorial director at American *Vogue*.

"Alexander looked at my portfolio for a long time and then he looked out of the window over the city, smoking a cigarette, and said, 'Your pictures are very beautiful, but far too exotic for American *Vogue*,' and that was that."

Sadly for Clive, it wasn't the only disappointment. "Through George Harrison, I started practising Buddhism. I was into drink and drugs – not heavy drugs, but the usual for that period. I'd always been interested in metaphysics, and Ann and I went to New York and I stopped drinking and smoking. Ann was my whole life. But in New York she left me for the Hare Krishnas. She gave up everything and gave them all her money." **He was heartbroken.**

*

Clive compares his camera to a time machine. "If you retouch a picture too much, it looks like a L'Oréal pack and loses its creativity – it has to be convincing. In the 1970s, it was all about lighting, not Photoshop. Without the light, there's nothing. For me, I have to have a sharp image to start off with, then I can go anywhere with it, but it's got to look good when you shoot it. You can't just think, 'Oh I'll do it in Photoshop.' That's not going to do it for me."

He has a point, and it appears he's not the only one that thinks so. One day, when Clive and Ann were in New York, she said to him, "I was working with Irving Penn today." "Oh, wow, he's so wonderful," Clive replied. Ann continued, "He said to me, 'How's the maestro?' And I said 'Maestro?' And he said 'Clive.'" **It doesn't get much better than that.**

66In the 1970s, it was all about lighting, not Photoshop. Without the light, there's nothing.99

Clive Arrowsmith was the only photographer at the time using double exposure to create standout images. Model Ingrid Boulting in British *Vogue*, 1972.

Clive Arrowsmith was inspired by an exhibition of Russian revolutionary posters in this image of models Ingrid Boulting and Marina Schiano for British *Vogue*.

CLIVE ARROWSMITH

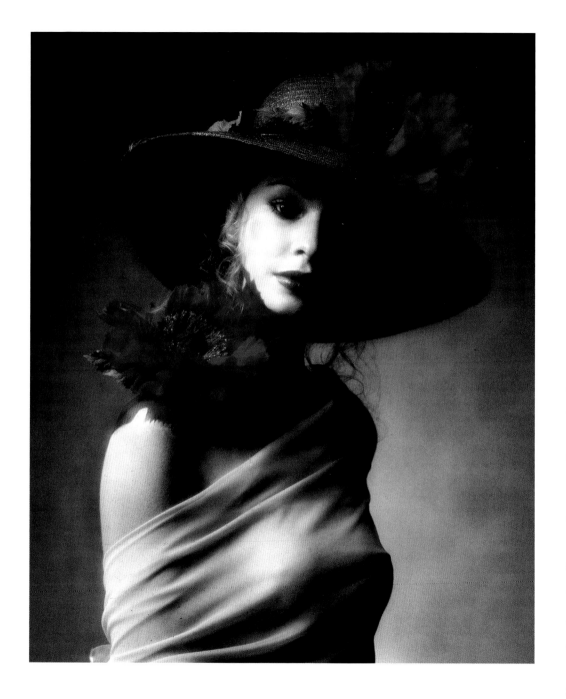

When *Vogue* editor Beatrix Miller saw this image of Ann Schaufuss, she exclaimed it was one of the most beautiful photographs she had ever seen in *Vogue*. British *Vogue*, June 1970.

CLIVE ARROWSMITH

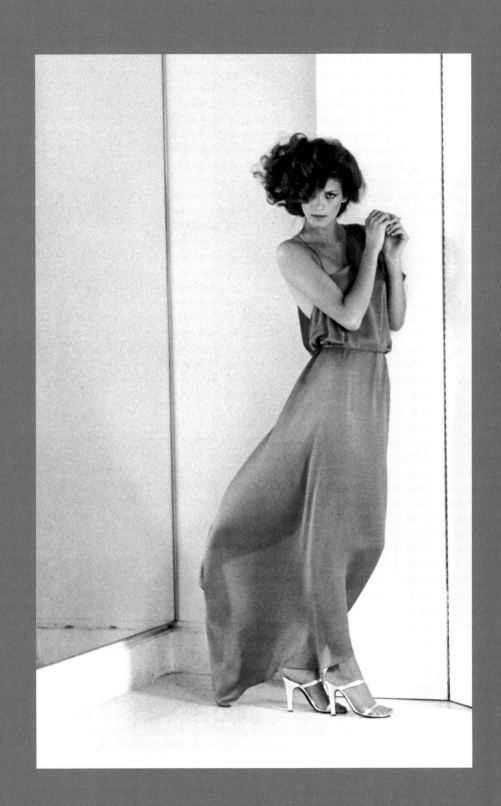

"naked

Sandy Linter
Make-up Artist

with gia"

Model Gia Carangi was considered by many to be the
most beautiful woman in the world during the 1970s.

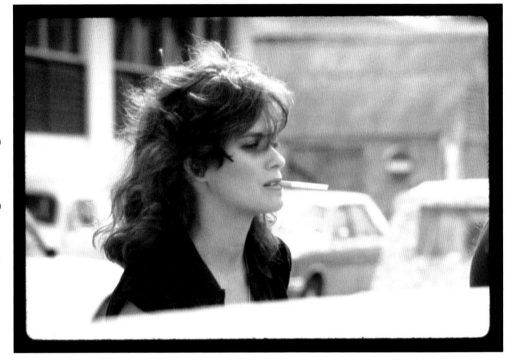

Gia Carangi, or Gia, as she was famously known, was bold, brazen and beautiful. She worked with all the great photographers of the time, from Irving Penn, Albert Watson and Francesco Scavullo to Chris von Wangenheim and Patrick Demarchelier, appeared on numerous covers of *Cosmopolitan* and *Vogue*, and fronted campaigns for Christian Dior, Versace and Yves Saint Laurent.

Arriving in New York at just 17, she was catapulted into the world of modelling from the minute she arrived. Hairstylist Harry King remembers when he first met Gia in the early days: "I was working at [Francesco] Scavullo's studio and this girl came in on a go-see, and he wanted to take some quick pictures of her to see how she moved. She was wearing a white shirt, jacket and jeans, and her hair was loose. She had fabulous hair. And as she stood there, I thought, *You know what? I haven't seen a girl like this since Lauren Hutton.* She was extraordinary."

Make-up artist Sandy Linter met Gia in 1978 and remembers her as a force of nature, a true rebel, and perhaps the most beautiful woman in the world at the time. Gia was a "punk princess" who loved the Ramones, David Bowie, Blondie and the Rolling Stones. Music was everything to her, but fashion paid the bills. Gia was also gay and proud of her sexuality; she made no apologies.

Everybody who worked with Gia fell in love with her, and Sandy was no exception. On an October day in 1978, the make-up artist's life was changed forever. Sandy had worked with Gia once before, but this day was different. "I was working on a *Vogue* shoot with photographer Chris von Wangenheim and the very beautiful Lisa Vale and Gia," she remembers. "Chris had brought in a wire fence – the kind you see in playgrounds all over New York – that covered the entire back wall of the studio. During the shoot, the girls would lean against the fence or put their hands up against it and Chris would shoot through it.

"It was a very typical day and nothing out of the ordinary had happened, but as I was packing up my make-up to go home, Chris came into the make-up room and asked if I would stay, as he was doing a personal shoot. He then said, 'I want to photograph you.' That was okay with me, but as he walked out, he turned back and said, 'Nude?' I agreed, but he came back in again, [and said] 'With Gia.' The hairstylist, Bob Fink, just swivelled round in his chair, looked at me and gasped. Chris left the room real fast. And that's how it happened."

At first, Sandy was mortified. "When I think of Chris von Wangenheim, I think of furs and high heels, the last thing I would expect would be no hair, no make-up and no clothes. I kept my boots on because it made me feel better." Fortunately, when the *Vogue* editor who was still at the shoot yelled, "She has her boots on!", Chris didn't care. Sandy assumed she would just be a prop in the shadows and that Gia would be the main focus, but the resulting image was far from that.

It was the following day that Sandy had a call from Gia and their "affair" began. It was a once-in-a-lifetime experience for Sandy. Gia regularly sent her flowers and stayed at her apartment and they partied most nights, but it wasn't a sexual relationship as such. Sandy remembers how Gia would spend her days with the best people in the

business, but when everyone went their separate ways, she hated being alone and hid a lot of emotional pain. Gia was deeply divided between being a cool, hipster lesbian and an ultra-chic and sophisticated *Vogue* model.

Eventually Gia's instant success and fame began to take its toll. Cocaine had become the norm in the fashion world, even on shoots, but when that wasn't enough to quench Gia's huge drug appetite she turned to heroin, and in the early 1980s, her life began to unravel. Her drug addiction took over, her behaviour became erratic and photographers stopped wanting to work with her. Having to disguise the shadows under her eyes and the needle marks on her body were things that even Gia's charm couldn't persuade them to put up with any longer.

Her life is often referred to as a tragedy, but hair stylist Harry King disagrees. "Yes, it was tragic at the end, but at the beginning it wasn't. When I knew her at her best, she was gorgeous, she showed up on time, she loved to work, she loved the life. But she was unlucky and she chose a dirty needle." **There's no denying that things went from bad to worse. The last time Harry worked with Gia was in 1983 for German *Vogue*.** "Gia was a mess and the photographer, Arthur Elgort, kept putting her in the shadow of the back of a car to take pictures because she had such dark circles under her eyes."

The last time Harry saw Gia was in the street. "She lived quite near me and was walking along in a grey suit, shirt partly undone and hair loose. She was wobbling along and when she saw me, I could tell she didn't want me to see her like that. We said hello as we walked by and didn't stop. I gave her that." **After disappearing from the fashion industry altogether, Gia died on 18 November 1986, from complications due to AIDS. She was 26.**

❝When I think of Chris von Wangenheim, I think of furs and high heels, the last thing I would expect would be no hair, no make- up and no clothes. I kept my boots on because it made me feel better.❞

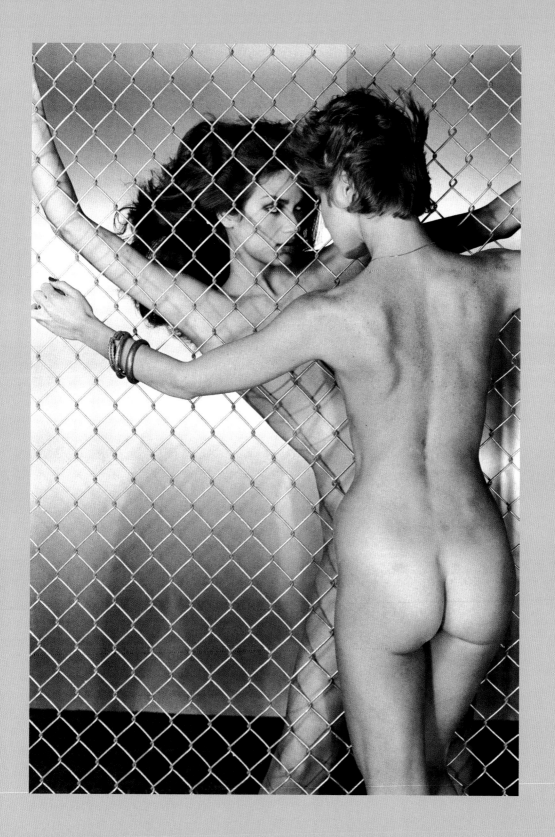

Chris von Wangenheim's infamous photograph, shot after hours, of Gia Carangi and Sandy Linter, 1976.

pat

Model

cleveland

Pat Cleveland worked with the designer Halston, and adored him. "He made sure all us girls were covered in diamonds and gave us gifts all the time."

Pat Cleveland loved working with designer Stephen Burrows. "Young people were getting noticed ... Stephen was all about music and dancing and freedom of movement."

Pat Cleveland was no ordinary model. As a child, she watched Marlon Brando and Eartha Kitt learn to dance, she was a muse to Halston, Karl Lagerfeld and Antonio Lopez, she sang "Happy Birthday" to Stevie Wonder at Studio 54, she hung out with the McCartneys, and Andy Warhol called her a superstar.

From the age of five, Pat knew that modelling was special. "My mother was an artist and I would model for her, and I realized that this was the most beautiful feeling I'd ever had in my little life – where I could be so appreciated just for being still. Quiet, still and serving a purpose simply by being present. And that's how I started modelling, by sitting and posing for my mother."

Yet she also loved to be playful and have fun. "I began modelling when everybody was very serious, in the tiny couture houses of Paris and New York, and it felt like a different time. It was so quiet and there was no music. The 1970s were just starting, and it was all about young people and music and being able to express yourself. I was a flower child, and then a mod. Yet when I first started out, I had to walk into the showroom holding a number in front of me without actually moving, as though I was made out of plaster, like a mannequin. It was so regimented and stiff."

But things were changing – and fast. "Young people were getting noticed. I started working with the designer Stephen Burrows, and he was all about music and dancing and freedom of movement. DJs were playing music in clubs that had never been heard before, and he used this in his first show in New York. We were young and the clothes were young.

"My aunt was a dancer with dancer and choreographer Katherine Dunham, so when I was a little girl, I would hang out in the studio watching Marlon Brando and Eartha Kitt dance across the floor. Afterwards, the dancers would come over to our apartment on the edge of Harlem, where our living room was covered in wall-to-wall mirrors. They would rehearse until late, with my mother playing the conga drums and the dancers half-dressed in the African way. I was allowed to dance with them, and it was the most thrilling experience that stayed with me. I always wanted to be a dancer, but I was too tall. So when I was given the opportunity to go out on to the catwalk, it just turned into a dance for me. 'My walking dance', I called it."

*

As fun as the early days were, modelling didn't come without its disappointments. In 1966, Pat met model agent Eileen Ford, who told her that if she wanted to make it as a model, she should consider shortening her nose to look more American. "There was a lot of discrimination again women of colour. They weren't considered beautiful," **she explains.** "I don't know where that kind of ignorance came from, but I had a taste of it. I'm mixed race – half Swedish and half African American – and it was hard to deal with that antagonism and racial hatred. It was frustrating because every time a magazine would shoot a cover on me, it would be given away to a more Caucasian girl, even though my covers were beautiful. It was heartbreaking that I could never get past that racial divide."

Pat Cleveland was inspired to model after posing for her mother, an artist, as a child. She loved that she could be present in the moment and become something important to help others work.

However, due to a chance meeting on the subway while she was still in school, when a fashion editor from *Vogue* spotted her wearing her own designs, Pat had a foot in the door at the magazine. It was here that she met a man that would change everything. "When I was in school studying design, I kept seeing these incredible illustrations by Antonio Lopez in the *New York Times*, and I would copy them," she remembers. She became a fittings model at the *Vogue* offices and it was only after a month that she realized the man drawing these beautiful six-foot drawings of her was Antonio.

"He was so beautiful and so talented and welcoming. He saw beauty in things that people didn't see beauty in and if he drew you, you just wanted to become that beautiful thing. He invited me to Carnegie Hall, where he had his studio. I walked in and there was Cathee Dunham, Antonio's muse and the most beautiful model of the time. I sat for Antonio for the first time and it was so much fun," says Pat wistfully.

Antonio would put Sly and the Family Stone on and blast it loud. Once he started to draw, Pat knew she could be there for hours, often through the night. "You had to be very still so he could focus, and his directions were very precise, yet the bold movement of his hand was so graceful. It was about making beauty." Other stunning girls would drift in and out of the studio, including Jane Forth, Donna Jordan, Grace Jones, Patti D'Arbanville and Jessica Lange.

*

However, it was soon time to move on. Antonio had moved to Paris with his partner Juan and model Donna Jordan, and he invited Pat to stay. She quickly adapted to Antonio's tiny apartment and life in Paris, staying up through the night and posing for him, sleeping in late (head to foot on a daybed with Donna), and heading out in the afternoons to Café de Flore.

The fifth member of Antonio's gang was make-up artist Corey Grant Tippin. "We used to call him the Adonis because he had golden curly hair and was so beautiful," says Pat. "People lusted after him. And then there was Donna, with her platinum-white hair and eyebrows and me, whatever I was, dancing along with the gang.

"Corey wouldn't let us leave the house unless he'd put on a ton of kohl inside our eyes. He was vicious with it – it was his passion. And he'd pull your head back and put his knee on your chest and make sure you had 10 layers of mascara on before you got to the door.

"There were the five of us, and we were the core of this little group who landed in Paris, and we had no idea that we'd become 'superstars', as Andy Warhol called us. It just opened up for us and we became the pearl in the oyster of Paris. It cracked open, and we were just sparkling from being happy, and it was infectious because we were so young, wild and free, whereas Paris was so sophisticated and elegant."

And then they met Karl Lagerfeld. "Karl was like our big brother, he had such a love for us," says Pat. "He didn't have an entourage when we got to Paris, so we became his little mandala – his circle of

energetic, happy people – and it made him happy. People were envious because we were American and modern, and he was part of that. We hung out with Andy Warhol and we would flirt and throw kisses, dance on tables. We were the ultimate glamour girls.

"Karl taught us so much about everything, from Marie Antoinette to Chanel. He seemed to know everything, and kept us near him. He told us that he grew up in a castle, but we didn't know if it was true. I mean his bathroom was like a castle. There were huge mirrors and a big round table in the middle covered in every fancy perfume you could imagine, and we would sit in the bathtub telling stories and pouring on the perfume. Then we'd get dressed up in Chloé [Karl was the brand's head designer at the time], go out to dinner and show off."

Despite his early death due to complications caused by AIDS in 1987, Antonio had a huge impact on Pat's life. "When somebody has changed your life in such a positive way, with his insight, love and attention, he made me blossom into something new. He's still a part of me and who I am. I could never have achieved all those wonderful moments unless he'd come into my life, changed my perspective and opened the world up for me."

*

Back in New York, another man was about to have a huge influence on Pat. "I was at a party with designer Stephen Burrows and he said to me, 'Oh you have to work for my friend Halston.' Halston turned up at the party and he was this extremely handsome, tall Nordic-looking man with dirty blonde hair, silk shirt open to his chest, black slacks and [a] big cowboy buckle. He looked so skinny and beautiful. He came over and sat next to me, just scooted over like that, and said, 'I know who you are, and I want you to work for me.'

"Halston was so much fun to be around. He was just gorgeous and a great host to everybody, and so caring. When the clients left, we would dance, play around and just be silly. He made sure all us girls were covered in diamonds and gave us gifts all the time. If we went travelling together, we always had our own wardrobes that he would design for us individually. Each girl, or "Halstonette", **represented a different type of woman.**

"He often invited me out to his house on Long Island to stay for the weekend and my room would be next to his. Andy [Warhol] would be there, along with Halston, and we'd sit around on the floor and

66We hung out with Andy Warhol and we would flirt and throw kisses, dance on tables. We were the ultimate glamour girls.**99**

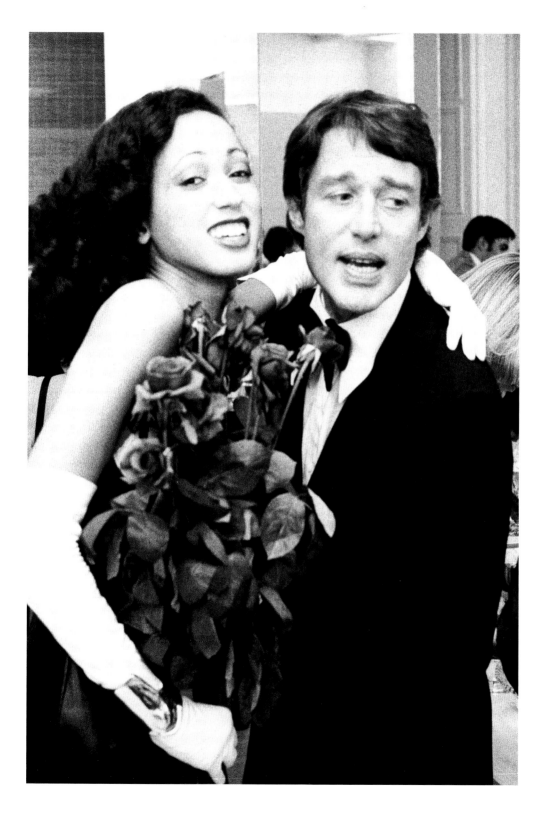

Pat Cleveland and Halston at the Coty Awards after-party hosted by Halston at his studio in New York City, October 1972.

Pat Cleveland wearing Halston's stunning made-to-order cashmere "Goddess Dress", British *Vogue*, November 1972.

watch monster movies. I'd make spaghetti, which would end up all over the floor because I didn't know how to cook, so we'd be living on celery sticks until somebody flew some food in from New York. None of us could cook back then.

"We had a really good time and we worked hard, but the 1970s was all about 'What are we going to do after 5 p.m.?' We'd go home, take a shower, have a disco nap, get changed and go out somewhere. One day, a friend of mine, Steve Rubell, said to me, 'Come with me, I want to show you my new club.' He opened the door, turned the lights on and said, 'I want you to bring your friends here so they can have a good time.'"

The club was Studio 54. "It just so happened that, one night, Halston called me up and asked if I would like to go over to his house for dinner," **remembers Pat.** "I said I'd go over but that we weren't staying in – I was going to take him somewhere. I took him over to Studio 54. The place was empty: it was just me, Halston and Steve.

"Steve turned on the lights and I said to Halston, 'Now you're gonna dance,' and he said, 'I can't dance, I have two left feet.' I said, 'You can dance, nobody is going to see you, just pretend we're at the studio playing.' And he started dancing and had such a good time and, before we knew it, he said, 'I'm bringing everyone I know.' And that's how it started, with Halston bringing all his VIP friends, from Andy Warhol and Elizabeth Taylor to the Supremes and Mick and Bianca Jagger.

"I used to sing there sometimes," **says Pat.** "I remember once they asked me to sing 'Happy Birthday' to Stevie Wonder, so there I was up in one of the DJ booths singing 'Happy Birthday' and Stevie comes out and started playing 'Superstition'. Everybody was stoned and I kept stepping over Sting and his band, who were sitting on the stairs, hanging out. You would feel so comfortable because it was one of the only places where you could really dress up and have fun."

*

But life wasn't all dress-up – and change was brewing. "Everybody, such as Antonio and Andy, were getting so famous. They were like big pieces of fruit hanging on the tree, and everyone wanted to get a taste. There were so many drugs and promiscuity, and a dark energy started collecting like a dust cloud. The rainbow tribe was disappearing and it became about black leather, dark clothes, sex and drugs. And then people were dying from AIDS, and it was heartbreaking. People were afraid to look at each other or touch one another. There was so much fear.

"The end of the 1970s was just so tragic, but in the midst of it all there were these sparkly beings who made life beautiful for everyone and made women feel beautiful. I worked hard, but your work is your play and you bring your play to your work. That's what we all did. We worked hard and we played hard, and many of those who passed away, such as Halston and Antonio, used to say, 'Well, I'd rather die young,' and they did. They lived fast and died young. But those boys gave me the ride of my life and made fashion worthwhile. They made life beautiful."

elsa

Jewellery Designer

peretti

Elsa Peretti at work in her studio. American Vogue, December 1974.

Elsa Peretti had her own sense of style that epitomized the 1970s. Pictured here on the streets of New York City, 1974.

Arriving in New York in 1968 with a black eye from her lover, Italian-born Elsa Peretti was rumoured to live on a diet of Champagne, caviar and cocaine. Little did anyone know that the model turned designer would go on to become the world's most successful jewellery designer.

New York life was a sweet affair for Elsa, a successful model, Helmut Newton's lover, Halston's best friend, the poster girl for Studio 54 decadence, a socialite and style icon. You could say there was something special about her. "Elsa's the only woman who can arrive at a dinner party dressed in a black cashmere jumpsuit with a rope of diamonds around her neck and look terrific carrying a brown paper bag as her evening purse," *Vogue* declared in 1976.

"Elsa was just fabulous and so glamorous, but also gracious and kind. She became the Audrey Hepburn of the 1970s," **says former "Halstonette" Chris Royer.** "She used to go to Army Navy Surplus stores with Halston's boyfriend, Victor Hugo, and pick up large collarless shirts and cargo pants. She would add jewellery and a Halston hat and look incredible. She was quite extraordinary."

*

Despite appearing on the pages of *Vogue* and *Harper's Bazaar*, Elsa always knew she wanted more. She was drawn to beautiful tactile shapes and objects, and decided that she'd like to design some jewellery. Inspired by a vase she found at a bric-a-brac shop, one of her first pieces was a small sterling-silver bud vase worn around the neck with a leather thong. Her friend, designer Giorgio di Sant'Angelo, included it in his show in 1969 with a rose stem inside, and it caused a sensation.

Halston started commissioning Elsa to make pieces for his collections. She made several of the bud vases to be worn on a chain, as well as what were to become her famous slice bracelets, lima bean earrings and teardrop necklaces. "The pieces sold out very quickly, but the problem was that Elsa's jewellery was all handmade and hand-polished, so she couldn't produce a lot," **remembers Chris.** "Halston realized very quickly that Elsa could be a much bigger and more successful designer if she had the right facilities and could do it in the right way. So that's when she was introduced to Harry Platt, the chairman at Tiffany. They had the best jewellery makers, so it was a great opportunity for her to achieve her goals and dreams." **It's said that she was hired by Tiffany in just 15 minutes.**

Elsa began phasing out her modelling to spend more time on her jewellery, but was hired by Halston to design his perfume bottle, which launched in 1975. Because Halston's foray into fragrance was backed by Max Factor, money was no object. "Halston's creative director Joe Eula would come in and sketch with his watercolours," **remembers Chris, who watched with fascination as the perfume bottle developed between fittings.** "Halston was there putting across his ideas, and Elsa had all these wonderful things to look at, such as different-shaped gourds and squash."

"Halston wanted the bottle to stand out on a woman's dressing table, but he didn't want it to be so classical like all the others that had big labels and

were very elaborate. He wanted something much more elegant, modern and tactile. 'You will identify it by the shape because it will be so different from all the others. I just want a little tape around the top of the bottle to say "Halston", I don't need a big label – because everyone will know that it's Halston,' he said. The gourds were just right, and Elsa started playing with the shapes and Joe was sketching. It was incredible to watch."

Because of its unique teardrop shape and the fact that the stopper was tilted, the bottle almost never saw the light of day. But Halston insisted, and Max Factor gave in and created a special tool to fill the bottles for production. It went on to become of one of the bestselling perfumes of all time.

*

At the same time, Elsa was developing her jewellery line at Tiffany. "She was so creative, with so many ideas," **says Chris.** "At Tiffany, she had the craftsmen that could interpret her ideas in the way she wanted and make them a reality." **Among her famous pieces was a gold-mesh bra, which launched in 1975.** "Elsa travelled the world and in India, she found this ancient way of knitting gold into fabric," explains Chris. "She took this technique and created the gold-mesh

bra. It was beautiful because it was very light and just twinkled. Halston did the pattern for the bra and he integrated it into several of his outfits."

One of her most famous pieces was the articulated snake belt. "That came from a real snake skeleton that she had. She collected bones and all kinds of natural objects. She was inspired by bees, starfish, even teardrops – and incorporated all of these into her jewellery.

"There were exquisite woven-bamboo evening bags inspired by a trip to Japan. They were absolutely beautiful. She created Diamonds by the Yard® and a whole collection of at least 20 different styles based on the lima bean, from earrings and necklaces to belts. She was very innovative and went on to design ceramics and glassware. It was amazing the way she could go from sterling silver, gold, titanium and diamonds to home décor, and create an entirely different concept from that. Such timeless pieces."

*

Elsa soon became Elsa Peretti for Tiffany. Gradually, she and Halston started working on separate projects because they simply didn't have the time to work together any longer. "They loved one another and it was a very special relationship,"

66She was very innovative and went on to design ceramics and glassware. It was amazing the way she could go from sterling silver, gold, titanium and diamonds to home décor, and create an entirely different concept from that.99

Model wears Elsa Peretti's gold mesh bra and Diamonds by the Yard® by Tiffany & Co. Diamonds by the Yard® became so successful that in 1977 Newsweek claimed that Elsa had created a jewellery revolution.

Elsa Peretti's asymmetric gold pendant bottle necklace was one of her famous designs for Tiffany & Co.

says Chris. But with Elsa's fiery Latin personality, their relationship didn't come without its rifts, culminating in a monumental falling-out in 1978 and the infamous story of the $25,000 sable coat:

"Joe Eula told me that one evening he was having dinner with Halston and Elsa, when all of a sudden, they started to argue. It quickly escalated and Elsa threw her beautiful Halston sable coat – a gift from Halston – into the fireplace. The flames destroyed the coat and stunned everyone in the room. Their relationship changed after that," **says Chris.**

The two eventually made up, but as was true for many in the fashion industry during the 1970s, New York began to take its toll. Elsa spent more and more time at her hideaway in Catalonia, Spain, which she had bought as a ruin in 1968. Her success continued for the next 40 years, and she earned millions from her deal with Tiffany, even after her death at the age of 80 on 18 March 2021. In December 2012, she signed a 20-year contract worth $47.3 million – ensuring that her legacy will carry on for years to come.

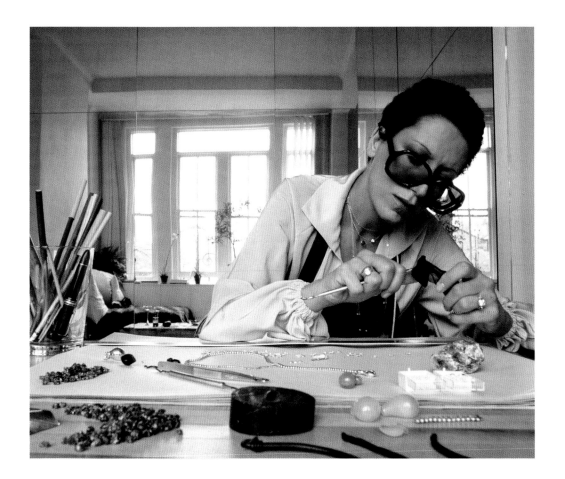

Elsa Peretti was inspired by nature, such as starfish, lima beans and teardrops, and incorporated these into her jewellery. American *Vogue*, December 1974.

willie

Photographer

christie

Willie Christie's famous green jelly cover for *Vogue* with model Jerry Hall and make-up artist Barbara Daly. British *Vogue*, February 1977.

For somebody who didn't set out to be a photographer, let alone a fashion photographer, Willie Christie has a pretty good track record. As well as photographing David Bowie, the Rolling Stones, Pink Floyd, Roxy Music, Grace Jones and Catherine Deneuve, he can claim numerous *Vogue* covers to his name.

In 1967, Willie was working on Elizabeth Taylor and Richard Burton's yacht, cleaning up after their dogs and replacing the chocolate bars beside their bed each morning. Willie's sister was dating photographer David Anthony, and Anthony's assistant went away for two weeks. Wanting to get into film, Willie offered to help out – and was still there a year later. "I learnt the basics of lighting and film, but then David and my sister broke up, so I was out," he recalls.

Then he met photographer Clive Arrowsmith and 10 crazy months ensued. "Clive taught me a lot. He was doing such beautiful work for *Vogue* and it was new and different," remembers Willie. "We were drinking and smoking a lot in those days and we used to play a lot of music together, so the days we weren't working descended into chaos and mayhem."

Clive and Willie became very close but, after a trip to Milan ended in disaster, with Willie having his precious guitar stolen, he decided to go it alone. Through Clive, he had got to know *Vogue*'s Grace Coddington, and was also dating her assistant. When that fizzled out, he and Grace got together and were married for a short time in 1976. Their marriage may not have been a success story, but their work together was phenomenal.

They didn't officially work together straightaway. "Because she used to be a model, Grace and I would do a lot of photographs together, and I was doing a lot of work for *Over 21* magazine," Willie remembers. "One day, Grace just said to me, 'I think we can do one.' I was lucky because Beatrix Miller, the editor of British *Vogue*, encouraged artistic flare and completely trusted Grace."

"Our first trip together was to Scotland. We borrowed a Range Rover, stuck everything on the roof rack and headed to Elgin, outside Inverness, with a model and hairdresser. It was a wonderful trip. I'd never seen anything like the light up there in Scotland. Everything worked – the light, the model, it was great. We would all pile into the car and just follow the light. We could never do that now, it's all about Winnebagos and assistants and their assistants. In those days, nobody complained about anything. We'd be freezing our nuts off wherever it was and it didn't matter if everyone was tired and cold, we just got out there and did it. Every job that came my way was a joy.

"Grace was such an inspiration. She just knew how to put clothes together and create a story. For me, it was like making a movie and everybody had a part to play. If you let everybody do their part, you're going to get all this great talent into the final result. I was also inspired by photographer Guy Bourdin, I loved his work. I started to develop my own style and I loved all the old Hollywood movies, so my work became a mixture of that, Clive, Guy and myself."

Willie Christie loved working with model Jerry Hall. "Her hair was her great strength, but she just knew how to do it, how to toss her head back – and then she had this incredible body."

WILLIE CHRISTIE

The epitome of 1970s make-up as worn by model Marcie Hunt. British *Vogue*, 1977.

Among the many models Willie worked with, Jerry Hall was a favourite. "She was wonderful. Grace had been in Barbados with her and said, 'You have to work with this girl.' Her hair was her great strength, but she just knew how to do it, how to toss her head back – and then she had this incredible body. And she was a lot of fun, always quite shameless. She didn't care about her trailer-park background; she knew where she wanted to go and she was very honest about it."

*

Although Willie loved what he was doing, fashion itself was always a means to an end. "It was never something I was going to spend my life doing. It had been great but I was getting bored." In the early 1980s, he moved into making commercials, sold his studio in 1985 and put his camera into storage.

"Looking back right now, I think I'm really lucky to have had that time," he says. "Working at *Vogue* was just wonderful. The fashion editors would be fighting over stories in the fashion department and David Bailey would stumble in, or Norman Parkinson. It was just brilliant. It was relaxed, but there was a common endeavour to do something different, better and before its time. And of course there was the kudos of *Vogue*. I got £30 a page, but people were seeing it and talking about it. It was a lot of fun."

"Working at *Vogue* was just wonderful. The fashion editors would be fighting over stories in the fashion department and David Bailey would stumble in, or Norman Parkinson. It was just brilliant. It was relaxed, but there was a common endeavour to do something different, better and before its time."

Lip service: Willie Christie's exquisite lighting lent itself to beauty photography perfectly. 1974.

WILLIE CHRISTIE

barbara

Founder, Biba

hulanicki

Barbara Hulanicki was inspired by her aunt to create Biba's
dark smudgy colours of olive, mushroom and aubergine.
They became an instant hit in London in the late 1960s.

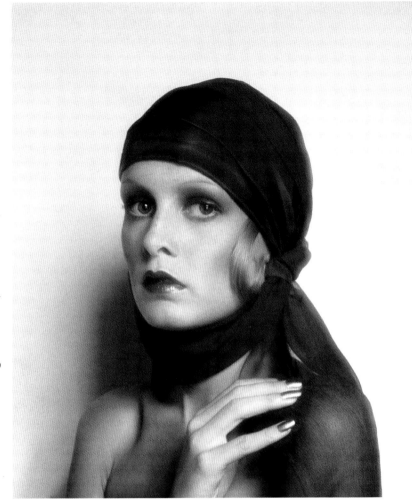

Biba was all about matching your colours: Twiggy wearing a purple headscarf with matching shades of lipstick and nail polish.

When Barbara Hulanicki and her husband Stephen Fitz-Simon, known as Fitz, designed a pink gingham dress inspired by Brigitte Bardot for the mail-order page of the *Daily Mirror* newspaper, little did they know that they would go on to the become the most sought-after and influential fashion brand of the time.

"It happened just by chance," **explains Barbara.** "I was working in fashion illustration in the mid 1960s and going to all these stuffy shows with ladies who lunch, and it was just so boring. It wasn't for young people at all. When I met my husband Fitz – who worked in advertising – he suggested that I went back to fashion design, which I had studied at Brighton College."

Barbara and Fitz created a catalogue that was different to anything else. "Catalogues were awful and cheesy, like the big fat ones from Littlewoods," **remembers Barbara.** "I did illustrations of our clothes that we had manufactured in the East End of London, and created this beautiful catalogue. The press loved it and used the drawings for their pages. We'd been doing this for quite a while, and were getting about 200 orders, but we weren't making any money. We'd had enough."

Out of the blue came a phone call from Felicity Greene, fashion editor at the *Daily Mirror*. "I was terrified of her at the best of times, but she called and said, 'I want a dress,' so I went to her office and designed a dress for her there and then. Brigitte Bardot was wearing a lot of gingham at the time, so I suggested gingham. 'Oh great, fantastic,' she said. Pink? 'Yes.' And then she added, 'I want it for 25 shillings [the equivalent of £1.25]. I said, 'Of course.' The look on Fitz's face – he never let me agree to a price ever again.

"And then we forgot about it; we thought nothing would come of it. Suddenly, there were 17,000 orders and we had to produce all these dresses. Sack-loads of postal orders arrived and we didn't have an office, so we were sorting them out in saucepans in our kitchen. It wasn't funny, it was terrible. And then we had to go and change them for cash. When we took the sacks to the bank, they just threw us out, despite having thousands of pounds, so we went to the one across the road. We had no idea what we were doing. We were just stumbling along."

*

Initially, Barbara and Fitz had no knowledge of fabrics or production, and because there were very few young designers doing what they were doing, suppliers and manufacturers were hard to find. However, fed up with storing their stock in a basement, Barbara came across a beautiful if not a bit dilapidated Victorian chemist in Abingdon Road, West London, still stocked with all its gold-painted medicine bottles. They paid £25 for one week so that they could hold the stock there. "One Saturday, Fitz was collecting more stuff from the factory and I left the door open while I popped to the loo," **explains Barbara.** "Suddenly, the whole place filled up with girls trying everything on. It was a complete fairy story, the whole thing." **By the time Fitz returned, the shop was empty.**

Barbara toyed with the idea of opening a boutique, but she didn't want to be a shopkeeper. "It wasn't exactly glamorous, but in the end, we decided to just fill it up with vintage furniture and put some handstands out. We took on a fabulous, extremely posh girl, Sarah Plunkett, and two fantastic Biba dollies, Irene and Eleanor, from the despatch department at Harrods, both with long, long hair

and blonde fringes. We only needed one, but they came as a pair, so we took them both." **The shop was called Biba.**

Inspired by Barbara's aunt, Biba's dark smudgy colours of olive, mushroom and aubergine became an instant hit. "As children, we had to dress correctly, especially for Sunday lunch, and I had to wear these sludgy crêpe dresses," **explains Barbara.** "But it worked in the English light, you see. These sludgy shades were quite bright in that awful grey light and nobody was wearing bright colours at the time – it was considered a bit tacky and cheap."

Biba's success was down to the fact that Barbara gave her customers what they wanted. Young, girly shapes in just one size, with tights and accessories to match, and constantly changing stock. Once it was gone, it was gone. Biba created a new, frenzied kind of shopping for young women, a far cry from reluctant shopping trips with their mothers. As the *Evening Standard* put it, Biba was a "place of pilgrimage for office girls seeking refuge from the dull dreary department store offerings". The price was also key. "The average girl was earning £9 a week, she paid £3 for her bedsit, she didn't eat, she spent £3 at Biba and went dancing," **says Barbara.**

But it wasn't just the office girls who were flocking to Biba. Models, rock stars and actresses all wanted a taste, including Sonny and Cher, the Beatles, Mick Jagger, Jean Shrimpton, Twiggy and Barbra Streisand – even Brigitte Bardot, who was happy to prance around the corridor in nothing but her underwear.

"We had no competition. We were fast, we became well organized, and our prices were ridiculously low. I had a sample room which grew and grew, and we tested everything in there. We bought our fabric in bulk and dyed it into 10 or 12 colours. I kept finding these amazing fabrics at [department store] Pontings, which back then was a smelly old store with an incredible room full of old fabrics in 'aunty' colours. Our manufacturer would copy them in viscose and we'd add our own prints."

Biba would often sell out of stock by midday, especially at the weekend, while they were waiting for the next lorryload to arrive from the East End. "It was all done by word of mouth. We never went out of our way to say that new boots or dresses were in, but they would just know about it," **says Barbara.** "I never understood how it got round so fast. They would know what was being delivered and when. And on a Monday morning, we would be so low on stock that some [shoppers] would sit there and wait. It was amazing."

Ask anyone what they remember most about Biba and chances are they will say boots. "I told Fitz that I had to have these tight boots with a zip just up to the knee. He wasn't keen because they mount up to a lot of money if they don't sell. I nagged him until he gave in and I finally got my first 100 pairs – which sounds like a lot, but across 10 colours it wasn't. They went in a flash.

"We were using practically every factory in England. The deliveries were literally coming in by the hour and there was always a queue. Girls would come back for another colour the next day. They would

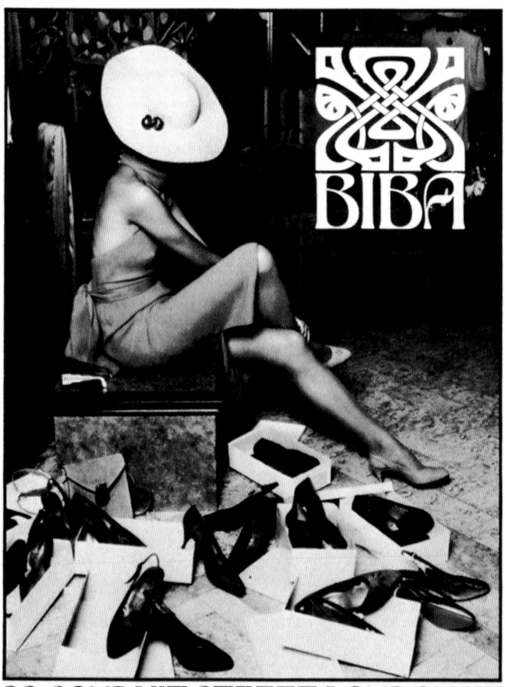

22 CONDUIT STREET LONDON W1

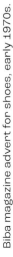

BARBARA HULANICKI

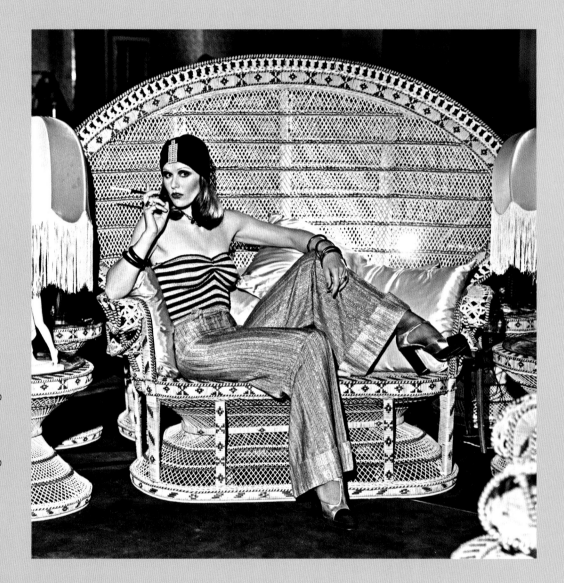

Wicker peacock chairs, lampshades and cushions were just some
of the home accessories available at Big Biba during the 1970s.

throw the boxes outside the shop, piles and piles of them, and other manufacturers used to come in the evenings and count them to see what we had sold. The boots had rubber soles and used to stink by the end of the day, so you'd have to put them on the windowsill at night. We sold 75,000 pairs of boots in three months."

*

In September 1973, Biba moved into the old Derry & Toms department store on Kensington High Street. "It was just down the road from us and I heard that they were going to demolish it. It was the most perfect example of art deco, which the British weren't into in those days – they thought it was really cheesy." **Barbara took Fitz to have a look at its famous roof garden, which had been left to wrack and ruin, and she fell in love instantly. She told Fitz they had to get it.** "And he did, in about three hours. Things like that happened then. They were fairy-tale times."

The new Biba was six floors and 400,000 square feet of shopping utopia. In addition to clothes, accessories and cosmetics, there was a record department with listening booths; a casbah area with Moroccan and Turkish finds that Barbara and Fitz had picked up on their travels; Egyptian changing rooms; the Mistress Room with long satin gloves, négligées and edible underwear; a children's area with a record-player roundabout and a section for early teens that was called, disturbingly, Lolita; a pet department, food hall and a home and décor section.

"Home was huge, especially wallpaper and paint, because nobody else was doing it," **says Barbara.** "We did all our paints in the same 'aunty' colours as the clothes, as well as black." **Everything you could possibly need to achieve the Biba look was available to buy, from leopard-print lampshades and toilet-shaped ashtrays to crockery – and even washing machines.**

The art deco Rainbow Room restaurant on the top floor was the pièce de résistance with its pink marble floors, neon rainbow lighting and tones of pink, peach and beige. Based on La Coupole in Paris, it was open until 2 a.m. and aimed to draw the party crowd. It also became a venue for concerts including shows by David Bowie, New York Dolls, the Pointer Sisters, the Manhattan Transfer, Bay City Rollers and the Kinks.

One of Barbara's favourite parts of the new store was the roof garden. It was the place to waft around in your Biba outfits and be seen. "I wanted

❝We were using practically every factory in England. The deliveries were literally coming in by the hour and there was always a queue. Girls would come back for another colour the next day.❞

BARBARA HULANICKI

The roof gardens at Big Biba were the place to waft around in your Biba outfits and be seen.

to try and preserve it all, even the incredible art deco loos," **she remembers.** "Everything was working, the river was running, there were one or two live flamingos left that looked really bad-tempered and they weren't pink." **After a trip to the zoo with her baby son, she was struck by how wonderful the penguins looked and thought she could have uniforms for the staff to look like penguins. But she didn't stop there.**

"We had the penguins, too – but they didn't like it up there. There was water, but they need very clear, cold water and it had earth in it, so they decided they'd had enough and marched off to the Rainbow Room. There were 12 to 15 of them and everybody was terrified of touching them because they were nasty and they bite. Fortunately, we were able to swap them for our flamingos, but they're horrible too, absolutely horrible. We had to give them special food to keep them pink, they stick together in little clusters and go for you if they feel threatened. We had to have signs saying 'Beware of the Flamingos'."

*

Just four months after Big Biba opened, high interest rates, inflation, reduced fuel supplies and power cuts led to the Three-Day Week in January 1974. The country was in economic turmoil and while Biba limped along by dimming the lights and turning down the heating it was British Land, who owned the majority share of Biba at the time, who suffered the most. When their shares dropped and the huge profits they expected weren't flowing, they screeched on the brakes and gradually ran Biba into the ground. Fluorescent lights and wire racks replaced the vintage lamps and hatstands, the glossy black cups and saucers in the Rainbow Room were discarded for paper cups and Barbara was shut out of the store that she had poured her life into.

On 19 September 1975, Biba closed its doors for the last time. "The reason Biba had worked so well was because, until near the end, we didn't have accountants breathing down our necks, but the figures people killed it," **says Barbara. And Biba's legacy?** "To tell you the truth, during the whole time of Biba, I rarely heard anything nice. It was nothing but complaints until we closed. Then, one day, this woman came up to me and she was in tears. I said, 'What's the matter with you?' and she replied, 'What am I going to do with my life? I won't be able to get the tights that match the dress.'"

❝Then, one day, this woman came up to me and she was in tears. I said, 'What's the matter with you?' and she replied, "What am I going to do with my life? I won't be able to get the tights that match the dress.**❞**

Twiggy photographed in Biba's famous Rainbow Room, which had seen the likes of David Bowie, Roxy Music and the New York Dolls perform.

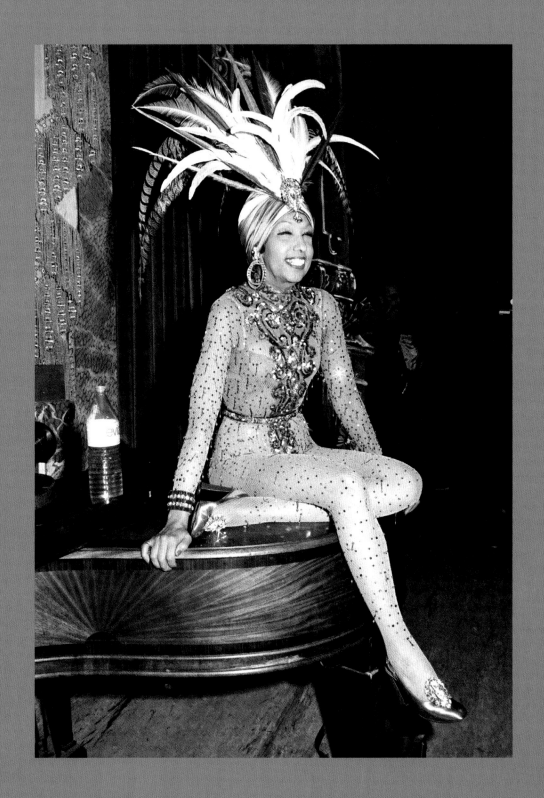

"the battle

Chris Royer and Pat Cleveland Models

of versailles"

Josephine Baker was part of the French star-studded
segment of the "Battle of Versailles" in November 1973.

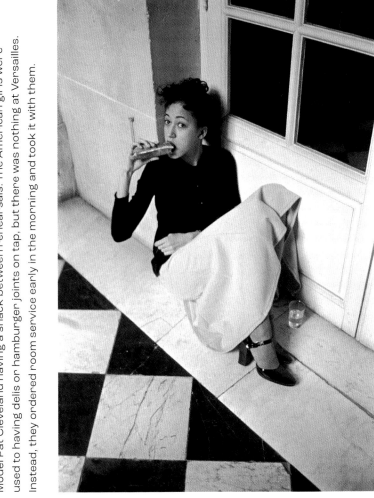

Model Pat Cleveland having a snack between rehearsals. The American girls were used to having delis or hamburger joints on tap, but there was nothing at Versailles. Instead, they ordered room service early in the morning and took it with them.

Among the marble walls, ornate ceilings, twinkling chandeliers and gilded statues, it was cramped, cold and damp. The window frames were rotting, pieces of the parquet floor were missing and the door handles were broken. There was no toilet paper, food or water.

It's no wonder that socialite Eleanor Lambert's 1973 fashion spectacle became famously known as the "Battle of Versailles". But the real battle was between the Americans and the French – and it went on to change fashion as we know it today.

"I don't know how one little show could get so much publicity," **says Pat Cleveland, one of the models who took part in the show.** "We just went over there to go to a party and to help fix the leaky roof of an old building. But that old building was important because it represented an era that everybody was interested in, it was so royal and steeped in history, the complete opposite to America."

What was the "Battle of Versailles"? The Palace of Versailles, King Louis XIV's former home 12 miles west of Paris, was falling to wrack and ruin, and something had to be done to save it. Legendary fashion publicist Eleanor Lambert, who was responsible for New York Fashion Week and the Met Gala, among other events, saw an opportunity. She was going to create an extravaganza that not only raised funds for the dilapidated building but also showcased American fashion designers. Until then, they had been thought of as copycats and were not taken seriously by their French counterparts, who saw themselves as the leaders of fashion.

She would pit Halston, Bill Blass, Anne Klein, Stephen Burrows and Oscar de la Renta against Yves Saint Laurent, Hubert de Givenchy, Pierre Cardin, Emanuel Ungaro and Christian Dior's Marc Bohan. From the word go, the Americans were seen as the underdogs. But all that was about to change.

*

Three days before the show, 36 American models descended on Paris. You could say it was an American Revolution of sorts – 11 of the 36 girls were African American, and this was something completely new to Europe, especially to the French. But the next three days were not easy for the Americans.

"We stayed at a hotel on the outskirts of Paris, and it took us so long to get to Versailles," **remembers model Chris Royer.** "We would get up very early to get on the bus and get back very late, but Versailles was truly magical. Even though it looked a little haunted and was in total disrepair, it was beautiful. You definitely knew this was going to be something fabulous."

Not everything went to plan. "When we arrived, it wasn't well organized, the French were taking up all the rehearsal time in the theatre and nobody was directing us. We were given rooms for the clothing, but the one for Halston was so far away from everything. He was furious, as each girl would be wearing two outfits – each designer only had a six-minute slot – so regardless of how fast we dressed, it would take us too long to get to the theatre, so we just pulled the racks down so they were near the stage. There were a lot of us, too – we had seamstresses for sewing and fixing things, to make sure everything was perfect, and Halston alone brought four or five assistants.

"Nothing had been provided for us. There was no toilet paper, and nowhere to get anything to eat, certainly not the delis or hamburger places we were used to. There was nothing, so we'd order

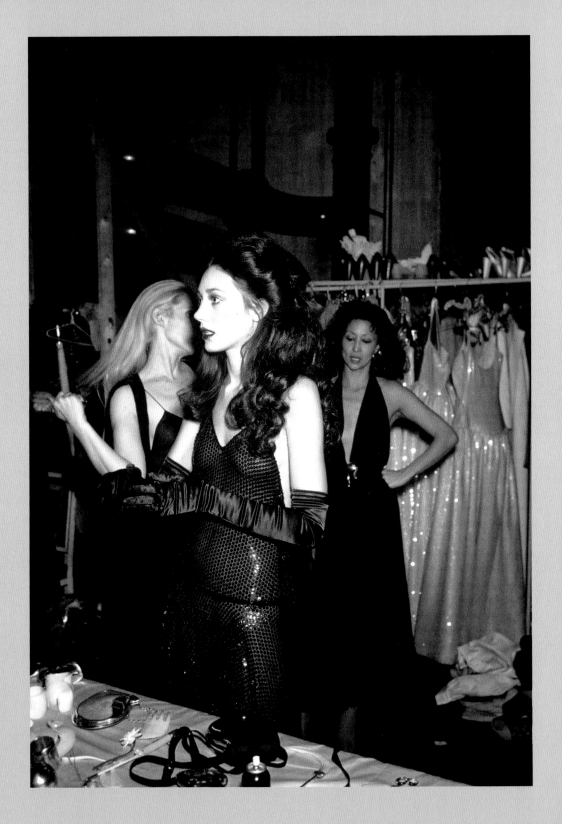

Model Marisa Berenson behind the scenes.

room service very early in the morning, drink the coffee and take all the croissants with us. It was also so damp and cold, and on top of that, it snowed. Everybody was frustrated, but we fought it out."

<center>*</center>

Within the glittering audience sat Princess Grace of Monaco, Elizabeth Taylor, Andy Warhol and Christina Onassis, among others, and the evening was hosted by Marie-Hélène de Rothschild. The French appeared to have it all, with a two-and-a-half-hour performance featuring Josephine Baker, Rudolf Nureyev and Jane Birkin. "The French had everything," **remembers Chris.** "Pierre Cardin had a spaceship, Dior a Cinderella pumpkin carriage, Yves Saint Laurent had crazy dancing horses – it was all so over the top."

In comparison, the Americans' 30-minute slot could not have been more different. There were no elaborate sets. Instead, they used dramatic lighting and music – and Liza Minnelli, Halston's closest friend, who had recently won an Oscar for *Cabaret*. "It was just us, the lights and music," **says Chris.** "In the opening act, we all wore assorted rain gear with umbrellas, and Liza opened the show with [her song] 'Bonjour Paris!'.

"The girls knew how to walk and how to turn, and they were familiar with the music; they were professionals. It gave us more of an edgy sparkle that the French perhaps didn't know about, so when they saw our American style combined with very hip music, such as Barry White and Al Green, it was incredible. During the finale, the audience started screaming and throwing their programmes in the air, it was fabulous."

Halston's set was one of the most memorable for Chris: "I opened the segment with Elsa Peretti and we had the music from the film *The Damned*. Elsa wore a white silk jersey dress and I wore one that appeared to be white. We were positioned back-to-back, and as the music started, we turned, and as I did so, you could see that my dress was in fact a split of black and white, not just white. I held a very long Elsa Peretti cigarette holder and Elsa was gazing into a beautiful clam shell compact – it was gorgeous. Each girl was hit by a spotlight and then she would turn and walk out of the light, as if drifting into the night, and the light would search for another girl. It was quite stunning.

"My other outfit was the glass princess dress in very light silk organza with a touch of green in it. Over the top was a layer of glacé piette sequins, so the dress twinkled. From a distance, it was just so sheer and shimmery. I had to twirl like a glass figurine; Halston wanted it to look like when you open a little charm jewellery box and the ballerina turns to the music. "Sadly, it was the one dress that disappeared. As fitting models, we were allowed to choose one of the dresses or have something made for us, for contributing to the show. I wanted that dress and Halston thought it was perfect, but it disappeared and we couldn't find it. When we got back to New York, it was just gone."

A lavish midnight buffet ended the star-studded evening. "It was like a fairy tale," **says Chris.** "I was wearing my fairy princess dress as we floated through the magnificent Hall of Mirrors and it was magical, everything just lit by candlelight. We met Yves Saint Laurent and Loulou de la Falaise, and the French were just fabulous."

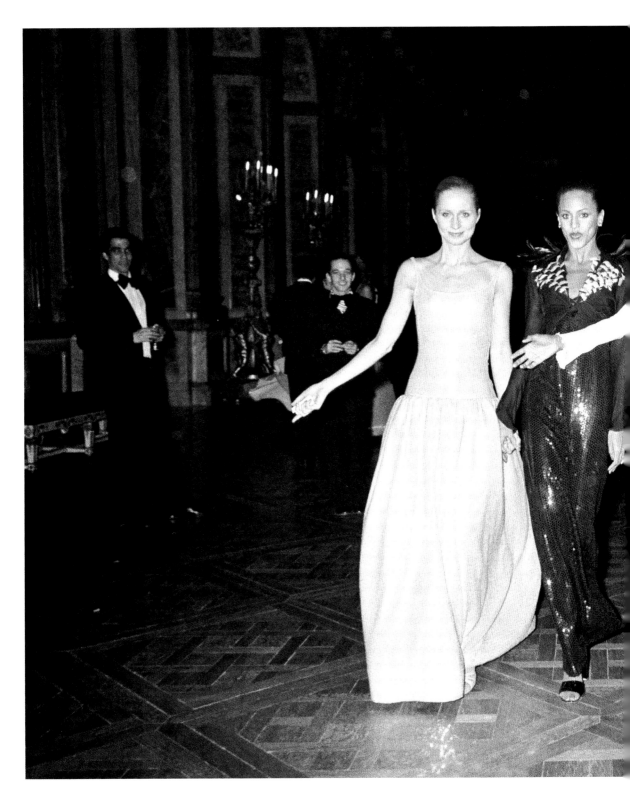

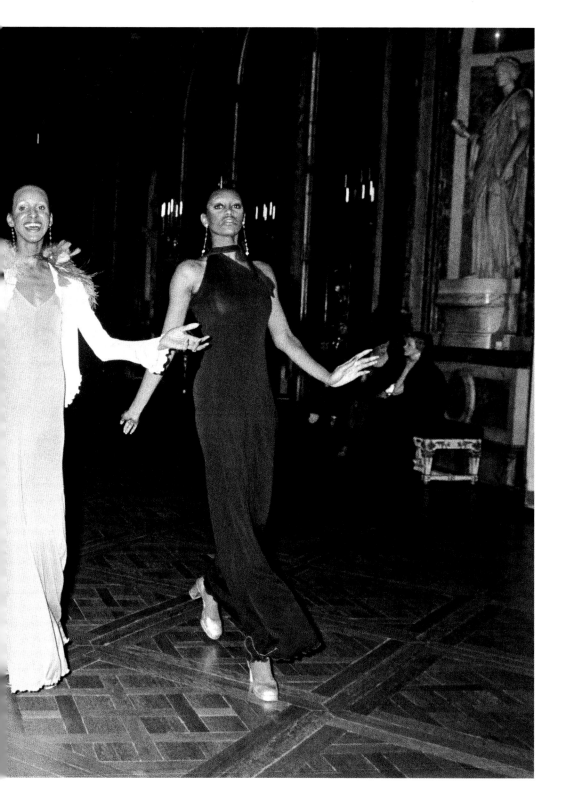

Models Chris Royer, Alva Chinn, Barbara Jackson and Amina Warsuma in the famous Hall of Mirrors at Versailles.

"THE BATTLE OF VERSAILLES"

It made an impact on Pat Cleveland too. "It was a huge event for us to be in a palace with royals, and all the spectacle of chandeliers and cherubs dancing on the ceilings. Everything was lit in the old-fashioned way, just candelabras, and there were beautiful boys dressed in satin pants with white tights and gloves, powdered wigs and tailcoats with embroidery. Oh my god, it was so divine.

"We were there with anybody who was anybody from high society and you could just imagine the pumpkin turning up for us and turning into a chariot. The Black models were linking arms and walking down the Hall of Mirrors. They looked like the Supremes. I was with Hubert de Givenchy, who was holding my arm, and we were talking and looking at ourselves in the mirrors and he was so excited. 'Look, we're in the Hall of Mirrors and we're together,' he said. It was lovely."

*

There was no doubt who were the stars of the night. The following day, the headline for *Women's Wear Daily*, the bible of the fashion industry, read: "Americans came, they sewed, they conquered."

"There was a real unity amongst us to really show what we could do," **says Chris.** "After hearing about the floats and boats on the French side, we were like, 'Okay, we have great clothes and we have our great music and we're gonna show them our style. Period.' It really was good old American showmanship. At the same time, we couldn't help but be affected by the magic of Versailles. You could feel how romantic and glamorous it must have been, and the French made the evening so beautiful."

For Chris and the American contingent, it was an honour to be part of the French spectacle. "We were surrounded by and working with all these incredible people. You could be in the corridor and all of a sudden, Josephine Baker is walking from the ladies' room and you get to speak with her, a legend. And Rudolf Nureyev and so many others that we would never have met otherwise."

The most important factor was that the "Battle of Versailles" left a legacy. "It revolutionized the concept of ready-to-wear, and that was very new to the French," **says Chris.** "They showed couture in their segment, it was all made to order, whereas for the Americans, it was all about Seventh Avenue, clothes that you could actually go to a store and buy off the rack, what they called 'off the hanger'. Anne Klein was also the first designer to show sportswear as well as ready-to-wear, another first. Seventh Avenue was the mecca for fashion in New York at that time and was where the majority of designers established themselves. It was known as the 'fashion row'.

"We got to see what Versailles was about and to contribute to it, but as well as the designers, it was a great opportunity for American models, especially the Black girls. It was a chance for the French to see how fabulous they were, and it opened up a whole new world for models such as Pat Cleveland, Alva Chinn and Billie Blair. It worked both ways, and it was a great opportunity for everybody to be inspired and to enjoy, to bring in the past and the future together."

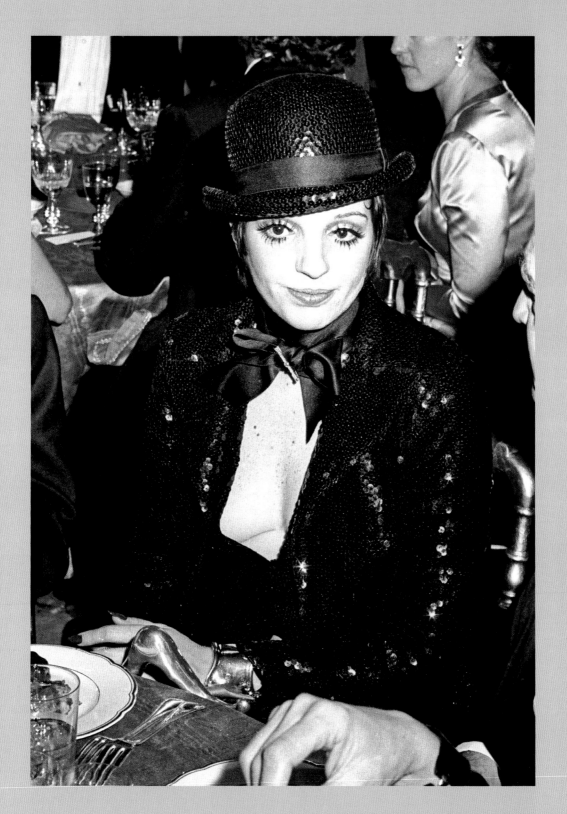

Liza Minnelli was the star of Halston's show at the Battle of Versailles, both opening and closing the set.

Model Chris Royer in Halston's twinkling-glass princess dress made of light organza and glacé piette sequins with a touch of green. It was so sheer that, from a distance, it shimmered.

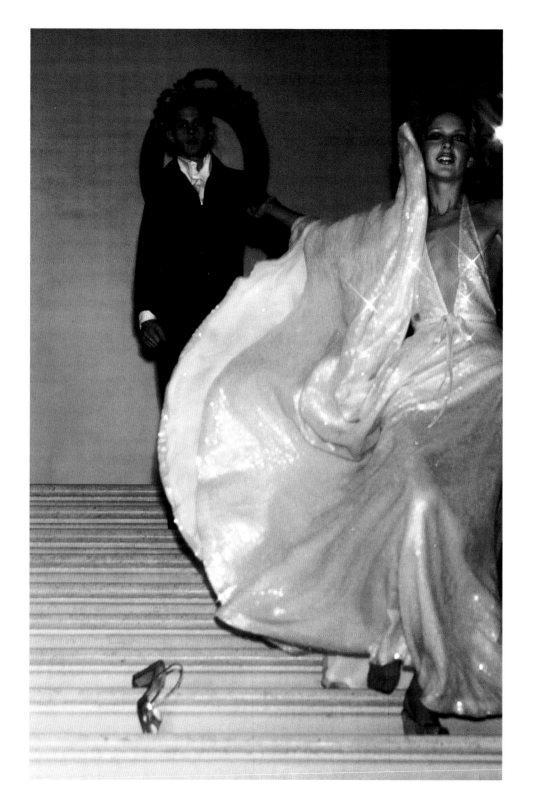

A model losing her shoe on the stairs. The whole evening had an air of Cinderella about it – the French even had a giant pumpkin carriage on stage.

"THE BATTLE OF VERSAILLES"

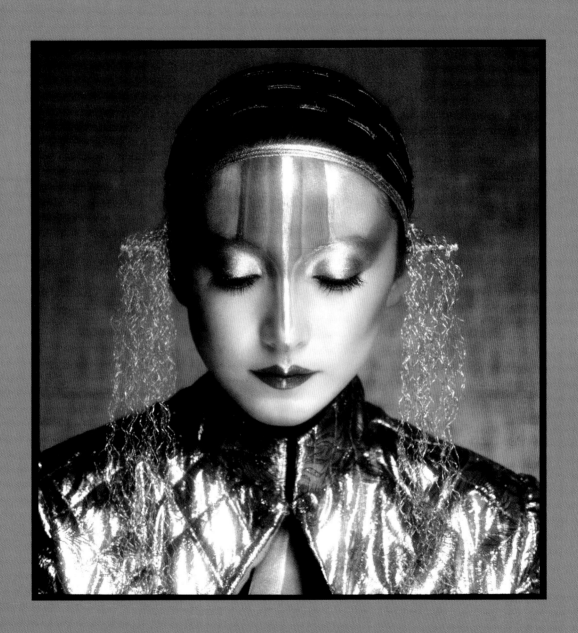

barbara

Make-up Artist

daly

Barbara Daly often worked with photographer Clive Arrowsmith, and they produced some incredible work together, such as this cover for *Harpers & Queen*, January 1979.

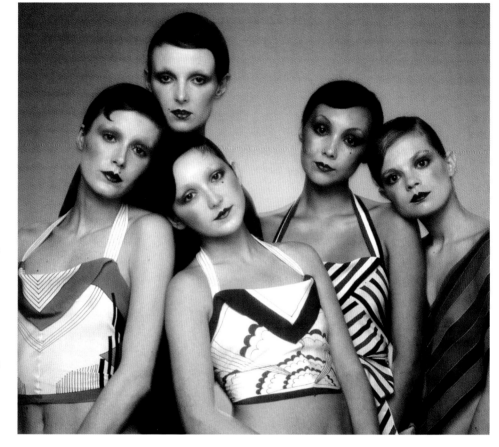

Legendary make-up artist Barbara Daly has made up the faces of every 1970s beauty from Jerry Hall to Marie Helvin and worked with all the great photographers including Norman Parkinson, Helmut Newton, Clive Arrowsmith and Barry Lategan.

She was Princess Diana's make-up artist of choice for her wedding day in 1981, she created the huge eyelashes in Stanley Kubrick's film, *A Clockwork Orange*, and Kate Moss learnt how to do her make-up from her books. In fact, she was one of the first fashion magazine make-up artists.

As an 11-year-old schoolgirl, Barbara knew she wanted to be a make-up artist, despite the fact that no such job existed – fashion models had always done their own make-up. She took a long and fortuitous route via art school in Leeds followed by a trainee job for two years in the make-up department at the BBC. Little did she know she would go on to become one of the most influential make-up artists of all time.

"I had no idea what I was doing. I didn't even know there was no such job," explains Barbara. "I just had in my head that I could probably do this. I'd been doing a bit of moonlighting for commercials on my days off, as my BBC job was so badly paid, and began to build up a mini portfolio – 10 snaps in a plastic pocket – and I thought I'd like to work more in photography. I was fascinated by the way models were looking; in the late 1960s, everybody wanted to look like Jean Shrimpton and looked identical. It was a great look, but everywhere.

"I took my plastic portfolio in to see art directors at various magazines, who just looked at me and didn't understand what it was that I did. I remember one saying to me, 'But why would I pay you?' They could get someone sent from a salon for free or the models would do it themselves. It was very much 'Don't call us, we'll call you.'

"But then a few people started calling me. I began to get one or two little jobs and it built from there – although it took a long time, I hasten to add. I didn't even have a clue what to charge because nobody else was doing it."

Barbara finally got her big break when photographer Barry Lategan booked her for a job that turned out to be for British *Vogue*. It was through Barry that she also met *Vogue*'s fashion director, Grace Coddington. "I'd been trying to get myself going for a couple of years and I was extremely fortunate to meet both Barry and Grace, who were pivotal for me meeting other photographers who would be prepared to take a chance with me," she explains. "Grace used to try and book me with whichever photographer she was working with and she worked with everybody from David Bailey and Norman Parkinson to Helmut Newton. She really was a mentor to me, the first person that picked me up, as it were."

⁂

Barbara developed her own style because there was nobody to compare herself to. "I learnt a lot from watching what the models did on themselves and then I'd refine it and turn it into something else that I was interested in. I also learnt a lot

from photographers. Nobody ever said, 'No, you can't possibly do that.' Whether it was Barry, Clive Arrowsmith, Willie Christie or David Bailey, they were open to ideas even if they seemed crazy – you would just have a go. And sometimes it didn't work. But this is where the genius of a great photographer comes in, because you could think that the make-up isn't working well and you're about to take it all off, and the photographer might look at it and say, 'No, leave it for a minute, let's just see where we go,' and then suddenly, they have a great shot."

For Barbara, it was all about collaboration. "With a good creative team, you bounce off each other. The key for me was to latch on to the photographer's style and really try to understand what they were trying to achieve. For instance, I might be doing a shoot with Barry one day and then Helmut Newton the next or Sarah Moon.

"Helmut always liked a certain look and, invariably, a red lipstick. I knew what he liked and he'd leave me to it. The first time I worked with him I was terrified, but you build a rapport with a photographer, and he was lovely. They all have their own style and a certain way of lighting. Norman Parkinson always used to use a pink sheet, which gave a very soft reflective quality to the light that was warm and beautiful.

"Sarah Moon had an incredible eye, and her imagery is soft but not that soft. Her eye is so unique – I don't think there's anybody else like her. I worked a lot with Hans Feurer for *Nova* magazine and he loved the early morning light, preferably in the tropics. You know what it is that they're going to see

through their lens and so you know what you have to do. It was up to me to get to know what they wanted and provide the imagination and, hopefully, a bit of technical know-how to give them what they expected to see."

But it wasn't just the photographers that had to be happy. Barbara felt very strongly that however fantastical the make-up look, she never wanted the model not to feel beautiful. "If you have a girl that doesn't feel beautiful, however extraordinary she might look, it's not going to be a good picture. I think many people think models just stand in front of the camera, but that's not true. She is absolutely crucial. If I was doing something involving a lot of face-painting and I had a girl that didn't feel good and didn't want to cooperate, we'd end up with a whole different story. The girls were very patient and worked hard, so there was no bulldozing, no bullying and no hysterics."

*

With a career that was in its infancy, Barbara struggled to find professional make-up. As a result, she became accustomed to using a combination of different products and mixing what she needed. And it wasn't always make-up.

"Colour was always a problem because there wasn't a great selection for photo shoots, so I used Caran d'Ache pencils. I used to mix them in with a bit of foundation to create a bright green or turquoise eyeshadow. They probably weren't particularly safe – or maybe they were absolutely fine – but it was all I had at the time."

Barbara Daly was able to be as daring with her make-up as she wished because nobody had gone before her in the world of magazines.

Barbara Daly frequently created her own make-up colours by mixing Caran d'Ache pencils in with a bit of foundation to create a bright green or turquoise eyeshadow.

Sourcing make-up wasn't the only arena in which Barbara had to improvise, as she remembers from one shoot. "You had to be prepared to work the most unearthly hours and long hours because it might always be the last job you ever do. If you have to be on set for 6 a.m. and get yourself to Shepperton or somewhere, and you know you have to get yourself up at 3 a.m. to get yourself there, you just do it.

"The first commercial I ever did was somewhere outside London. I was up at 4 a.m., which wasn't unusual. I can remember getting a train and assumed that I could get a taxi at the station, as I was dragging heavy boxes of kit, but when I got there, there weren't any. It was in the middle of nowhere and the very early hours of the morning. Finally, I saw a milkman on a milk float and asked him how I could get to where I needed to be. He said there were no buses or taxis and told me that it was on his route, so I arrived at my first commercial on a milk float. And I was on time."

Unlike her counterparts in New York, who partied at Studio 54 until the early hours, Barbara loved nothing more than an early night but it wasn't always like that. "During the collections in Rome, we would only work through the night, and we'd probably do a week of this. Thankfully, we were young and got used to having a quick nap under the dress rails. I think some of the best creative work I ever did was at 3 a.m. for Italian *Vogue*.

"The world I worked in included a lot of actors, rock stars and fashion designers, and they used to like to party. Working all the hours I worked, I never went anywhere. I worked all day long and went home, I never went out. I couldn't have done what Sandy Linter did in New York, out every night. I don't know how she did it. I'd be so grateful to get home. I was never good at the social thing."

"But it was fun. Everybody knew everybody, but you had to work hard. You really couldn't pull a number and say you were too tired. I knew that it was a special time, but when you're young and just doing it, that's all there is to it. I was doing what I wanted to do. I didn't know it was so revolutionary at the time – we just didn't think about the future."

66Everybody knew everybody, but you had to work hard. You really couldn't pull a number and say you were too tired. I knew that it was a special time, but when you're young and just doing it, that's all there is to it. I was doing what I wanted to do.**99**

beverly

Model

johnson

Beverly Johnson loved being a model but was shocked to discover that few people understood Black skin and hair. American Vogue, April 1974.

Beverly Johnson was one of the many diverse models who worked with designer Halston in the 1970s. Evening dress by Halston, January 1975.

Beverly Johnson, the daughter of a steel labourer and a nurse, was raised in Buffalo, New York, and was a competitive swimmer. Her goal in life was to achieve straight As at school and win swimming tournaments. Little did she know that she would go on to become the first Black woman to appear on the cover of American *Vogue*, something that would change her life forever.

It all began when she was watching the civil rights protests on her father's black and white television. "Black protesters were being attacked by police dogs, and it was at that moment that I decided I wanted to become a lawyer, to do something. I was 11 or 12 years old. I went to college in Boston and my goal was to become a lawyer or a judge," **remembers Beverly.**

The summer before college started, her mother made her get a seasonal job at a local department store so that she could buy smart clothes for college. "All I had were sweats because I was an athlete, and she said, 'You can't work as a lifeguard this summer, you have to work at the store to get clothes for school.' I was like, 'What?'"

Beverly's manager at the store, Mimi, kept talking to her about being a model. "I said, 'With all due respect, Mimi, I'm going to be a lawyer.' I didn't really know what this modelling thing was, but I knew it wasn't for me. But on my last day at the store, she wrote down a number and said that if I ever changed my mind, I should call this woman."

At college, Beverly taught swimming at the local YWCA part-time and, after her first year, she decided to stay in Boston for the summer and continue working. Out of the blue, her job at the YWCA was cut. "I had no summer job and was freaked out because I'd worked since I was 14 years old," **she says.** "My friends were saying, 'Why don't you just become a model?' 'What was this modelling

thing?' I asked. They literally grabbed a magazine, opened it up and showed me a girl standing with her hands on her hips. 'And they make $75 an hour,' they told me. My father made that in a week. That was the light-bulb moment. I ran back to my room and found the number that Mimi had given me the year before, crumpled up in my plastic wallet. And of course, the rest, as they say, is history."

*

Against her father's wishes, Beverly and her mother headed to New York. She was a teenager and had never been on a plane. "Just looking up at the buildings, walking in the streets and feeling the energy was amazing," **she recalls.** "We met Mimi's friend at another boutique and she made an appointment for us at Condé Nast. We waited all day to be seen, and then they told my mother that they wanted to take me on a 10-day trip to Fire Island on a shoot for *Glamour* magazine. Of course, I then had to convince my father that I wasn't going to become a streetwalker.

"It was such a left turn. I was heading in one direction, very focused, and then everything changed. The cheque from *Glamour* came in for $300 and I had never seen so much money in my life. I was being asked to do other jobs too, so I moved to New York. I started studying at Brooklyn College at night – I couldn't give up my dream, I had to finish what I'd started." Beverly was signed by Ford Modelling Agency and fell in love with

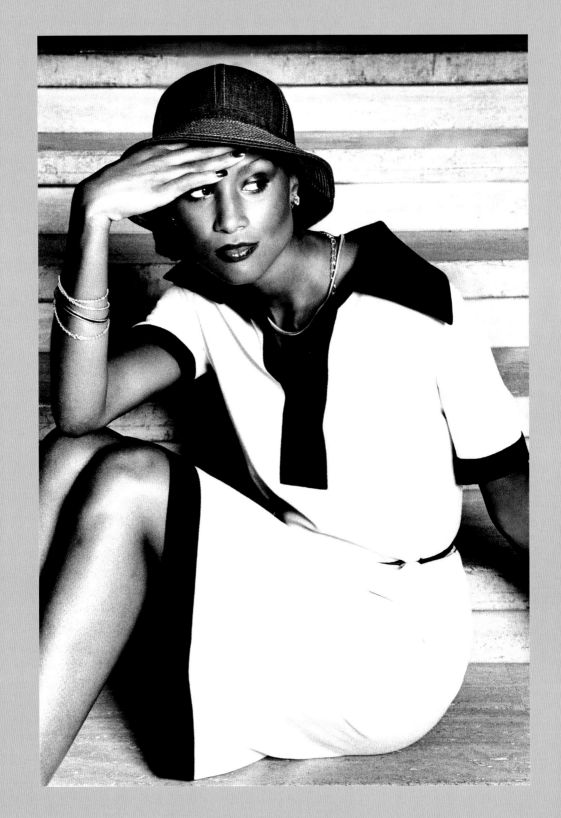

After Beverly Johnson appeared on the cover of American Vogue in August 1974, suddenly Black was beautiful and everybody wanted to be a part of it.

New York. "The city was just contagious – it was so vibrant and alive and gave me an introduction to the whole world of arts, from opera and ballet to the theatre. It was just amazing."

Beverly loved being a Black model. "It was incredible, it was James Brown, it was 'I'm Black and I'm Proud', it was *Shaft*. Girls had Afros. We had come out of the 1960s and we thought we'd overcome the prejudice. There were a lot of Black models, as well as Black modelling agencies."

However, behind the scenes there was very little diversity, and Beverly was shocked. "There were a lot of Black hairdressers and beauty salons in the city, but whenever I worked for *Glamour* or *Vogue*, I was the only Black person on set. There was always a white hairdresser and white make-up artist who knew nothing about Black hair and skin. I always slicked my hair back into a ponytail or chignon because it was easy and they didn't have to do up my hair, so I passed the hair problem. But when it came to make-up, they just didn't have the right make-up for it. I generally made up my own by using a mixture of baby oil and iodine to bring out the redness in my skin, mascara and a little lip gloss."

But this was about to change. "I was on a shoot for *Glamour* and when the make-up artist arrived, he was shaking," **remembers Beverly.** "He was dressed head-to-toe in leather and was high. There was no way I was going to let this guy use an eye pencil under my eyes, and so I spoke to the editor. She said he was all we had. I knew of make-up artists that were Black and really talented, so I said that I knew of this one who might be available (I knew he would

be, all Black make-up artists were available). It was Joey Mills, the first Black make-up artist. He arrived, so flamboyant, and he was so good. He went on to become so famous and worked with the best girls in the world."

*

Beverly had lost none of her competitive edge, and her next goal was to become a top model, one of the best. She was already working for *Vogue*, but she knew that the pinnacle of any model's career was that all-important *Vogue* cover. She went to see her agent, Eileen Ford, and told her that she wanted to sign a cosmetic contract, to write a beauty book, and to be on the cover of *Vogue*.
"The cover was one step too far for her," explains Beverly. "I don't believe she said it out of any kind of hostility. I think it was just the facts as she knew them. 'You'll never be on the cover of *Vogue*,' she said, and when Eileen said something, she meant it. That's when I realized that I wasn't going to get the cover through her."

Wilhelmina Cooper, one of Ford's most famous models, had started up her own agency, and she agreed to help Beverly get her cover. "You never knew when a picture, usually from a beauty shoot, was going to end up on the cover," **she explains.** "I was on a *Vogue* shoot with photographer Francesco Scavullo. They were always very intense and you

OVERLEAF: Beverly Johnson worked regularly for *Glamour* and *Vogue* magazines, and is seen here in a Calvin Klein jumpsuit. American *Vogue*, November 1975.

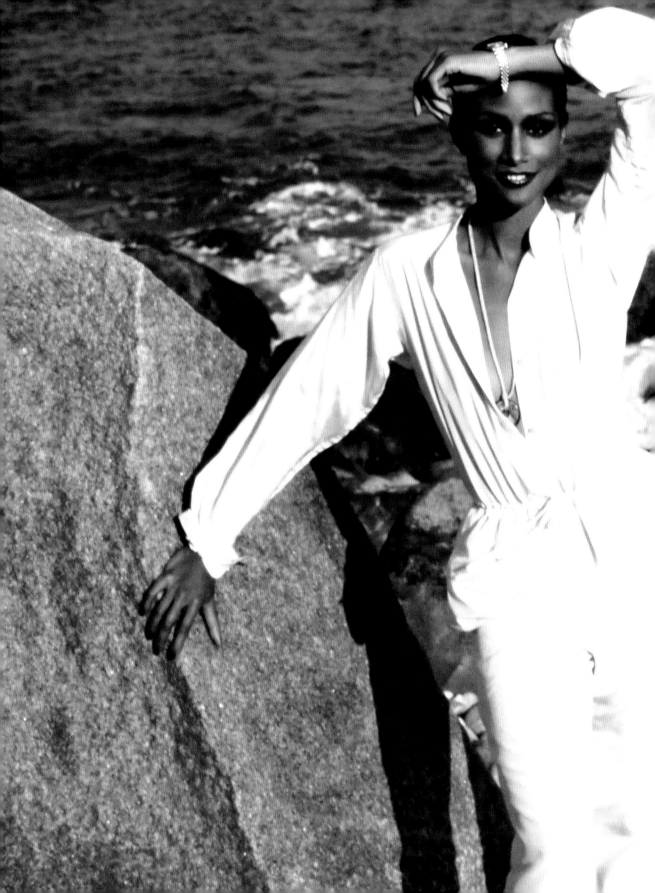

were working with the best of the best. Make-up artist Way Bandy was taking three hours to do the make-up with a Q-tip and I was holding as still as I could for him while hairstylist Suga was working on my hair. I'll never forget how many times the fashion editor took the scarf off my neck and tied it – if it was 100 times, it was 150 times. I just stood there with the patience of Job and let her do whatever she had to do.

"All shoots with Francesco were wonderful and very beautiful, but it felt special in the sense that he was very animated that day while he was taking the pictures. The big white studio – even the floors were white, with one huge light and me performing. Looking back on it, it was a very special day."

A few months later, Beverly got a call from Wilhelmina. "She never used to call, it was always an assistant," **she explains.** "She said, 'You got the cover.' 'The cover of what?' I asked. 'The cover of *Vogue*. It's on the newsstand now.' She couldn't make that call until it was physically on the newsstand, because you could always be bumped for another one at the last minute." **It was August 1974 and, at last, Beverly had her *Vogue* cover.**

"I have never, except for the birth of my daughter, been that excited. I had won lots of medals and trophies, a lot of different things have happened to me in my life, but I had never been as excited as I was that day. It blew my mind. I rushed to the newsstand and when I saw it, it was beautiful. I had left my apartment without my purse and was trying to explain that I lived just around the corner, that

I'd be right back, but could I take the magazine because I was on the cover. The newsstand seller was having none of it. I can remember calling my mother and screaming down the phone. I could hardly sleep that night, waking up every hour to turn on the light and look at the magazine. *Yep, I did it.* At that moment, I didn't think it could get any better. But it did. It got better and it got worse."

*

Slowly, Beverly began to realize the importance of what had happened and the impact of being the first Black woman on the cover of American *Vogue*. But despite the jobs pouring in, there was a problem. "I didn't really have a handle on racism. I thought it was something we had overcome in the 1960s, but I was young and naïve. Up until then, I'd always been on set with white models who were my friends. They were always supportive, saying how great my *Glamour* covers and spreads were. But showing up at the studio, they were all sitting at the make-up mirrors and when I said 'Hi', there was complete silence. No one spoke to me. I couldn't believe it could be about the *Vogue* cover, it just couldn't be. But nobody mentioned it, not even the photographer.

"I could understand it to a point – it was a competitive world, it's human nature. But the white models? They were on the cover all the time and I had just got the one. Were they thinking, 'Who does she think she is?' Was it a privilege that they thought was unique to them? It made me think about race and what did this cover actually mean, not only to me but to Black women around the world."

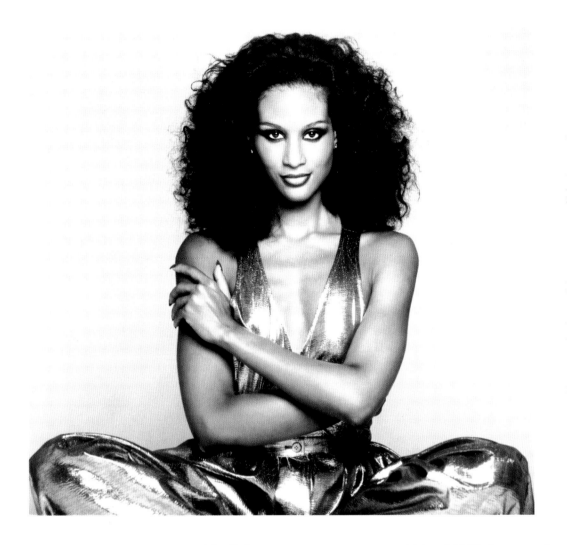

Beverly Johnson loved being a Black model. "It was incredible, it was James Brown, it was 'I'm Black and I'm Proud', it was Shaft. Girls had Afros."

On the plus side, a Black face had finally been accepted in the fashion industry at the highest level: *Vogue*, the fashion bible. Suddenly, Black was beautiful, and advertisers wanted to be a part of it. "Gradually, everyone got used to it," says Beverly. "I did more covers and exploded on to the scene. After a while, people just accepted."

Despite striving so hard to achieve that cover, the next Black model to appear on the cover of American *Vogue* wasn't for another three years, in 1977. Between 2000 and 2005, three out of 81 models on the cover were Black. In 2018, Beyoncé insisted that Black photographer Tyler Mitchell shoot her cover for the September issue, making him the first Black photographer to shoot a *Vogue* cover in its 125-year history. Nearly 50 years on, there is clearly a long way to go. Beverly is at the helm, still modelling and still pushing for more Black models, photographers, hairstylists and make-up artists behind the scenes, and rightly so.

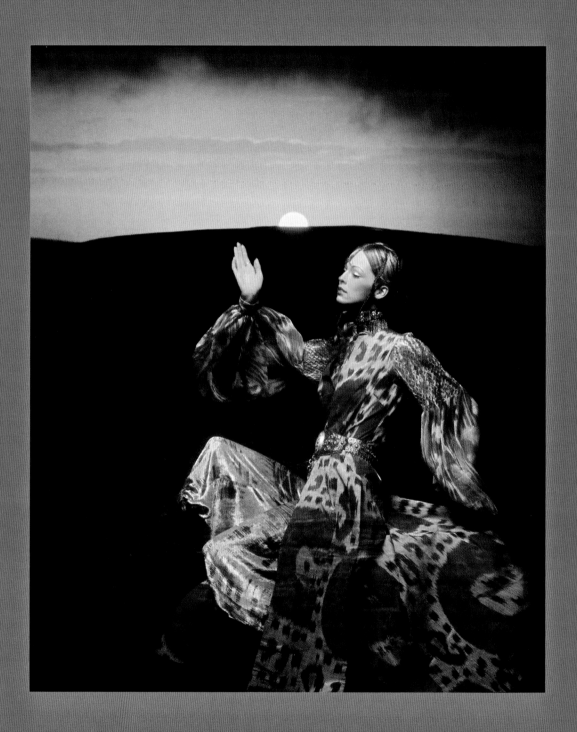

thea

Designer

porter

Model Ann Schaufuss wearing a Thea Porter
antique ikat tunic. In British Vogue, December 1970.

Scribbled notes and sketches on the back of a Thea Porter envelope.

As a child, Venetia Porter spent many school holidays in her mother Thea's Greek Street shop in the heart of London's Soho. It had formerly been a Chinese restaurant with a sex worker living upstairs, and Thea Porter had transformed it into a treasure trove of luscious furnishing fabrics, huge embroidered cushions, pearl-encrusted Ottoman furniture, lavish wall hangings and incense burners.

Thea's passion for the fabrics, clothes, scents and colours of the Arab world came from growing up in 1930s Damascus, Syria. "That's often what's been said of her, she had that real authenticity from her upbringing," explains her daughter Venetia. "She often used to talk about wandering around the Damascus souk in the trail of her mother. To see her with fabrics was something absolutely extraordinary, and she kept every single scrap. She had them all in a big chest. So when it came to making her abayas, she'd go to it and pull something out."

The first dress Thea made was copied from a pretty embroidered wedding kaftan she found in Aleppo, along with Turkish waistcoats stiff with gold braid, which pushed up the bosom like a corset. But Thea couldn't actually sew. "She worked incredibly closely with a number of outworkers and it just evolved," remembers Venetia.

"It all began with Julie Christie coming into the shop to buy a pair of curtains and asking for a dress in the same fabric. She started with Syrian or Ottoman dresses that she cut up and changed a little, or she might add organza sleeves. None of her clothes were tailored and this was completely new. Her 'gypsy' dress was very fitted on the bust, but the abayas and kaftans weren't, and that was the joy of them. It was a very different kind of aesthetic for the time."

Hazel Collins, one of Thea's favourite models and her muse, remembers the Greek Street shop well: "It was like walking into a movie set from the 1930s. The shop was like a sitting room, every item was beautiful and there was this marvellous smell of incense. There was black and burgundy velvet on the walls, exquisite gold and crystal mirrors and all these wonderful sheer fabrics. It was as if Thea would just put some pins in the fabric and a dress would appear.

"She had these long beaded curtains in the doorways, but they weren't ordinary. They were made of beautiful crystals and made the most beautiful sound when somebody approached. I remember one day, standing on a stool while having a dress pinned on me, when Elizabeth Taylor walked in. Those eyes through the crystal curtain – it was as if she could see right inside you, and they were the colour of lavender. Thea didn't bat an eyelid."

*

Elizabeth Taylor, Faye Dunaway, Julie Christie, Bianca Jagger, Lauren Bacall, Joan Collins and Barbra Streisand all visited that tiny shop. Venetia didn't go without her fair share of "gypsy" dresses either. "They were amazing to wear, but I was very blasé about it when I was 16 and 17. I used to go to parties, and they were incredible to dance in because there were yards and yards of fabric and you could twirl around and feel great – as they were also so fitted in the bodice – and you felt completely secure."

Before Thea left Damascus, she had trained as an artist and was constantly visiting exhibitions and bookshops for inspiration. "On Saturdays, we'd have lunch in Soho and then she'd raid the till, take all the cash and we'd go to this fantastic art shop and she'd buy beautiful books on Japanese kimonos, symbolist painters or Ottoman textiles. She would

draw sleeves she saw in paintings and adored Proust (Jocely) and Fortuny (Mariano)," **Venetia remembers.**

"The thing about my mother is that she had such incredible taste; literally everything was perfect. The shop, the window, the chaise longue at the front – it was just effortless. There was nothing gaudy about it, it was all just beautiful."

Venetia loved hanging out at the shop but was not really aware of how the business was always hanging by a thread. As talented and creative as Thea was, she had no head for business. "It was fun and everyone who worked there was so nice. There'd be lunch from the local Turkish restaurant, followed by coffee, and my mother would be working in the back. But she was always struggling with the bills. In fact, I think it was bad right from the beginning. It was always very hand to mouth. She would sell a dress and pay a bill. Or if she didn't pay a bill, she'd buy more art books or take people out to lunch.

"I remember being there during the Three-Day Week and there were candles in the shop and it was such a lovely atmosphere. Somehow, everyone managed to keep on going partly because Thea was so funny. She had such a lovely way with people, always so polite and kind with a wicked sense of humour. She could be very opinionated but she had so much energy and she never stopped working. She, her work and her clothes were one."

*

When things finally started going well in London, Thea opened a shop in Paris. "She loved Paris, but it was a drain on the business because all the energy was going into it," **explains Venetia.** "She would be endlessly taking suitcases of clothes between London and Paris, and it was exhausting. The Paris shop never really took off; her style wasn't very French. Some people loved it, but it wasn't enough."

In 1979, the Paris shop closed. And, as if that wasn't enough, in 1981, the landlord of the Greek Street shop increased the rent from £3,000 to £35,000 a year. "It became really horrible for Thea in the 1980s, the worst moment being when she had to leave Greek Street. The rent went up – it happened everywhere – the bank refused to help anymore, and she was declared bankrupt.

❝The thing about my mother is that she had such incredible taste; literally everything was perfect. The shop, the window, the chaise longue at the front — it was just effortless.❞

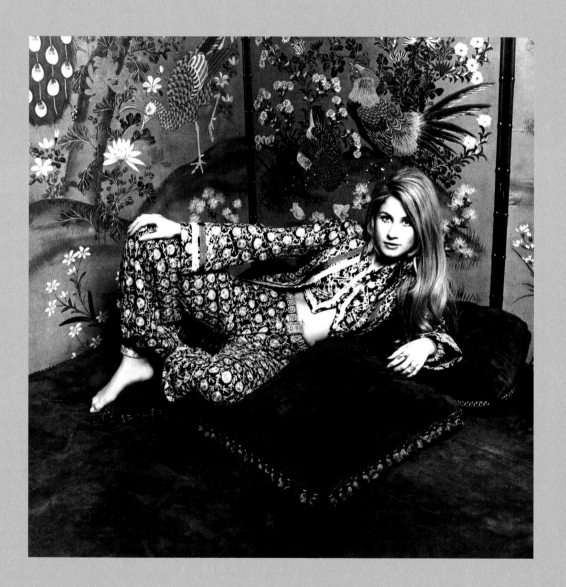

Famous names, including Faye Dunaway, Elizabeth Taylor and Joan Collins, flocked to Thea Porter's Greek Street store. Actress Jane Holzer in British *Vogue*, January 1969.

The "Faye" dress, originally created for Faye Dunaway, was one of Thea Porter's signature designs.

The Faye dress

Baty Jane Holzer

Thea Porter's "Gypsy" dress sketched by artist Catherine Dubreuil.

THEA PORTER

Finishing touches: Thea Porter at work in her shop in Soho's Greek Street, London, August 1977.

"The thing about Greek Street was that it was the shop, the clothes, the atmosphere – everything just joined up. The prostitutes, the sex shops, the art galleries. Soho and its atmosphere were destroyed by developers and greedy landlords, and that will never be recaptured. That was all lost and I think she lost something inside as well. She tried desperately to recreate [the original shop] Thea Porter and made beautiful spaces in Avery Row, Beauchamp Place and Motcomb Street (which was a disaster), but they never had that magical 'thing'.

"Thea had always loved the creative side, but wasn't interested in the boring bits. She was an absolute eternal optimist; she always assumed that it was going to be fine. The other thing about her is that she took never took advice – except from astrologers, and that wasn't the ideal way to create and run a business. She was so brilliant, but her own worst enemy in that way.

"The 1960s was extraordinary, but the 1970s was far more interesting. Everything seemed possible and we weren't aware of the changes at the end of the seventies, early eighties, until after they happened because we were living it. We didn't feel it until it had almost gone, by which time the realities of business changed it all."

A spread from Thea Porter's sketchbook.

kim

The Biba Shop Girl

willott

The shop girls at Biba were expected to be incredibly fashionable, thin and glum-looking. If you asked, "Can I help you?", you risked being fired.

In the mid 1960s, a small boutique in a converted chemist shop, tucked down a side street in Kensington, was about to revolutionize the way women dressed. Girls in their teens and young women queued at the door to stock up on cheap clothes for Saturday nights out on the town.

Tea dresses and T-shirts in murky tones such as olive, rust and "bruised purple", knee-high suede boots, shoes, tights, accessories, make-up – everything was under one roof. No longer did young women have to shop in stuffy department stores with their mothers. The shop was Biba.

Every London girl's dream was to work at Biba, the epitome of youth and style. Kim Willott, a 14-year-old schoolgirl, was already shopping at Mary Quant's shop, Bazaar, saving up for a maroon cardigan in the sale and dyeing her hair to match, which almost got her thrown out of school. But then Kim's sister's best friend went to work at Biba.

"She kept telling me how amazing this shop was, so I went to have a look at it, thinking that perhaps I could get a Saturday job there. She said she'd ask Barbara Hulanicki, who asked me to come in and meet her," explains Kim. "I borrowed one of my mum's 1940s coats in lilac with big shoulders, and it flared out with lovely buttons down the front. I had been to Portobello Road and found a pair of silver platform sandals, which were amazing, so I thought I'd wear those. My mother was horrified, but it was only a Saturday job, for heaven's sake."

"All that Barbara did was sit me down on a chaise longue and ask me about my clothes. She wanted to know what I was wearing underneath the coat, and made me take it off. Her response was, "Oh my god, you're amazing. When can you start?" I was only 15 and still at school, so it was just Saturdays to begin with. However, after the summer holidays, I went back to school for two weeks and then Biba offered me a full-time job. You could leave school at 15, and

that's how it started. I earned £4.50 a week and, after two weeks, they put it up to £5.50.

"The early years were amazing. We used to go to parties thrown by the Beatles and Rolling Stones. They all used to come into the shop, and as 'Biba girls', we had real kudos. Chrissie Shrimpton, Jean Shrimpton's sister, was dating Mick Jagger, and we became friendly. All the 'main' girls at the shop would be invited. Chrissie and Mick had a mews house somewhere in Bayswater, and we would go to these parties and there would be John Lennon, Paul McCartney and Marianne Faithfull. It was a good, fun time."

Working at Biba had other perks too. "We got a new dress each week, and because we were so badly paid, sometimes if we saw something we liked, we would 'borrow' it. We would have a new dress for every Saturday night, and everyone knew that we 'borrowed' stuff, but we had to look glamorous."

With its wooden hatstands, Tiffany-style lamps and ostrich feathers, Biba became *the* celebrity hangout. "All the celebrities of the time came into Biba. Brigitte Bardot, Mia Farrow, Sonny and Cher, Jane Asher, Pattie Boyd, all the regular household names of the time. There was also Anita Pallenberg, Charlotte Rampling, Catherine Deneuve, the Kinks and Queen. Rod Stewart used to come in with his girlfriend, Jenny, but he was so shy he used to stand outside the shop and not come in.

"Freddie Mercury and Brian May came in regularly and hung out in the window, just smoking and chatting with the girls. A lot of people did that.

The "dolly girl" look was all part of the Biba aesthetic, with make-up and accessories to match your clothes.

When Biba moved into the old Cyril Lord shop on Kensington High Street, as you went down the stairs, there was a big seating area underneath where everyone used to hang out, smoking cigarettes and joints. And the boys were naughty; I think a lot of relationships were probably formed under those stairs.

"We had a shoplifting incident with Diana Dors. One of the girls spotted her shoving stuff into her bag. I told her not to be ridiculous when she told me, but she insisted that [Dors] was in the corner of the changing room filling her bag. I really didn't know how to handle this one, but when she got outside, I said, "Excuse me, I think you have a couple of things that you've forgotten to pay for." Of course, she denied it, claiming that she had bought everything the week before, but we knew it wasn't true, as the clothes had only arrived the previous evening. She threw everything on the floor and flounced out to her chauffeur-driven car that was waiting outside."

And then there was a young Anna Wintour, who worked behind the jewellery counter. Kim remembers her well. "We had a table full of Corocraft costume jewellery, along with all these plastic earrings that were just thrown onto it. That's where Anna worked. She wasn't there for long, but we were told that as [she was] the daughter of the editor of the *Evening Standard*, we weren't to work her too hard, so we put her on the jewellery counter."

*

Being part of Biba meant being part of a family. "I had a flat just off Holland Road in west London, and if any of the Biba girls didn't have anywhere to live, they would come and stay with me and sleep on the sofa. They were so badly paid that most of them couldn't afford to work and have a flat as well. By this point, I was a manager, so I was slightly better paid. It was every young girl's dream to work at Biba, and I really didn't mind if they crashed at my flat. It was important that they had somewhere to stay and could tell their mothers they were safe."

However, there was also an unwritten prerequisite of being a Biba girl, and that was to be thin. And surly. "We were all on diets and some of the girls were very thin. We would have an apple for lunch, and there was a little dairy around the corner where they would weigh out 2oz of cheese for us to have with our apple. You didn't dare to be overweight – it just wasn't Biba. I was apparently the only one who ever smiled, the girls were meant to be very sullen and moody. The rule was that if we said, 'Can I help you?' to anyone, we would be fired."

❝We were all on diets and some of the girls were very thin. We would have an apple for lunch, and there was a little dairy around the corner where they would weigh out 2oz of cheese for us to have with our apple.❞

One winter, Biba took over the Hotel Post in Zermatt, Switzerland for the winter season, and sent the Biba girls out there for several weeks at a time. "It was my first trip abroad and I went with my colleague, Eva. As we arrived, two other girls were flying back and one of them had bruises all over her face. When I asked her what had happened, she told me that she had got drunk and fallen over in the snow. And that's what it was like, it was just brilliant. We didn't have to do much work, just stand around taking the money. We were open every day until about midnight, after which we'd go dancing, followed by skiing in the morning, and whatever else we could get up to, really. I was 16 and having a ball."

Kim was also sent to Paris and Milan. "There were only two of us that could speak any French, and because I had French O level, I got to go and launch the cosmetics at Printemps in Paris," says Kim. "It was a real opportunity, if you were in the right place at the right time and spoke the right language. I also spoke Italian and was sent to Fiorucci in Milan. I was just lucky."

The next trip was to launch Biba make-up at 14 retail cosmetic units for Judy's in California, USA. "There was a very definite Biba 'look', and everything had to match, from your hair and fake lashes to lipstick, blusher and mascara, so that you were totally colour-coordinated. Biba brought out a make-up range called China Doll, which included blue and even more blue. They sent me samples including blue lipstick, bright blue hair dye, and blue nail polish. I went to see the managing director wearing all this blue, and he went flying out of his office saying, 'We're not having that, we'll never sell

it.' Finally, he agreed to have it on sale or return, so that if he didn't sell it, we wouldn't charge him. It sold out in a week and was followed by green and purple. The beauty of it was that you could achieve the whole look in about two minutes."

Seven months later, Kim had a call asking her to go to New York to launch the cosmetics in Bloomingdale's. "For some reason, I stayed at the Plaza Hotel, which was silly really, because it was such a waste of money. However, it was a wonderful place to be. There were many wild times, such as bumping into Mick Avory and Dave Davies from the Kinks and ending up at Carnegie Hall with them backstage, and hanging out with Tony Secunda, who managed T. Rex, Marc Bolan and Chrissie Hynde. I don't know how I got up in the mornings, but there was always plenty of make-up to put on to cover all those bags under the eyes."

*

When Biba moved into the Derry & Toms building on Kensington High Street in 1972, Kim could see what was going to happen. It was the most beautiful store in the world, but fashions change, and she could see that when she came back from America.

"Jeans and the American look were coming into fashion, and if you walked down the King's Road in London, the Jean Machine was opening, along with Jeans West and the Pant House. They were all selling jeans, jeans, jeans. It was a very different look." Kim met Billy Murphy, founder of the renowned The Emperor of Wyoming on London's King's Road. "He was bringing in denim from the States in huge

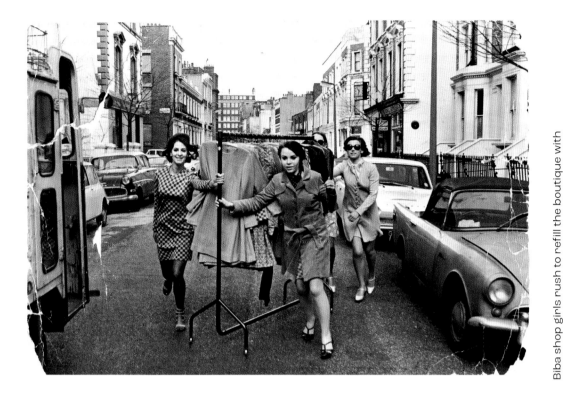

Biba shop girls rush to refill the boutique with more stock as it flies off the shelves.

containers, such as Western shirts, denim jackets and Levi's jeans. I loved that look and was very influenced by it." **Soon afterwards, Kim was offered a deal with an American jeans company that she simply couldn't turn down.**

Kim had already left Biba when it closed in 1975. "When British Land bought Biba, it was the beginning of the end," **she says.** "I can understand why it had to close if it wasn't profitable, but they treated Barbara so badly. I didn't know she'd been banned from the store until I phoned her up, having heard it was closing down. I was happy to work for nothing and help out. It was such a shock."

Looking back, some of Kim's fondest memories are those heady days at Biba. "When I left school at 15, my headmaster told my mother that I'd end up working in a shop and amount to nothing," **remembers Kim. The irony is that she did end up working in a shop, but it was a far cry from her headmaster's prediction.**

"I was at Biba for seven years and it took me to wonderful places – Zermatt, Paris, Milan, Los Angeles and New York – all before I was 21. I met and socialized with people from all walks of life, from film and TV to musicians, artists and royalty, having a fabulous time along the way and forging lifelong friendships. The work was hard, often 12-hour days, and the pay was rubbish, but I loved every minute of it."

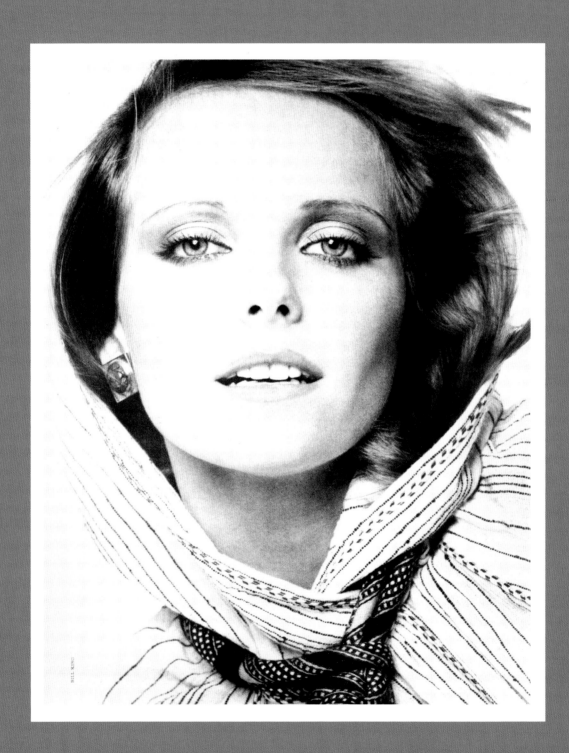

cheryl

Model

tiegs

As well as being a swimwear model, Cheryl Tiegs appeared on the pages of *Vogue*, *Harper's Bazaar*, *Glamour* and *Elle* during the 1970s.

Famous for her incredible body, Cheryl was the first celebrity model to put her name to everything from cosmetics to mass market clothing.

In the late 1970s, no model earned more money than Cheryl Tiegs, who had signed the largest cosmetics contract ever written with CoverGirl for $1.5 million. So how did a girl from deepest Minnesota knock Farrah Fawcett off the walls of several million teenage boys' bedrooms by posing in a pink bikini?

"It was a very slow start," **remembers Cheryl.** "My girlfriend from next door would come over with *Seventeen* magazine, and kept saying how I could be a model. I thought she was nuts. I thought those girls were from another world. But I met a small-time model agent at a charity dinner and he told about 11 girls to come and see him. I was no shining star, but I was the only girl who took him up on his offer. I did fashion shows in parking lots for free. I would do anything they asked me and would be absolutely thrilled."

Cheryl's first big break came in the form of a bathing-suit ad. "It was a double page spread in *Seventeen* and the editor of *Glamour* saw it and said, 'I want that girl in St Thomas next week.' I'd never even been on a plane before. The other model was Ali MacGraw, who was so generous and gave me a lot of self-confidence. It was a big start.

"I was working in both California and New York and trying to make it work around college. Then, one day, I just packed my bags and said to Mom and Dad, "I'm going to New York". All I did was work. I didn't make friends for a long time. I just worked, sometimes 12 hours a day, and then I'd take my bag and head to an all-night shoot. I was very happy, though – it was what I wanted to do.

"Modelling can be a very lonely career. You're on a plane every other day and you arrive somewhere, meet a hundred people who are all very nice and interesting and fun, and then you leave the next day, so it's very hard to keep up friendships because nobody knows when you're in town and when to call you. But I travelled the world and explored new places, I loved it."

*

Cheryl's career really took off in 1978 when she appeared in *Sports Illustrated*'s annual swimsuit issue in a white fishnet bathing suit. "It was a small picture that almost wasn't used," **she says.** "It was one roll of film taken at the end of the day and it was about to rain. To me it was a very simple, sweet picture, but it became incredibly famous. Fans still talk about it today."

Another famous shot – the one that replaced the millions of Farrah posters – is of Cheryl posing in a skimpy pink bikini. It was photographed by Albert Watson, and he remembers the day well. "It was one of the most successful pin-up pictures of all time," **he remembers.** "I did it at the end of the day. Cheryl came to me and said, 'Would you like to make $5,000 in 20 minutes?' I said, 'Sure, I'm always open to that.' She said, 'I'll give you $5,000 if you do two rolls of film of me in a bikini.' I did it and before she left the studio, she gave me a cheque for $5,000. She was going to sell it as a pin-up and she knew that it was going to be good."

Cheryl became a swimwear model and spent much of her time living in the Caribbean, the Seychelles and Hawaii – anywhere there was water. "I spent a

lot of time there, and that's what I really miss. The smells, the flowers, the water, the air – everything was just so luscious and divine. I would get up at 3 a.m. and we'd do hair and make-up by flashlight, I'd steal a banana from the kitchen the night before for my breakfast, and then we'd drive for an hour to the location before the sun came up. We'd work all day in the sun without a break and I'd get back to the hotel at 11 p.m. After a few hours' sleep, I was up at 3 a.m. to do it all again. You had to have a lot of patience because everyone would get a little on edge from the lack of sleep, the heat and the constant flies bugging you to death. It was not always as breezy as it appeared on the pages."

Cheryl worked for *Sports Illustrated* as well as *Glamour* (she believes she was in *The Guinness Book of World Records* for appearing on more *Glamour* covers than any other model), *Harper's Bazaar*, *Vogue* and *Elle*, but the real money was just around the corner. In autumn 1979, Cheryl signed a contract worth $1.5 million with cosmetics company CoverGirl. "It was a new thing, and girls weren't used to getting contracts. Along with *Sports Illustrated*, they started using my name, which was unheard of. Then *Time* magazine did a cover story on me – they interviewed me, my friends, my neighbours – and that changed my world."

Suddenly, Cheryl Tiegs was a household name and became known as the first celebrity model.

But she was also smart and used her fame to her advantage. "Many models, such as Ali MacGraw, went into acting, but I wasn't a very good actress, so I never followed that path," **she admits.** "Instead, I designed a line of clothing for the department store Sears. We sold 1 billion dollars' worth of clothes over the next decade. My signature had become my trademark and it was the Cheryl Tiegs line of clothing. It was very mass market, which nobody had really done before, but I'm from Minnesota and my family and fan base were mass-market people and that's what I wanted to do."

Looking back, the 1970s was a special time for Cheryl. "The seventies were so glamorous, sweet, sexy, a lot of fun, a lot of laughter and a lot of magic. I don't think anybody realized that what they were doing was amazing until they look back at it. I think that no matter what you create, how hard you work, or how much you contribute to something, you don't realize the strength and power of it until it's over. Then you look back and you think, 'Wow, nobody had done that before.'"

Cheryl Tiegs wearing a Halston sequin evening gown, *American Vogue*, December 1973.

8
9
10
11
12
13
14
15
16
17
18
19
20
21

Patrick

the

Joey

Olivier

Get for Billy a
soccer ball in gold
2 of these.

Maria Pia

Bob Brown

Patrick

"magazine

Lizzette Kattan
Editor-in-chief,
Harper's Bazaar Italia

wars"

Memories of Lizzette Kattan with photographer Patrick
Demarchelier and her team in her notebook, 1978.

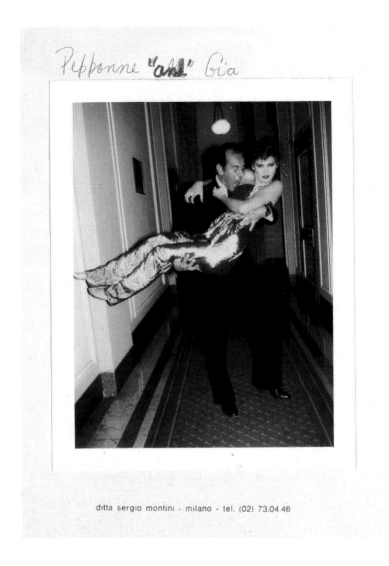

Peppone "and" Gia

ditta sergio montini - milano - tel. (02) 73.04.46

Bazaar's Italian publisher, Giuseppe "Peppone" della Schiava, and model Gia Carangi in 1979.

There has always been rivalry in fashion. If you were part of Karl Lagerfeld's entourage, you didn't mix with Yves Saint Laurent and his following; if you worked with photographer Helmut Newton, you couldn't work for Chris von Wangenheim.

Model Marie Helvin worked exclusively with David Bailey for *Vogue* while they were married, and former model Hazel Collins fell foul of Karl Lagerfeld when she modelled for Givenchy in one show. Karl didn't speak to her for two years.

But the greatest rivals of all are the magazines *Harper's Bazaar* and *Vogue*, and it's not just the American editions that feed into this rivalry but also the British, French and Italian. Despite being the older of the two – *Harper's Bazaar* launched in 1867 and *Vogue* in 1892 – *Harper's Bazaar* has a history of playing the underdog to its competitor *Vogue*, although it hasn't always been that way. And if there's anyone who knows this to be true, it's Lizzette Kattan.

*

Former model Lizzette had moved from New York to Milan and began at *Harper's Bazaar Italia* in 1978 when she was just 23. Money was no object, and she hit the ground running. "When I started working at *Bazaar*, I always had a team of people on my shoots. I'd bring them from New York and worked with the best of the best," she recalls.

Working closely with Bryan Bantry, New York's leading photography agent at the time, Lizzette handpicked up-and-coming talent. "Bryan discovered many photographers and I put them in business through the pages of *Bazaar*," she explains. "Patrick Demarchelier was one we put on the map, but many of the photographers we discovered don't give us the credit because they feel that *Harper's Bazaar* is number two and *Vogue*

is number one. They forget what they did before they were picked up by *Vogue* years later, all the editorial pages they did for *Bazaar Italia*. Herb Ritts was another one that started with us, the first pictures he ever did in his life were with me for *Bazaar [Italia]*.

"In my opinion, Steven Meisel is another example of a photographer who forgets where he started. I personally rented a camera for him to use for his first editorial shoot. He was working as an illustrator for *Women's Wear Daily* and I loved his work so much that I suggested he turned them into photographs because they would make great fashion images. He worked for us, and then *Vogue Italia* liked what they saw and stole him away from us. Even Anna Wintour recently said how she discovered Steven. Hello? Move over. I felt that *Vogue* would watch what we were doing and take their pickings."

In 1992, when the former editor of British *Vogue*, Liz Tilberis, took over the helm at *Harper's Bazaar*, Anna Wintour, the editor of American *Vogue*, put an embargo on Tilberis's stable of photographers. If they worked for *Harper's Bazaar* they would be banned from every Condé Nast publication worldwide. However, this didn't prevent Patrick Demarchelier from switching allegiances and defecting back to *Bazaar*, albeit temporarily.

*

The 1970s was probably *Bazaar*'s most successful decade, with Lizzette running not only *Harper's Bazaar Italia* but also the French and men's editions, as well as *Cosmopolitan Italia*. But

Harper's Bazaar Italia was the magazine of the moment, and there wasn't another glossy magazine in the world giving photographers as much freedom. There were simply no rules to break.

"We had big budgets and no limits, which is why the magazine was so great, because we had such freedom," **says Lizzette.** "I would choose whatever I wanted to do, and if I didn't like what a designer was doing, I'd ask them to make something especially for the shoot, and they did because they trusted me. *Bazaar* was the fashion bible through all those years and designers really believed in what we were doing. I didn't care about advertising or how much a shoot cost. If we didn't like something, we'd just do it again."

Photographers were treated like superstars and the magazine became famous for treating its talent well. Lizzette was also responsible for making sure that everyone was credited for their work. "I was the first one who started to put the names of photographers, hairstylists and make-up artists on the editorial pages," **she explains.** "Nobody had done that before. Previously, you wouldn't credit these teams of people."

*

Another key to the success of *Harper's Bazaar* during the 1970s was that Lizzette wasn't afraid to push boundaries. "I was young, crazy and fearless. I put Brooke Shields on the cover of *Bazaar* when she was 13 years old. At the time she was the youngest model to appear on the cover of a fashion magazine ever. I was criticized by the *New York Times* for using models that young, but she was already 'Brooke Shields' and had made the movie, *Pretty Baby*, in which she played a child prostitute. We went on to work with her for years."

Lizzette also worked regularly with controversial photographer Chris von Wangenheim. "We travelled the world together. He was fantastic. A lot of people didn't understand him as a photographer; they thought his pictures were too sexy. So he felt comfortable working with us because we gave him the freedom to express himself. We were 100 per cent behind him, and that's when he really exploded. We also worked with Helmut Newton, but he refused to work with us when I started to use Chris. He told me we had to make a choice – it was him or Chris – so I chose Chris, and he never talked to me again. I went for the younger photographer that I could have fun with, mould and explore things."

❝*Bazaar* was the fashion bible through all those years and designers really believed in what we were doing. I didn't care about advertising or how much a shoot cost. If we didn't like something, we'd just do it again.❞

Lizette was with *Harper's Bazaar* for 14 years. "I left because, in the meantime, I got married, had two children and really wanted to be with them. My first son had so much mileage, more than any other child in the world, because I'd taken him everywhere with me. When I had another one, it became too difficult."

During those 14 years, Lizzette produced and published thousands of pages of fashion each month, and *Harper's Bazaar Italia* rose to new heights. Sadly, it wasn't to last. Over the next two decades, budgets were slashed and the magazine was pipped to the post by *Vogue* once more. By the end of the 1990s, it had closed. But *Vogue* may have a new competitor now. In 2020, *Harper's Bazaar Italia* was relaunched as a digital-only magazine, and at the end of 2022, a print edition was launched with much excitement. Only time will tell whether it will knock *Vogue* off the top spot once again.

bibliography

Acosta, C. (2021) "Remembering 80s Icon and Supermodel Gia Carangi", *L'Officiel*, 29 January. Available at: https://www.lofficielusa.com/fashion/supermodel-gia-carangi-80s-last-photo

Borrelli-Persson, L. (2021) "Everything You Need To Know About Elsa Peretti", *Vogue*, 20 May. Available at: https://www.vogue.co.uk/fashion/article/everything-you-need-to-know-about-elsa-peretti

Cleveland, P. (2017) *Walking with the Muses: A Memoir*. New York: Atria Books, 37 Ink.

Coddington, G. (2012) *Grace: A Memoir*. London: Chatto & Windus.

Cooper, S. (2018) "The story of Gia – the world's first supermodel who died of Aids at 26", *Dazed*, 14 September. Available at: https://www.dazeddigital.com/fashion/article/41317/1/the-story-of-gia-the-world-s-first-supermodel-who-died-of-aids-at-26

Crump, J. (2018) *Antonio Lopez 1970: Sex, Fashion & Disco* [streaming]. United States: Amazon.

DeMarco, A. (2013) "Tiffany and Elsa Peretti Extend Partnership for 20 Years", *Forbes*, 2 January. Available at: https://www.forbes.com/sites/anthonydemarco/2013/01/02/tiffany-and-elsa-peretti-extend-partnership-for-20-years/?sh=285bd5e6c3dc

Donohue, M. (2021) "How the 1973 Battle of Versailles Changed the Course of Fashion History", *Town & Country*, 16 May. Available at: https://www.townandcountrymag.com/style/fashion-trends/a36388021/battle-of-versailles-fashion-show-true-story/

Drake, A. (2012) *The Beautiful Fall*. London: Bloomsbury.

Elan, P. (2020) "*Vogue* has a race problem. It can't be fixed with a few token black models", *The Guardian*, 16 June. Available at: https://www.theguardian.com/commentisfree/2020/jun/16/fashion-industry-race-vogue-anna-wintour

Fraser, K. (1981) *The Fashionable Mind: Reflections on Fashion 1970–1981*. New York: Alfred A. Knopf.

Gardner, C. (2020) "Makeup Artist Sandy Linter Recalls Gia Carangi Romance: 'We Did Love Each Other'", *The Hollywood Reporter*, 9 June. Available at: https://www.hollywoodreporter.com/news/general-news/makeup-artist-sandy-linter-recalls-gia-carangi-romance-we-did-love-1297324/

Givhan, R. (2015) *The Battle of Versailles*. New York: Flatiron Books.

Gordon, N. (2021) "The Battle of Versailles: The true story behind the fashion extravaganza as seen in

Netflix's *Halston*", *Harper's Bazaar*, 25 May. Available at: https://www.harpersbazaar.com/uk/fashion/fashion-news/a36475199/battle-of-versailles-true-story-netflix-halston/

Gross, M. (2011) *Model: The Ugly Business of Beautiful Women*. New York: It Books.

Helvin, M. (2007) *Marie Helvin: The Autobiography*. London: Weidenfeld & Nicolson.

Hulanicki, B. (2007) *From A to BIBA: The Autobiography of Barbara Hqulanicki*. London: V&A Publishing.

Johnson, B. (2020) "I was the first black model on the cover of *Vogue*. The fashion industry still isn't fixing its racism." *The Washington Post*, 16 June. Available at: https://www.washingtonpost.com/opinions/2020/06/16/i-was-first-black-model-cover-vogue-fashion-industry-still-isnt-fixing-its-racism/

Linter, S. [@sandylinter] *Posts* [Instagram profile], 2019–2022. Available at: https://www.instagram.com/sandylinter/

Mears P. & McClendon E. (2015) *Yves Saint Laurent + Halston: Fashioning the 70s*. New York: Yale University Press.

Nothdruft, D. (2019) *Zandra Rhodes: 50 Fabulous Years in Fashion*. London: Yale University Press.

Odell, A. (2011) "From Disco to JCPenney: The Enduring Tragedy of Halston", *The Cut*, 19 December. Available at: https://www.thecut.com/2011/12/halston-from-the-disco-to-jcpenney.html

Pearl, D. (2022) "Harper's Bazaar Italy Launches Print Edition", *The Business of Fashion*, 7 July. Available at: https://www.businessoffashion.com/news/media/harpers-bazaar-italy-print-magazine/

Porter, V. (2019) *Thea Porter's Scrapbook*. London: Unicorn Publishing Group.

Reginato, J. (2014) "Elsa Peretti's Great Escape", *Vanity Fair*, 16 July. Available at: https://www.vanityfair.com/style/2014/08/elsa-peretti-halston-studio-54

Rourke, M. (1992) "Money. Power. Prestige. With so much at stake, Anna Wintour of Vogue and Liz Tilberis of Harper's Bazaar are locked in a... : Clash of the Titans", *Los Angeles Times*, 17 May. Available at: https://www.latimes.com/archives/la-xpm-1992-05-17-vw-356-story.html

Turner, A.W. (2004) *The Biba Experience*. London: Antique Collectors' Club.

Van Rooy, W. (2011) "Made of Fiber Glass...", *Willy van Rooy*, February. Available at http://willyvanrooy.com/2011/02/

index

Numbers in bold are subjects featured; numbers in italics are pages with captions.

credits

Tamara Sturtz-Filby is a fashion and lifestyle journalist. Her work has appeared in *Vogue*, *Marie Claire*, *Harper's Bazaar*, *Grazia*, the *Telegraph*, the *Sunday Times* and the *Guardian*.